PETER MOORE
SNEAKER LEGEND

For
Christina,
The Moore Family
&
Peace

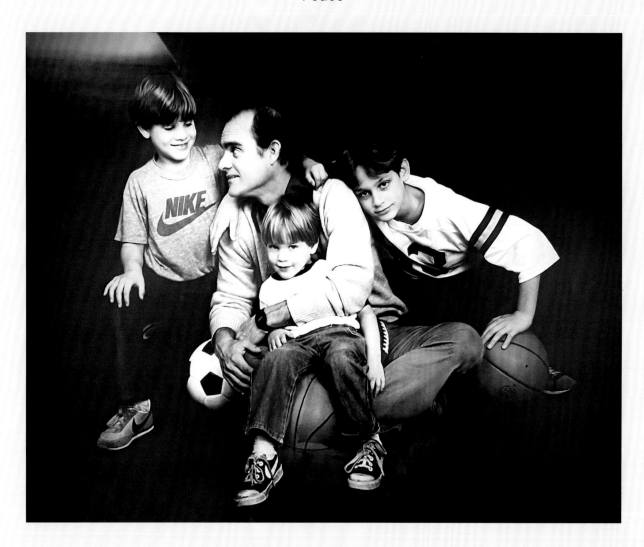

PETER MOORE
SNEAKER LEGEND

The Story of the Creative Visionary Who Revolutionized Nike
and Unleashed the Best of Adidas

BY JASON COLES

To learn more about Peter Moore,
visit petermoorecreated.com

RIZZOLI
NEW YORK

New York · Paris · London · Milan

WHEN I FIRST ASKED PETER MOORE if I could write a book about his life and career, his response was, "Why would anyone read a book about a one-hit wonder like me?" Typical Peter.

I first got to know Peter when his great friend Jacques Chassaing asked if I minded if one of his friends art directed the book we were writing together, *From Soul to Sole*. When he revealed this friend was the great Peter Moore, there was only one answer: "Oh, God, yes!" Getting to work with a legend of the industry I'd grown up in and who had designed the Jordan 1 and Dunk and cocreated adidas Equipment and Originals was the chance of a lifetime for a shoe nut like me.

However, what began was not six months of hearing Michael Jordan and Kobe Bryant stories or finding out why adidas Equipment was green. It was six months of learning what it meant to be truly creative. During my own career in the sports business, I've been fortunate enough to work with some extraordinarily creative people, but none of them holds a candle to Peter Moore—not because of what he did to make Nike an intrinsic part of popular culture, or his role in turning John McEnroe, Michael Jordan, and Kobe Bryant into superstars, or in returning adidas to greatness, but because he was an incredible teacher and molder of people. In the short time I got to know Peter, every day was a school day. He taught me the power of sheer will and the beauty of simplicity. He showed me how you can say everything without saying anything, and he challenged me to challenge myself.

To the sorrow of countless many, Peter passed away in April 2022, leaving an inestimable legacy. The purpose of this book, however, is not just to serve as a portfolio of that legacy. Using Peter's own words, gathered through numerous interviews by myself and others, its purpose is to pass on the experiences, work, and philosophies of a person who spent his entire life doing just that, and in doing so just happened to shape the modern sport and fashion industries. One reason this book is not a portfolio is that I could never have encapsulated such an incredible life in just 300 or so pages. So I hope for anyone who reads it, this book will serve as just the starting point of your immersion into the life an extraordinary creator and teacher, who was so much more than just a one-hit wonder.

JASON COLES AUTHOR

TO MY MIND, PETER MOORE was the first person to bring storytelling and glamour to the sporting goods industry. With his brilliant and clever posters, he was the pioneer of turning athletes into superstars. For the first time, people started to see athletes in a different light. Before, they were people who performed on a Sunday and then disappeared for the rest of the week. Peter changed that by giving them a personality, or perhaps it's more correct to say that he brought it out of them.

They were the first examples of taking an athlete and making a story out of them. Whether it was Moses Malone parting a Red Sea of basketballs or Stormin' Norman Cooper riding lightning, people were being told stories about these athletes that turned them into icons for the first time. It's not by chance that every kid in America had one of those posters and today they are hugely coveted.

Moving beyond the posters, Peter continued that storytelling as the guy behind some of the first and most impactful TV ads in the history of the sporting goods industry—from "I Love LA" to the groundbreaking "Revolution" ad for the Air Max and Air Trainer. They really changed everything by being more music videos than TV commercials.

For me personally, Peter left a legacy of fearlessness. I was already a seasoned designer and a pretty good storyteller, but my problem was I was perhaps too reserved or concerned about the reactions of the powers that be. Watching Peter telling people exactly what he thought without reservation was very empowering to me. A lot of people think of Peter Moore as just a shoe designer, but he was really one of our industry's greatest and most fearless storytellers and, to me, that is his most outstanding achievement.

TINKER HATFIELD VP DESIGN AND SPECIAL PROJECTS, NIKE

WHEN RENÉ JÄGGI BROUGHT PETER MOORE and Rob Strasser to adidas in the early '90s, many of us that thought he was crazy. As the architects of Nike's success, they had also been the architects of our failure. They were the last people we thought could be our saviors.

The smartest thing we did was to listen to them. And the smartest thing Peter and Rob did was to tell us the truth: adidas was no longer the best. While it was tough to hear, it was something we needed to, because many of us were living under the illusion that adidas was still the greatest sports brand in the world. We weren't.

More importantly, not only did they diagnose adidas's problem, they had a solution: go back to the original philosophy of our founder Adi Dassler, whose motto was "Only the best for the athlete." They showed us that our greatest strength had always been in helping athletes achieve their best by providing them with the very best equipment. They also showed us that we had forgotten this. They reminded us that the needs of the athlete that Adi Dassler had always considered—comfort, function, and quality—had not changed. So why had we? The path was clear. We needed to put those values back at the heart of everything adidas made, and so we did.

It's no exaggeration to say that Peter's arrival at adidas changed my life. I had never met someone who exuded such creativity and confidence. He had a natural gift for knowing how to create solutions that really connected with people in a simple way. He also had a fearlessness and decisiveness that inspired me. I don't mind admitting I was very much in awe of him, yet he was always so open and willing to listen to my ideas.

It's almost impossible to define Peter's legacy. It's too immense, so I won't try. To me, he was simply "Peter", my mentor and my friend, and my life was all the better for knowing him.

JACQUES CHASSAING FMR HEAD OF FOOTWEAR DESIGN, ADIDAS

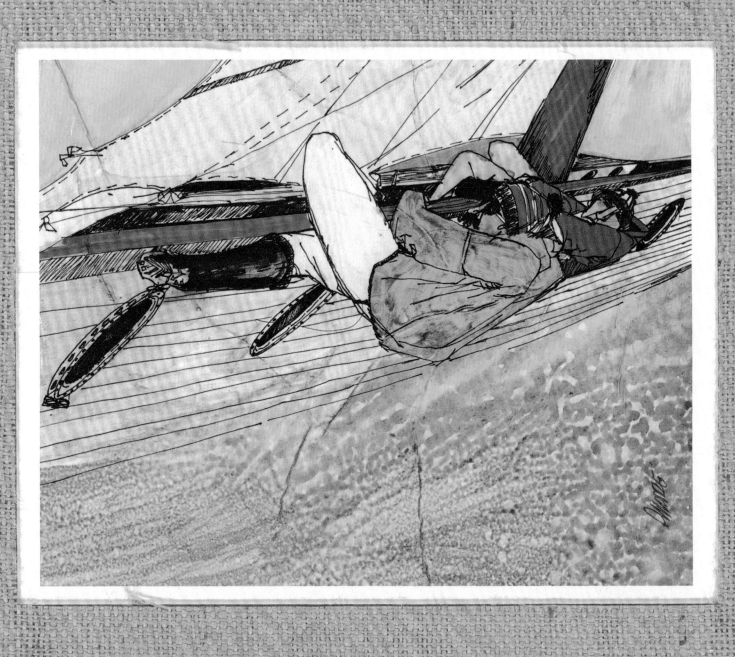

CERTAINLY NO SAILOR

EARLY YEARS 1944–1976

BEING BORN IN TO A NAVAL FAMILY, with a mother who was an admiral's daughter, and a father, brother, and brother-in-law who all went to the United States Naval Academy at Annapolis, I would forgive you if you assumed I followed the family tradition. **But I was never one to follow others, and I was certainly no sailor.** Dad was an officer who specialized in submarines and engineering. His job meant we spent much of my youth moving back and forth across the country from base to base, so sports didn't really become a factor in my life until Dad retired from the Navy in San Diego and I was finally able to focus on basketball and baseball at school. I got just about good enough as a pitcher to attract the attention of the Chicago Cubs, but a bad shoulder and apparently "a bad attitude," put an end to that.

Then I discovered golf. When I figured out you could smoke and drink while you played golf, it became a life-long addiction, and I spent pretty much every spare hour at the country club working on my game. Another life-long relationship that would develop as a result of golf was with Christina, the daughter of the club pro, who would become my wife and the love of my life.

After making it to the California state championships two years in a row, I was finally in demand and San Diego State, Arizona State, and the Naval Academy were chasing my signature. I chose San Diego State. **When I told Dad I wasn't going to the Naval Academy, I think he was actually relieved, because I guess he knew I would've been a shitty naval officer. I played college golf for about a year and a half, but when I realized I wasn't going to be good enough to make the Tour, I found myself at a crossroads.**

A combination of the influence of my aunt and reading Ayn Rand's *The Fountainhead* had stoked an interest in architecture, but to study architecture I needed to improve the grades that I'd sacrificed for golf, so I transferred to Southwestern Junior with the aim of getting into University of Southern California. The Dean of USC's School of Architecture advised me to prep for architecture by taking classes in fine arts, unwittingly leading to my realizing that art was far more interesting than architecture. I began to apply the same passion I had for golf to art. It must have paid off because my art professor, Robert Methany, recommended that I apply to the famous Chouinard Art Institute. I really didn't know what to expect of art school or where it would lead. I knew I had some talent, but I had no idea what it might mean in terms of a career. There certainly was no grand plan in mind about the future. I really didn't even know what to expect of myself.

Previous: Untitled early artwork
Opposite: Peter (*foreground*) with fellow art school student and lifelong friend Jim Bagley

"WHEN I FIGURED OUT YOU COULD SMOKE AND DRINK WHILE YOU PLAYED GOLF, IT BECAME A LIFE-LONG ADDICTION, AND I SPENT PRETTY MUCH EVERY FREE HOUR AT THE COUNTRY CLUB WORKING ON MY GAME."

Call Robert Overby for top graphic design (1) (805) 966 23 59

Poster by Robert Overby

"OVERBY'S APPROACH WAS SIMPLE: THE BUSINESS OF DESIGN WAS ABOUT PROBLEM SOLVING, AND THE SOLUTION TO THE PROBLEM IS INHERENT IN THE PROBLEM ITSELF. IT BECAME THE FOUNDATION OF MY APPROACH TO DESIGN."

At Chouinard, the curriculum was designed to give every student a solid foundation in all of the visual arts before focusing on either painting, filmmaking, or graphic design, and sticking with it for two years. Whatever the specialty, the approach was the same. **What I learned at Chouinard is how you boil out the problem to its essence and solve the problem in whatever creative manner that you think works.** This approach to art, where you look at it as a problem to solve rather than creating an aesthetic, became my approach to everything, and I would resort to it whether I was designing, brand building, marketing, or running a company.

There were three guys who I really thought were not only great painters but great communicators: Larry Rivers, Jasper Johns, and Robert Rauschenberg. These are three guys who had a big influence on me in the way their work looked and the way they communicated. I think it was their approach to art, which had a sense of being practical but bold, sort of no bullshit, about it. It wasn't anything so mystical or heavy or overintellectualized. It was just basically whatever they said, they said—and they said it in paintings that I thought had a lot of emotion and power to them.

Quite frankly, I didn't know what the hell I wanted to be. First, I wanted to be an architect, then a painter, then a sculptor. The only thing I was sure of was I didn't want to starve. That had no particular appeal to me at all. I had no ambition to be a bohemian, but when it came time to choose, I entered the School of Graphic Design. Here I learned another lesson that I would carry throughout my career: despite the similarities between design and fine art, they are distant cousins. It's all in how you attack the problem. There's a big difference between graphic design and painting. **As a graphic designer, you solve your client's problems. As a painter, communication is personal. The problems to solve are your own. A much more difficult situation. That's why painters suffer.**

Don't get me wrong. I've thrown things across rooms, yelled and screamed at clients, and told them they're dumb. But it's not a question of advancing a personal style or vision. The struggle always stems from getting clients to realize that a particular solution is not some arbitrary aesthetic gesture, but it is the best solution to their problem.

At Chouinard, I started working for Robert Overby, the man I still consider my mentor and biggest influence. He convinced me to spend an extra year with him after graduation. Overby's approach was simple: the business of design was about problem solving, and the solution to the problem is inherent in the problem itself. It became the core of my approach to design. It wasn't the only thing I gained from Overby, however. When it came to clients, he had the worst personality you could imagine. He would say to them, "Look, you know this is right. If you don't like this, then the hell with you." And then he'd walk out. As you can imagine, there was a regular turnover of clients. When he quit to become a painter, he passed his two remaining clients on to me, and Peter Moore Graphic Design was born.

The "Mooremobile" outside the Peter Moore Graphic Design office on S.W. Water Avenue, Portland

WHAT THE HELL IS A GRAPHIC DESIGNER?

PETER MOORE GRAPHIC DESIGN 1977–1982

KITTY HAWK

A ride from Kill Devil Hill started air travel. In the winter of 1903, after three years of trial and disappointment and after a coin flip with his brother, Orville Wright flew 120 feet in 12 seconds.

People were trying and failing to put air in shoes even before the Wright Brothers rolled the flying machine from their shop.

It has now been done. A cushion of air for the runner.

It's not been easy. Invented by an aerospace engineer, developed by a 2:19 marathoner from Minnesota and old shoe makers from New England. It's taken six years.

The shoe is called Tailwind.

Runners who have tested the Tailwind have been reluctant to return even crude prototypes. They say it is the most comfortable shoe that they have ever worn. They tell us that knees and legs don't tire as quickly. They talk about increased stamina and distance-running ability. PRs have been reported.

And before you ask — the Tailwind doesn't go flat.

Nike stands by the reliability.

The Wright Brothers didn't foresee the Concorde or Apollo 11. But we are looking beyond the Tailwind.

We believe this is the most revolutionary thing we have ever done. We believe we are making the next generation of footwear.

Coming January 1. Air Travel.

NIKE

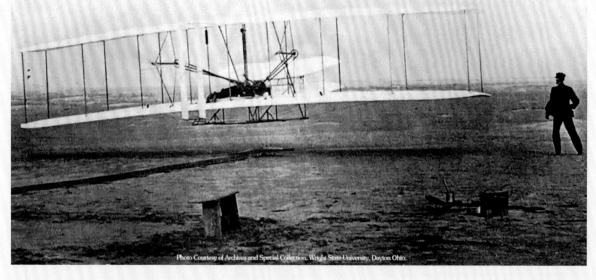

Photo Courtesy of Archives and Special Collection, Wright State University, Dayton Ohio.

Nike Tailwind "Kitty Hawk" advertisement (1979)

"THEY'RE CALLED NIKE. THEY'RE HERE IN TOWN." SO I SAID MAYBE I SHOULD GO SEE THEM. HE SAID, "DON'T BOTHER. THEY'RE GOING NOWHERE. THEY JUST RUN, DRINK BEER, MAKE SHOES, AND SELL THEM OUT THE BACK OF A VAN."

THE NIKE THING STARTED after there was an earthquake in LA in '71. My wife Christina didn't like the idea of living on a fault, so we decided to move. Jim Bagley, a friend who had been my college roommate, was in Portland, Oregon, and he said that Georgia-Pacific was looking for somebody like me. They called it a "creative guy." They were an old-fashioned, straight-laced, Southern Baptist lumber products firm that made everything from construction materials to paper. I applied, kind of hoping they wouldn't answer. They answered. So we moved to Portland. It was a dismal place back then and, coming from Los Angeles, it was like going back to the 1950s. Just two years later, I realized corporate life wasn't for me, so I left Georgia-Pacific and once again I was Peter Moore Graphic Design.

One evening, I was working late and decided to go get something to eat. There was a photographer who had a studio below me, so I thought I'd stop by to see if he wanted to join me. He was photographing these weird nylon shoes with funny rubber bottoms on them. I'd never seen anything like them before so I asked him, "What is this?" He said it was a running shoe. For me, that meant spikes, so I said, "You mean a track shoe?" and he said, "No, it's for running. People run miles in them. They're called Nike. They're here in town." So I said maybe I should go see them. He said, "Don't bother. They're going nowhere. They just run, drink beer, make shoes, and sell them out the back of a van. But I'm a runner; they give me shoes and I shoot 'em for them." I thought, what the hell, I like sports and drinking beer too. I'll go see them.

So I went out there, but they didn't get what I did and had no work for me so nothing happened at first. It was pretty evident that they weren't really shoemakers at all and commercially very naive. Phil Knight had started the company after he went to Stanford for his master's and wrote a paper about how Onitsuka Tiger could surpass the German running shoe companies in the same way the Japanese had surpassed the German camera companies. His professor was so impressed, he told him to pursue the idea. I didn't know about it at the time, but I heard about it later from his professor.

Later, this guy, Rob Strasser, who was then Nike's lawyer called and asked if I'd come over as he had a few questions. Out of curiosity, I agreed. He was huge—over 300 pounds—the last person you'd expect to work at a sports company. **The first thing he asked me was to sign a confidentiality agreement. I told him I wasn't signing anything. So he said, "You have to." I said I didn't have to do anything and got up to go. He sort of liked the attitude** and asked me not to leave. I assured him I wasn't going to tell anybody anything. He was working on an ad for the first Air shoe, which was a photograph of Kitty Hawk, the first flight of the Wright brothers' airplane. He wanted to have it sepia toned, but the ad agency had said it had to be black and white. So he wanted to know if I could do it and I said, "Sure." Then he asked me, "So what is it you do exactly?" When I told him I was a graphic designer, he said, "What the hell is a graphic designer?" It was the start of a beautiful relationship.

Rob thought of me as a Hollywood guy. An agent, if you will. So I explained to him the difference between an advertising agency and a design firm and how advertising agencies tend to fight against you, whereas design studios tend to work with you. They had an ad agency, but they were abusive of the brand and didn't really understand it. So we started talking about taking care of the brand, and he agreed that they should be doing this. He offered me $500 a month for six months, and we'd see how it goes. I said fine, but they soon became a full-time client and it snowballed. I worked on anything creative—from corporate reports to how the buildings looked. Everything to do with their identity. Then I got into marketing with Rob. He would bring me into marketing meetings, and I learned why things got rejected, or approved. I tried to change that and eventually ended up becoming responsible for advertising.

When I first took Nike on as a client, posters were one of the company's major forms of communication, but they were all over the map—from traditional action shots to posters featuring Nike employees and their families in cute settings. The ad agency, John Brown & Partners, had started a style that was a real departure from the typical game shot photo with the athlete's signature at the bottom. The early posters were by an art director by the name of Denny Strickland, and they showcased the athlete with a generous helping of attitude and humor. I concentrated on this style but took it a step further by focusing each idea around the part of the player's personality that made them unique. **Sometimes, the idea was so obvious, it hit you in the face, like the Moses Malone poster, because between his name and his playing style, he basically opened the way for teammates to score points. It was natural to give him a staff and have him parting a basketball court like the Red Sea.**

Back then, sports, athletes, and even Nike were all part of a fantasy world. I wanted to take these posters right into the imagination of kids. The props, the costumes, and everything else were taken to the extreme. The funniest poster had to be of Lance Parrish when he was playing for Detroit. It was called "Tigerrr Catcher." We had a live tiger brought in for the shoot. We had the thing set up and the photographer shooting, and the tiger opened its mouth and almost clamped onto Parrish's thigh! For a minute I thought, "Great, I've just ended this guy's career." Luckily, the trainer had some raw meat and was able to stop the tiger from biting Parrish.

"BACK THEN, SPORTS, ATHLETES, AND EVEN NIKE WERE ALL PART OF A FANTASY WORLD."

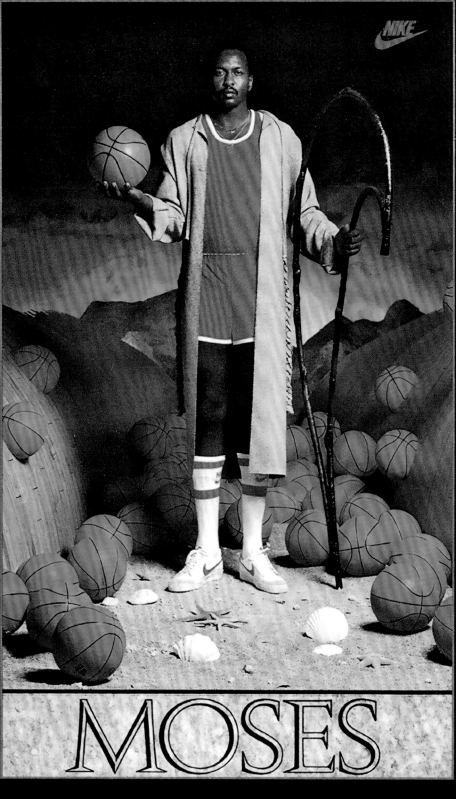

Moses Malone – "Moses" poster (1980)

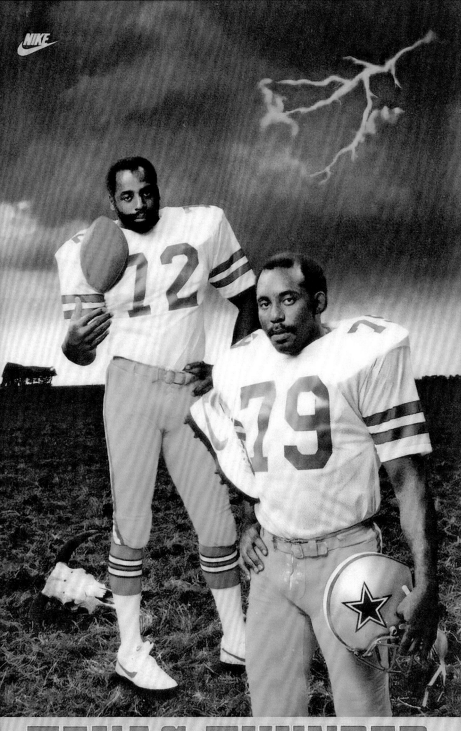

Ed "Too Tall" Jones and Harvey Martin – "Texas Thunder" poster (1982)

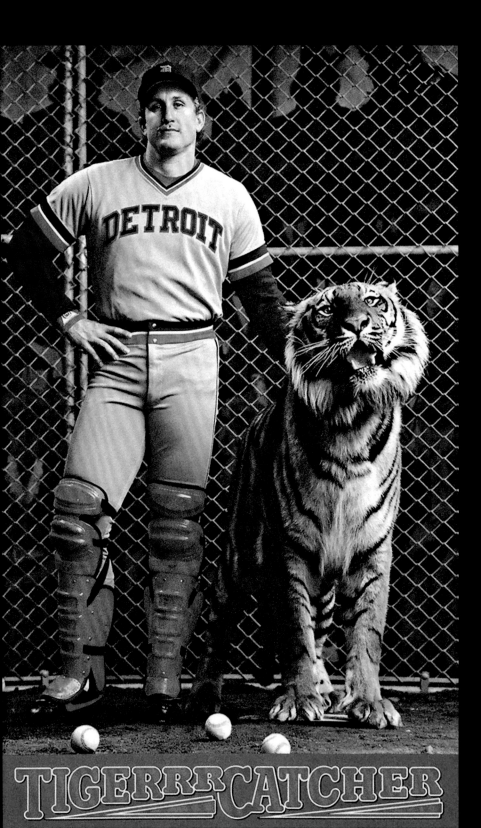

TIGERRR CATCHER

Peter was responsible for the posters that made Nike famous, and we decided that I would tag along and shoot the making of them. One of the most memorable was with Lance Parrish, who was a catcher for the Detroit Tigers. **Peter came up with this idea that we would have him with a Bengal tiger and the poster would be called "Tigerrr Catcher."** So he came to me and said, "Where can we get a Bengal tiger?" So I said, "Well, I don't know. Let's start checking around." There was an actress called Tippi Hedren, who was in Alfred Hitchcock's movies. She was a fan of wild tigers and lions and had a sanctuary in California. So I was thinking if anybody would have one, it would be Tippi.

In checking that, we found it wasn't possible with her, so we found a guy in Los Angeles called Steve Allen, who was an animal trainer. So Peter hired Bill Sumner, who was a still photographer based in Texas. He was one of those guys who would just take a piece of tinfoil and crumple it up and put a light bulb in it for his light source. He was very creative about stuff. So Bill was tagged to shoot the "Tigerrr Catcher" poster, and Peter's idea was to have Lance hold onto the tiger's tail. That was the shot he wanted to get.

So we went to LA and Bill found this crappy little studio that looked like a car park. It was just this warehouse with low ceilings. So Bill set up the backdrop, which looks like the crowd. He had a wire fence to make it look like it was in the batting cage. So we're all ready to go and now it was time to bring in the tiger. I went out to the parking lot, and I had a camera on my shoulder to shoot the tiger in his cage in the back of this truck. As soon as I came around the corner, the tiger hit the cage and started roaring at me. I was thinking, "Oh, my God! What are we going to do now? You're really going to turn this cat loose inside with a bunch of people? No!" But Steve Allen and his crew got the tiger out and brought it into the studio. I wanted to get up high and shoot down upon the scene, but the trainer said, "No, no, no. You don't get up above a tiger. They don't like anything above them." It also turned out that the reason he hit the cage was that they'd been on a shoot a few days before where the cameraman was teasing him and that's why he didn't like it when he saw me. So I was thinking, "Oh, great. Now I'm tiger meat." The other thing was they had a bag full of steak meat and a stick with a prong on it. They were feeding the tiger little chunks of meat all day long.

Well, we finally brought the cat in to let him get used to Lance. And this went on for hours. The trainer got the shin guards and pads from Lance, and the cat had to sniff them and get used to him. Eventually, we put the cat next to Lance and, as Bill took maybe three shots, the cat reached up and motioned as if he were going to bite through Lance's leg. Everybody yelled, "Whoa!" The trainer rushed and slugged the cat between the eyes like boom, boom, boom, and then he took the cat with a chain around his neck and that was the end. Shoot over. Peter turned to me and said, "I wouldn't stand next to that fuckin' cat." Thankfully, it didn't even scratch Lance's skin or tear the uniform or anything. Nobody got hurt. **But the whole thing was just so Peter. He was always thinking about crazy different ways of doing things.**

LES BADDEN FMR DIRECTOR/
CINEMATOGRAPHER, NIKE

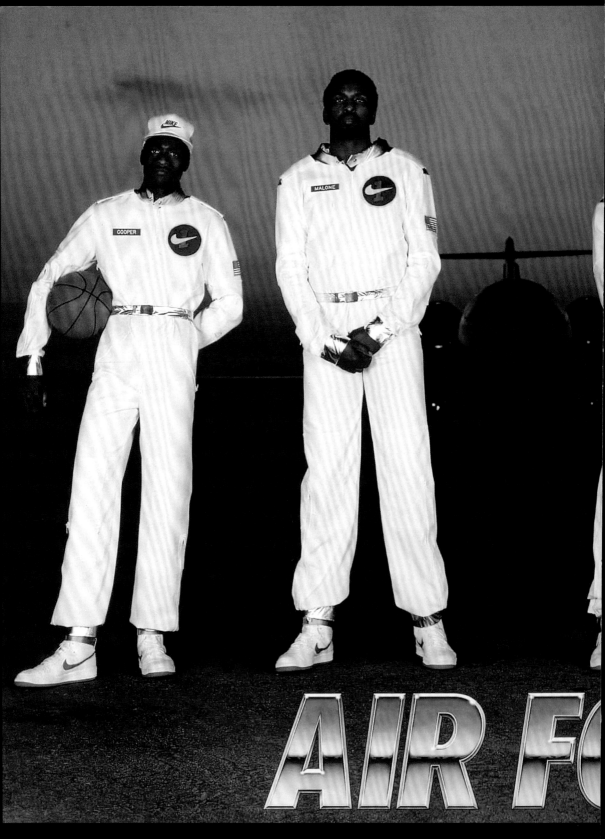

(Left to right) Michael Cooper, Moses Malone, Calvin Natt, Jamaal Wilkes, Bobby Jones, and Mychal Thompson – "Air Force 1" poster (1984)

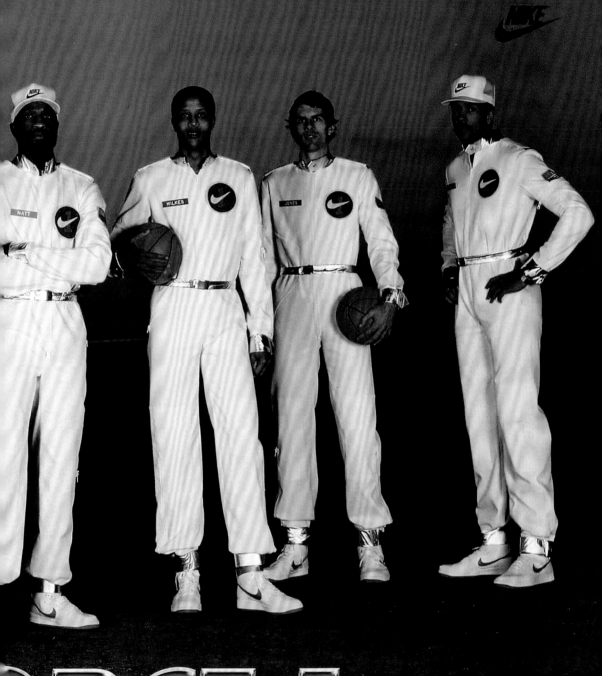

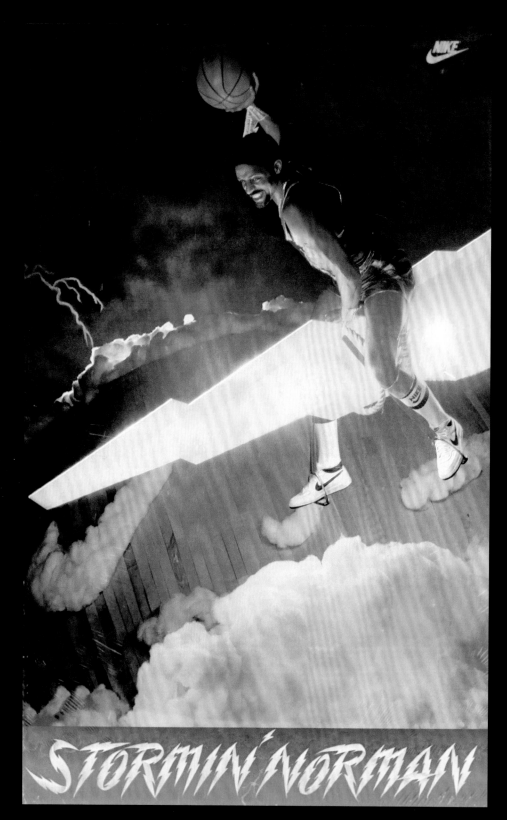

Norman Nixon – "Stormin' Norman" poster (1985)

DR. DUNKENSTEIN

Darrell Griffith – "Dr. Dunkenstein" poster (1985)

The personality posters were so successful for us that athletes began requesting "poster clauses" in their Nike endorsement contracts. But I gradually felt the need to evolve them. **Sport was changing.** It seemed like it was becoming less about real heroes and more about agents and multimillion dollar contracts and greed. **The innocence was going away. To reclaim some of that innocence, I moved certain posters away from a focus on the individual personalities to a focus on the emotion of the sport.** We showed guys in pickup games, working out, training. Half the time, we didn't even name the players. I tried to get away from the fantasy trappings and show athletes in a more realistic way.

Unlike the personality posters, which we evolved fairly dramatically over time, the Nike running posters remained fairly consistent in expressing the solitary nature of the sport. What seemed to resonate with the imagination of runners were the photographs that were purposely evocative, even haunting. A moonlit beach with a blurred figure running out of a frame. A wet pier at dawn. The smoking crater of Mount St. Helens circled by a lone strider. Running wasn't about high profile players or winning. Fantasy was still a part of the communication, but it was a completely different kind of fantasy—one of being out there, on your own, away from the world, even if you were running through the middle of a city. And the runners were never identified so that everybody could identify with them.

I did the posters for more than ten years at Nike. The thing that was so fun was that there were almost no boundaries to what you could do. Part of it was the times. **Nothing was limited or tied to a slogan or an ad campaign or a product line. It was almost wide open, as long as you stayed true to the athlete and the brand**. Part of it is just sport itself; it can be funny, or tragic, or just a grind, to something almost spiritual.

Opposite: "Urban Runner" advertisement (1983)

"WHAT SEEMED TO RESONATE WITH THE IMAGINATION OF RUNNERS WERE THE PHOTOGRAPHS THAT WERE PURPOSELY EVOCATIVE, EVEN HAUNTING."

Most heroes are anonymous.

NIKE®
Beaverton, Oregon

"Battle of Atlanta" poster (1978)

GRETZKY

Wayne Gretzky – "Gretzky" poster

MOONRUNNER

NIKE

"Moonrunner" poster (1984)

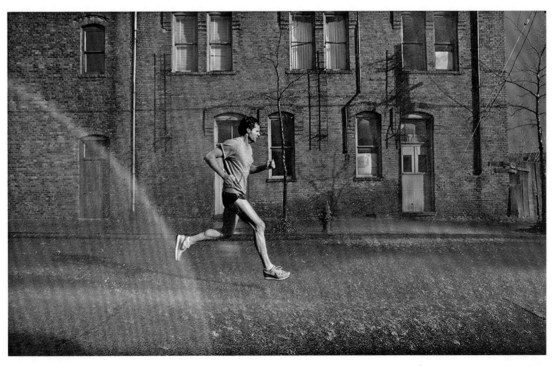

PEGASUS

NIKE

"Pegasus" poster (1984)

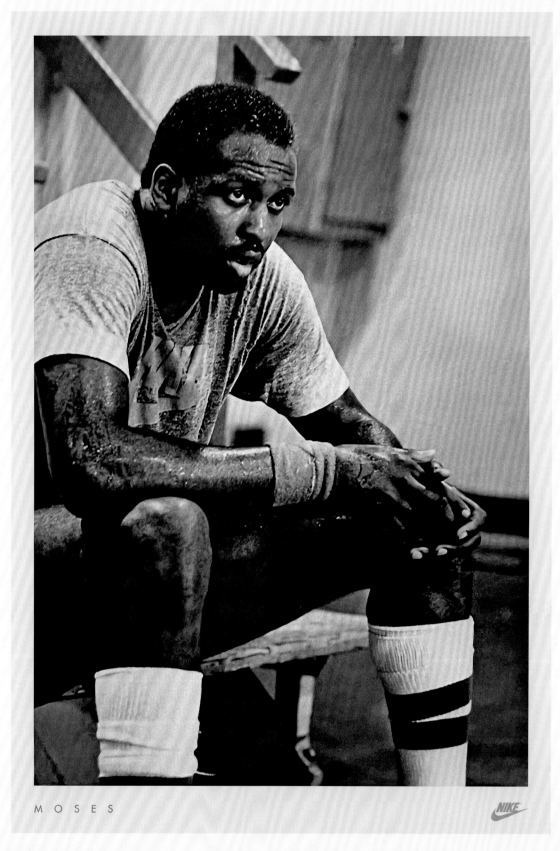

MOSES

Moses Malone – "Moses" poster (1982)

Peter's genius with the Nike personality posters was to think about an athlete and create something that wasn't just about their nickname but also the essence that made them special. It was like everything that he did. He was trying to boil it down to "What is this guy really about?" He then came up with props or a setting that made them completely unlike other traditional sport posters, which were usually just the athletes in their team uniforms doing their sport. He had to do it in a way that was fun enough that some kid would want to put it on his wall. Part of that necessity came from the fact that Nike didn't have the rights to use the uniforms. So early on, he always had to come up with something that put them in a situation that reflected the athlete's character, not their team's, which was something new at the time.

The other special thing about the posters was that Peter had a way with athletes. I think he appreciated them and really respected their talent, but he didn't fawn over them or get intimidated. When he planned them, he'd bring out his concept boards and show them how he was thinking about portraying them and why.

And the athletes saw cool, fun ideas that felt special, and they really responded to them. There's a reason why everyone wanted a poster clause in their contract when they signed with Nike. **They knew that Peter would create something unique that they couldn't get from another shoe brand.**

One of the best athlete posters Peter did was the Moses Malone poster. Unlike most of them, which were planned well in advance, it was during a typical situation when the ad agency would be filming a commercial. Peter would see something, often just a split second moment, and create a still out of it. Moses was taking a break. He was just sitting down and leaning over. He was so tired because we'd been making him do rebounds over and over and over. He was just sitting there, taking a breath and sweating. Peter had the photographer quickly shoot it and created a poster out of that one moment in black and white. It's a beautiful piece.

CINDY YOSHIMURA FMR ADVERTISING MANAGER, NIKE & ADIDAS

...

One of the biggest things about Peter for me was that even though I worked for him, I didn't realize until he passed away how much he was a part of my life as a child.

I grew up in Portland and down the street from my house was a mom and pop sneaker store that sold all the posters and everything. **I could never afford to buy the sneakers and my parents weren't into sports like I was. But I would buy all these posters.** "The Iceman" was my favorite, and "Dr. Dunkenstein," and "The Field Generals."

Tape wouldn't hold them up, so I would literally nail these posters on my mom's wall with screws and nails, and I would take silver tape and one of my dad's old

record player covers and a hanger and make a basketball hoop to put on my door. And we would throw a ball of socks and play hoop.

It wasn't until I was at his memorial when all the posters popped up, I began to cry because I realized Peter had affected me back when I was like 8 or 9 years of age and I didn't even have a clue. So it wasn't until his memorial that I was like, wow, **Peter affected me then and my love for sports and dreaming big and all of that.** So my relationship with Peter technically started when I had first put those posters up on the wall.

RONNIE WRIGHT FMR DESIGN DIRECTOR, ADIDAS

Peter standing before a replica of the *Nike of Samothrace* statue in Las Vegas

BREAKING THE RULES

NIKE DESIGN 1982–1987

By 1982, NIKE WAS GROWING so fast it had become all-consuming and pretty much swallowed up my business, so Peter Moore Graphic Design became Nike Design. We worked 24/7 just to keep up, and I was kind of overwhelmed by how fast it all happened. I think I had always imagined myself at a drafting table with maybe just one other designer and another to pick up the phone, but that was all. But more work didn't mean more money, so when our needs and Nike's became the same thing, I accepted an offer from Nike to buy the business and become creative director.

Our work remained the same: the design and production of all of Nike's brand materials, from logos, posters, catalogs, and packaging to brand manuals, annual reports, and event displays—the whole kit and caboodle. At first, we stayed in the same office, a small house on S.W. Water Avenue in Portland to which we'd moved in 1980. People would be shocked if they knew where Nike Design started. It was about as far as you could get from a high-tech, hip, creative environment. It was next to a swamp, and we had a goat for a neighbor that lived on the porch of the house opposite. It got so cold in winter that we had to wear coats inside. And in summer, it was so hot that we had to make sure we didn't drip sweat on whatever we were working on. I loved that house.

But as the workload increased and we had to start hiring more designers, the house got cramped, so we moved and created Nike's first creative workspace. **The idea was that it was totally open plan and broke down the idea of offices and walls. It was noisy and there was little privacy, but it got people talking to each other about their ideas—a concept that would become a Nike trademark.** As Nike Design grew, we also started to do advertising, video production, trade shows, and space planning—anything to do with the visual element of the brand. Everything had to tie back to the three things that had built Nike: sport, performance, and innovation. It had to be authentic and had to perform.

Nike was still trying a lot of different things: golf, women's lines, and even bowling, for Christ's sake. So there was the opportunity as a designer to try new things. Some ideas pushed the boundaries of the brand. The first women's catalog was the first time Nike tried to speak to women in terms that would matter to them. It was a beautiful, almost sensual look. In a way, it may have gone too far, but it dramatically shifted the way Nike spoke to women.

Some ideas were really out there, and some definitely bombed. There was this aquarium display, for example, designed to show how waterproof our hiking boots were. It was a real aquarium, big and clunky. I mean, who would ever want it in a store? On top of that, the boots leaked. But even though some ideas were crazy, it was part of breaking the rules, and pushing and trying new things. **And, for the most part, I think we succeeded in building an image that set the brand apart and marked a turning point in the company—a recognition that design mattered and was no longer something you could choose not to do.**

"IT WAS NOISY AND THERE WAS LITTLE PRIVACY, BUT IT GOT PEOPLE TALKING TO EACH OTHER ABOUT THEIR IDEAS—A CONCEPT THAT WOULD BECOME A NIKE TRADEMARK."

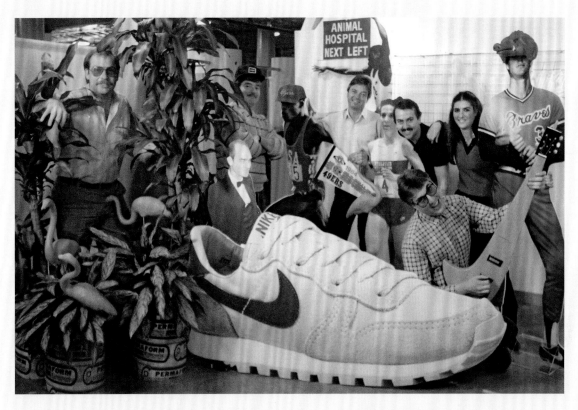

The Nike Design team *(from left to right)* Roger Thompson, Mark Pilkenton, Michael Doherty, Les Badden, Bob McErvin, Sue Dinihanian

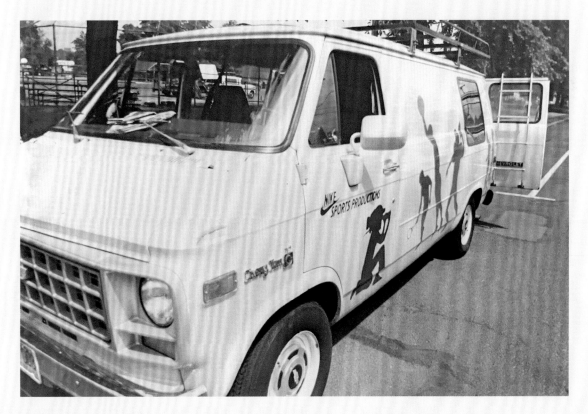

The Nike Sports Productions Chevy van (Peter was the model for the silhouettes.)

First Nike Women's catalog

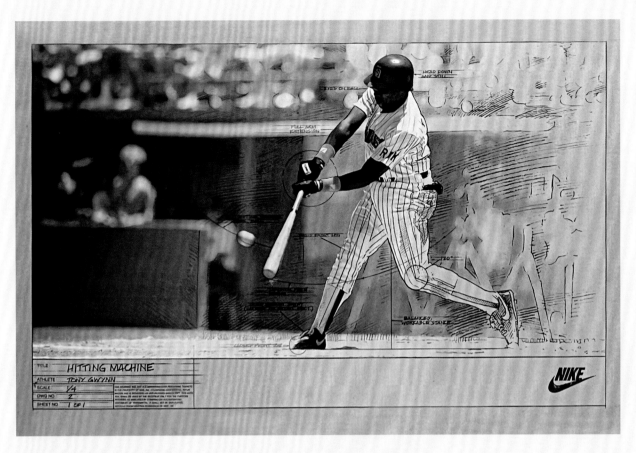

Tony Gwynn – "Hitting Machine" poster (1986)

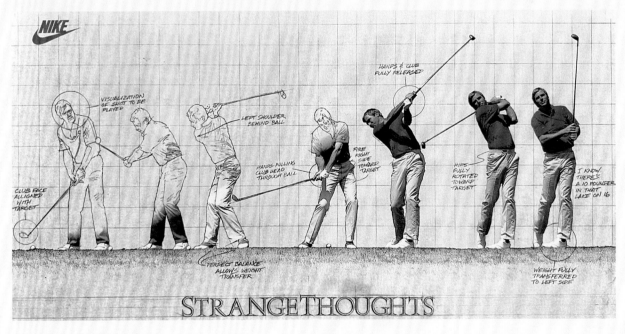

Curtis Strange – "Strange Thoughts" poster

1983 Nike annual report

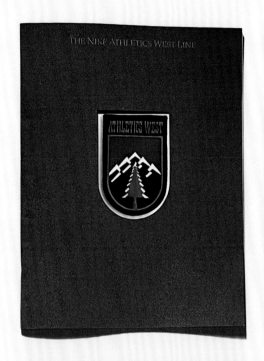

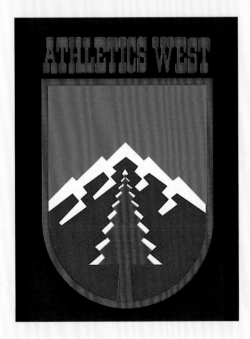

Athletics West logo design and brochure

My relationship with Peter started when I was at Museum Art School in Portland in 1977. The way the school was set up was pretty small classes and, on the design side, they would bring in a professional teacher once a week; that's where I met Peter. He really introduced our class to the world of graphic design. During our first class, he asked everyone, "Who is Paul Rand?" No one answered. So he told us, he was "the Pablo Picasso of graphic design." His next question was, "Have you guys ever even taken a design class?" The fact was we were total newbies just learning that graphic design was even as a business, so he was one of our first graphic design teachers. So he was like, "Ok, we got a lot of work to do. No one knows Paul Rand."

Peter had graduated from Chouinard Art Institute, and I remember him mentioning Louis Danziger as a teacher. Danziger's was absolutely the design philosophy that Peter adopted and that he later taught to me. It was an approach to problem solving that was essentially based on the idea that the solution to the problem is in the problem itself. Along with what he had learned when he got out of school and worked for Robert Overby, it was a philosophy that Peter taught out of the gate. The other thing was taking out any elements that aren't contributing anything to the idea. He pushed the whole concept, the idea of problem solving, over and over.

One of his assignments in class was to design an ad for Kiwi Shoe Polish. He would give us just the general idea, and we'd have to come up with the headline and the aesthetics. We had a week to do it. We all would then pin up our work in front of the class, and he would walk up and down, look at it, and then he would tap it, turn around, and ask whose it was. Then you'd say, "Well, that's mine." A lot of times he'd be shaking his head or quietly looking at this stuff, and you'd be like, "Oh, my God. Who is this guy?" **He'd ask questions about your thought process, and when it was good, he would tell you why and how it could be better, but then there were the instances where if you hadn't put the effort in or it was half-baked, he'd pull the pins out and let it fall to the floor and move on.** When you think about today, everyone is worried about hurt feelings, but it was a very honest, very insightful approach. You learned that you better not show up in class again without something being done right. It was that sense of discipline and him saying, "Hey, this is serious. That's why you're here. I take it seriously so I hope you do too."

The day I graduated, I went down to Peter's office with my portfolio and asked for a job. He said, "Okay, here's the deal. You have your own business, you pay your own taxes, and if I'm busy, you're busy." So I was the first person to technically work for him and that's how it started. He was getting Nike work, and we were starting to do some of Nike's posters and collateral. It was pretty crazy. Eventually, there were about six or seven of us in a little house by Ross Island Bridge in Portland. We just got more and more Nike work and started working on sales catalogs and sales meetings. Then when Peter was hired as Nike's creative director, everybody came in-house, and that's when we moved downtown to a warehouse. That was the start of the graphic design group within Nike. At the same time, there was Michael Doherty, who headed up the film and video group; Tinker Hatfield; and Rob Strasser. That was a fun group to be with.

There was a whole attitude that set the culture at Nike. There was no dress code. You never saw anyone wear a tie. In fact, Rob used to cut ties off anyone who wore one. He was always in Hawaiian shirts, and Peter wore jeans, golf sweaters, and running shoes. When those two got together, there were f-bombs dropped on a regular basis. In the business culture today, you couldn't do what we did back then. There was this freedom; you weren't afraid to communicate your point of view. You might be shut down or be challenged, but that's how great ideas came out of it. The amount of risk-taking and just wanting to do something different was a high bar set by Peter and Rob. We were always trying to push it higher, and they definitely set the level of expectation for us.

With that expectation came a lot of trust. Peter would send me to a shoot to art direct and, although he knew the photographer there, he would send me or Steve Sandstrom. You'd be responsible for art directing that entire shoot, and that's how you learned the whole gig. When he would send us out to a shoot or something important, he knew you were being stretched or were going to take on a big responsibility, and that it would be a learning device. **He wouldn't say, "I need you to art direct it like this." He'd say, "Don't fuck it up." So you walked out with the understanding that this is important and it was on you, so you better not fuck it up. It was all the direction you needed.**

RON DUMAS FMR SNR CREATIVE DIRECTOR, BRAND DESIGN, NIKE

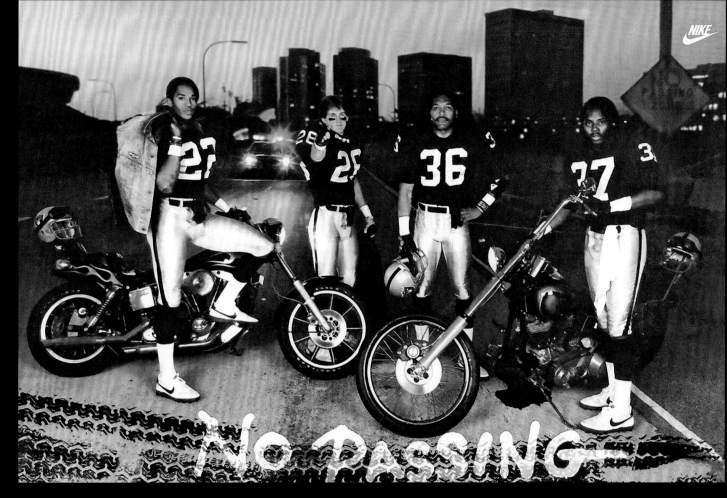

Mike Haynes, Vann McElroy, Mike Davis, Lester Hayes — "No Passing" poster (1985)
Art direction by Ron Dumas

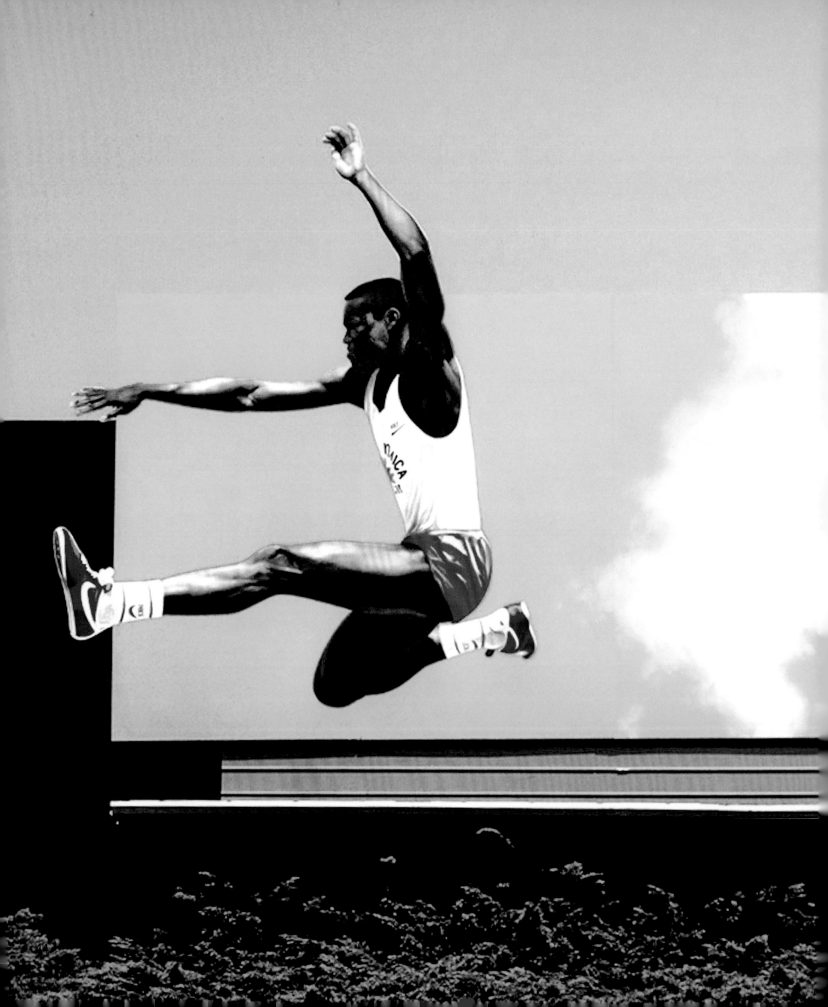

During the '84 Olympics in Los Angeles, Nike wanted to make a big statement. Chiat\Day was getting acclaim for its famous "1984" Apple commercial, so Peter and Rob Strasser contacted us about pitching for the Nike business on the LA Games. They showed up, and Peter said, "We don't want to meet any pin-striped, zoot-suited account executives. We only want to meet guys that actually do shit." All they wanted to deal with were creative people—no management—and they just wanted to come to LA and work. How they carried on was often funny because they'd argue. Peter was always kind of sitting back, being cynical, and Strasser was always really boisterous and getting crazy about stuff. It was fun working with them because together they made magic happen.

As Nike wasn't the official sponsor of the Olympics (Converse was), the idea was to hijack the Olympics. So we put together a whole room full of thinking. It had billboards, a commercial based on Randy Newman's "I Love LA," and a whole bunch of other cool ideas. This was a very exciting opportunity for us, so we put all our energy into trying to show Peter and Rob the kind of creativity that would strike a chord with them because we knew Peter especially didn't like advertising. To him, it was this thing that had nothing to do with what a brand was supposed to do when talking to its audience. He felt ad agencies were just trying to win awards, not audiences. But at the same time, he loved creativity. He was one of the most creative guys at Nike, and he wanted somebody special to do the Olympics because Nike needed a cool showing.

So we pitched with all our heart and then heard zip. Guy Day was trying to find out what was happening, but he couldn't get through to anybody. One of the ideas we had presented was painting walls in LA with athlete murals and a Nike logo. So we took that idea and made a wall with 100 bricks. We painted it, then sent each person we knew at Nike some bricks and told them to take them to Rob's office and build the wall. So we did that, then waited, and waited some more, and still nobody answered. Finally, one day Mary Decker, one of Nike's Olympians, showed up in our lobby with a big bottle of champagne and said, "Strasser and Moore told me to come over and have a drink with you guys because you just won the Nike business." Peter told me later they decided it was us because of our brick wall. They had to do something special but were waiting for Mary Decker to be in town. It was so Peter.

When it came to the campaign, we knew for Nike it had to celebrate the brand and the athletes. **It was the beginning of Nike making athletes a key part of its marketing strategy. So as opposed to just showing sports, Nike made heroes out of its athletes, like Carl Lewis, John McEnroe, and Mary Decker.** But we knew that where Peter was concerned, it couldn't be in the form of typical ads. So we told them that because billboards were part of the LA driving culture, we needed to do billboards, walls, and even skyscrapers. And just as we'd pitched, we did simple images of athletes and a Nike logo. No words. They took over the city. Later, when we did focus groups asking kids what they thought, they said, "Nike is cool because it isn't advertising; it's celebrating."

The other thing people loved was the "I Love LA" commercial. We got together with Randy Newman and his brother Tim, who was the director of the original music video. He gave us permission to change it and add Nike athletes and LA culture. It was a commercial that looked like a music video, and people still love it to this today. So the whole Nike LA experience was great. It took over the city, and everyone thought Nike was the Olympic sponsor, not Converse, which was the point.

Working for a client like Peter raises the bar in terms of the creative people figuring out how to deliver the maximum creative energy. **It invigorates creative people when the client says, "I want something great, but I don't want any bullshit." And that's how Peter and Rob always got the best out of us.**

LEE CLOW FMR CHIEF CREATIVE OFFICER,
TBWA\CHIAT\DAY

Previous: Carl Lewis billboard from the 1984 LA Games campaign

The often-seen scene of Nike advertising head Cindy Yoshimura defusing a spirited debate between Peter and Rob, illustrated by Lee Clow

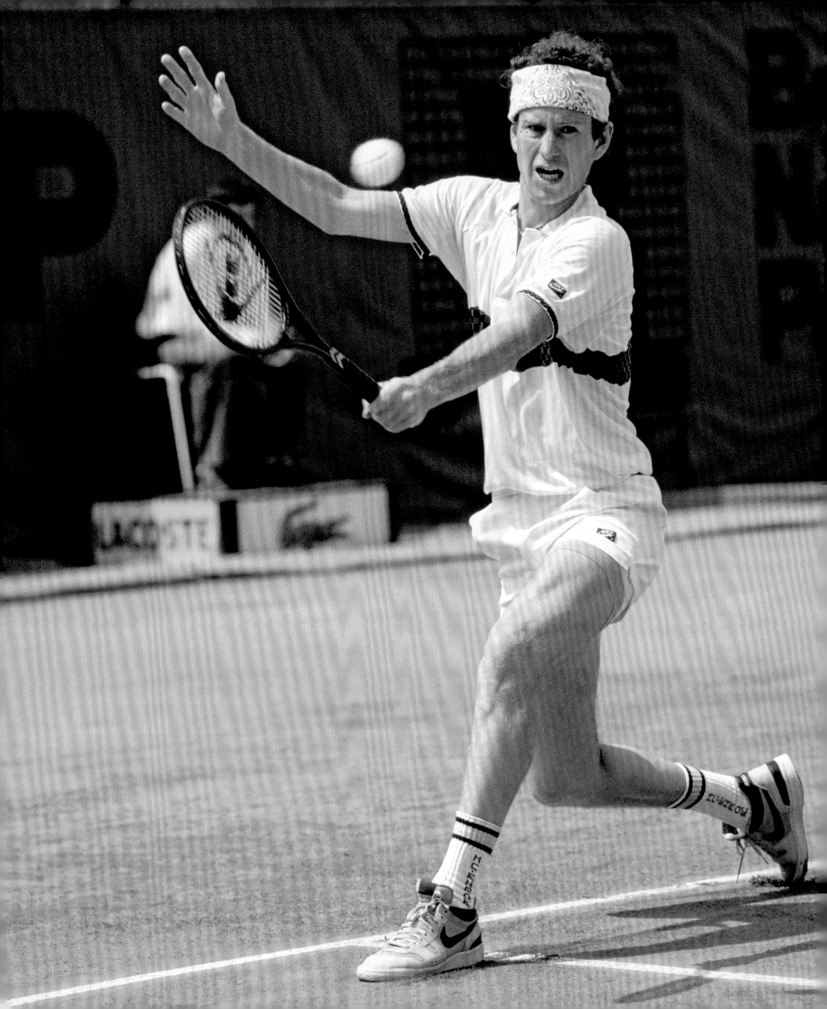

WHO THE F**K IS JOHN McENROE?

JOHN McENROE 1984–1987

THINK JOHN McENROE is the most creative tennis player to ever play the game. He was the first guy whose attitude went beyond just showing up and playing. Yes, he got out of control and people thought he was a jerk. But half the time, he was just yelling at himself.

I think the most important thing about what we did at Nike was the marriage of the personality of an athlete to a brand, and McEnroe was possibly the best of example of that. The story of how it happened is typical Nike. Phil Knight went to Wimbledon to sign Jimmy Connors. Rob Strasser was sitting in Portland with Jimmy Connors's mother, who was his agent. He was trying to find Knight to say, "Meet Jimmy at such and such location." But Knight wouldn't return the phone call. Knight was out on Court C at Wimbledon watching a young kid from Stanford named John McEnroe play tennis. Knight signed McEnroe. He returned and Strasser asked, "What happened?" Knight said,"I signed John McEnroe." Strasser replied, "Who the fuck is John McEnroe? You were supposed to get Connors!" But as it turned out, it was a genius move, as McEnroe's personality fit Knight's personality, and Knight's personality is Nike.

I first met him at a photo shoot in 1982. His association with Nike had begun in the late 1970s as a traditional endorsement, with McEnroe being paid to simply wear the products in competition. **He was the first athlete, outside of running, who really fit Nike. He had a lot in common with the brand in the sense that they were both brash and cocky** but kind of had a right to be. They were both very competitive. Early Nike projects included a few print ads and one action poster. I don't think Nike really knew what to do with the kid or even how far Nike could take him.

We took the first real step in revealing McEnroe's attitude in a less conventional manner, with a poster that has since become perhaps the most famous McEnroe image of all. **Taking him away from the expected setting of a tennis court, we dressed him in a leather jacket and photographed him with one hand in his jeans pocket and the other holding a racquet.** Using multiple images, we composed the poster so that McEnroe appears in front of the Brooklyn Bridge at dusk. The result broke with every tradition associated with tennis at that time. I think people liked the poster because it was so New York, and John was the ultimate New York guy. It was almost a James Dean look. I didn't plan it that way, but that's what came out of it. That was McEnroe. He was the original rebel in tennis, before it became the acceptable thing. People were fascinated by the guy. I know I was. Hell, I was even proud to be the president of his fan club, which was administered by Nike Design.

> "KNIGHT SAID 'I SIGNED JOHN McENROE.' STRASSER GOES 'WHO THE FUCK IS JOHN McENROE? YOU WERE SUPPOSED TO GET CONNORS!' BUT AS IT TURNED OUT, IT WAS A GENIUS MOVE, AS McENROE'S PERSONALITY FIT KNIGHT'S, AND KNIGHT'S PERSONALITY IS NIKE."

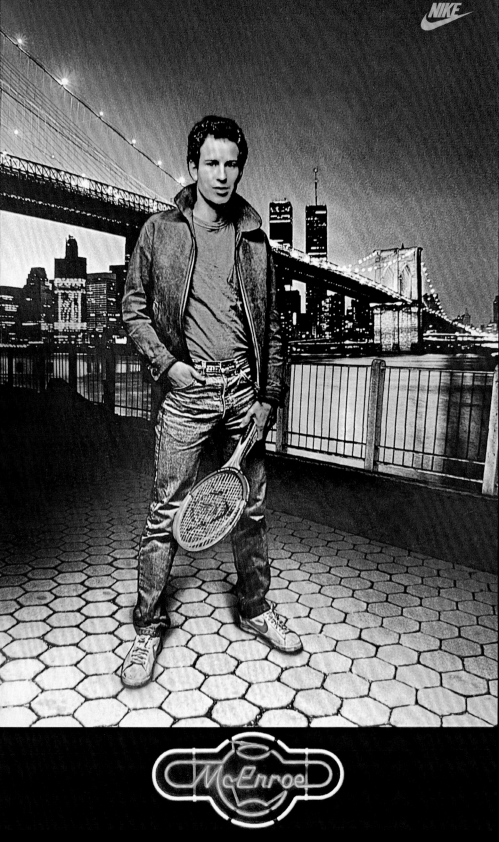

John McEnroe — "Brooklyn Bridge" poster (1982)

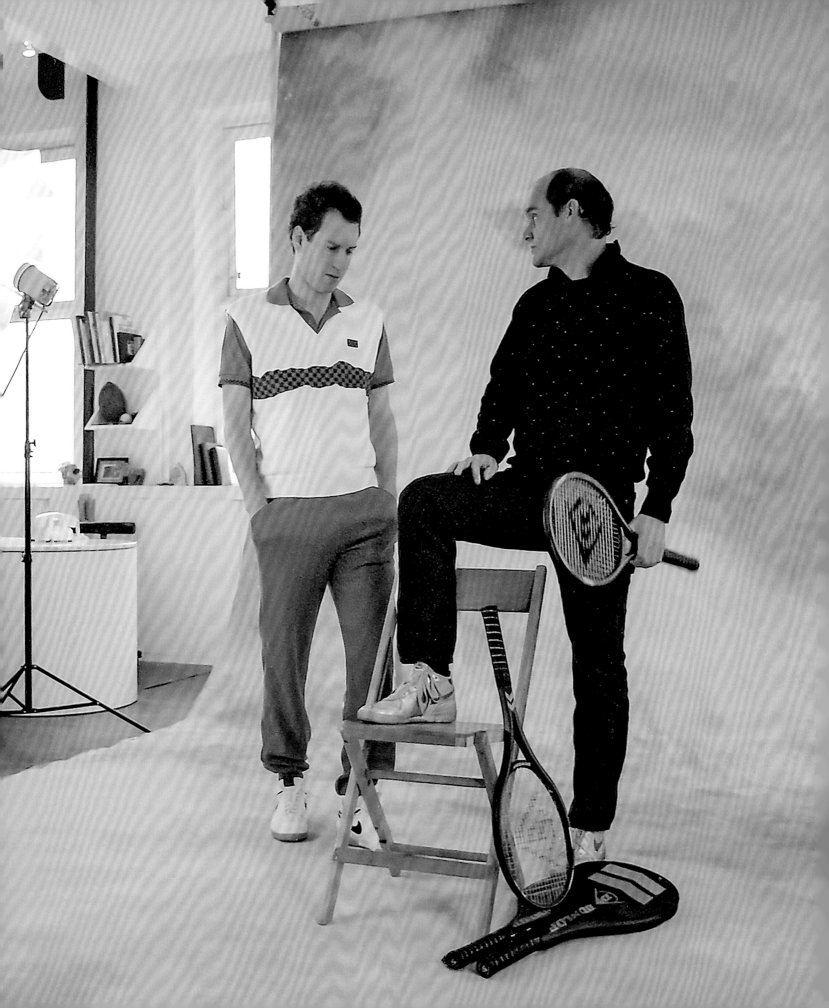

"McENROE WASN'T THE EASIEST GUY TO WORK WITH, BUT YOU ALWAYS KNEW WHERE YOU STOOD WITH HIM."

When it was decided that Nike would produce a line of tennis apparel around McEnroe, my objective was to develop a product and marketing concept that would be consistent with McEnroe's personality. The products were radical—for tennis. We used really strong colors and a lot of black—a complete contrast to the traditional white. Signature tennis lines were nothing new, but this went beyond putting the guy's name on the shirt. It was real. McEnroe was an aggressive, controversial player, and the line reflected that. It was distinguished by two new logo treatments: a black and blue checkered field with a red Nike and swoosh, and a funky oversized logo suggesting a rock band tour jacket.

There were two sides to McEnroe's personality. There was the competitor who people saw on the court, which was represented by the checkerboard. Then there was the other side—the guy who hung out in clubs and played guitar. So we put the rock and roll patch on the apparel you wouldn't actually compete in: the warm up, T-shirts and things like that.

Part of creating the McEnroe image involved advertising. I've never been terribly comfortable with advertising agencies. And I don't know that they've ever been terribly excited about working with me. **There are some incredibly talented advertising people out there, but the approach is very different. Ad agencies seem to look at an idea as "Is it a good idea? Or is it a bad idea?" While I was trained to look at it as, "Does it solve the problem?" Sometimes the two cross over, and that's, I think, when you get some great advertising.** But if you only judge it on whether it's creative or unique, a lot of times you miss the mark. I think the McEnroe advertising worked because it was so directly tied to his whole attitude.

John McEnroe wasn't the easiest guy to work with, but you always knew where you stood with him. He was very honest. And he never tried to surprise me. I asked him once, "If you could wear anything to play tennis in, what would it be?" He said, "A pair of cutoffs." So we developed a denim short for him. Shortly after the denim shorts were introduced, however, McEnroe got out of the game. It's ironic that Andre Agassi ended up becoming known as the tennis guy who wore denim because it was McEnroe's idea. And it was like everything we did for him: it broke the rules.

Opposite: Peter and John McEnroe during an apparel photo shoot

FORGET WHAT TENNIS USED TO BE.

If you look at the Nike McEnroe tennis gear and you look at the posters of John McEnroe, John being a rebel, it was something that was very Peter. He always looked at the whole person and then really used that to communicate style and that in turn informed design.

The McEnroe off-court range, which was more lifestyle, sort of night clubby, and had the rock and roll logo on the back, that was really a reflection of John's personality. *And Peter just got it. He loved him. He didn't change anybody. He just looked at them and saw the truth of someone, and that was plenty to work with. He didn't have to manufacture anything.*

I don't know if you remember the acid-washed denim shorts, the Agassi tennis shorts, but those were not actually made for Agassi. They were made for John McEnroe. And the one you see in the advert with the player's back, that's John McEnroe in the shorts. So that collection was made for John McEnroe, but Andre Agassi was the one who made it famous.

MARY MCGOLDRICK FMR APPAREL MANAGER, NIKE & ADIDAS

Above: A sweat-drenched John McEnroe wearing the Peter Moore-designed shirt and denim shorts
Opposite: John McEnroe models a warm-up suit from his signature apparel line

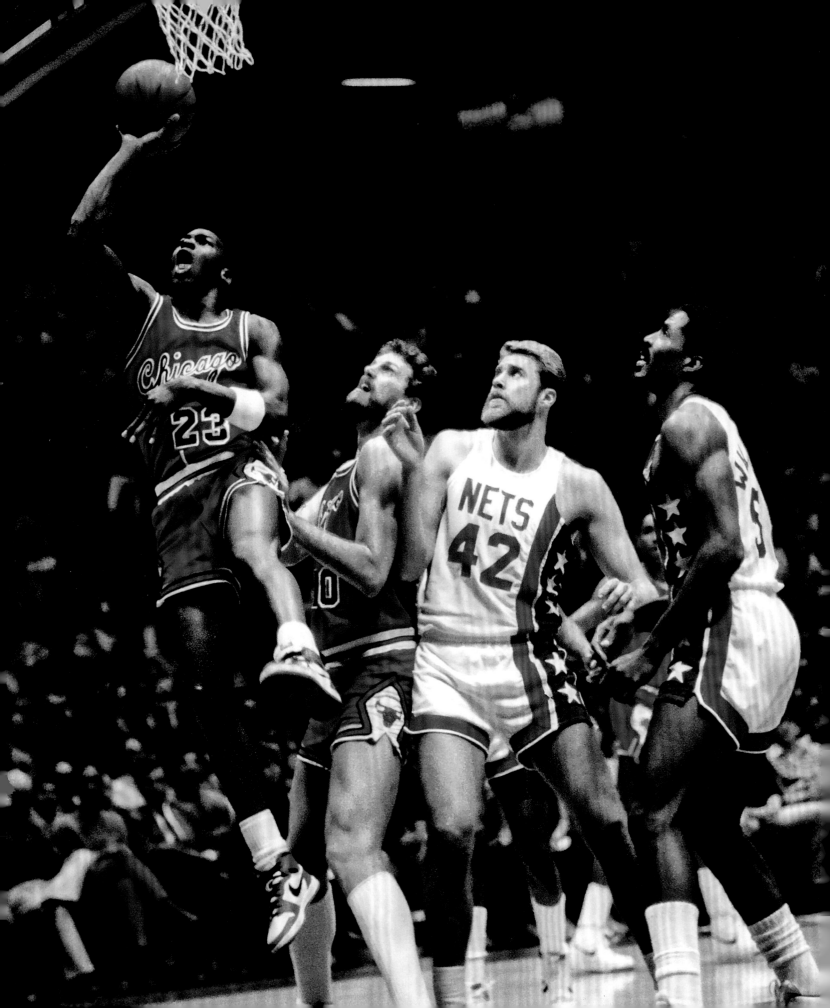

MICHAEL, WHAT ARE THOSE?

I T'S EASY TO TAKE THE OBVIOUS PATH. Michael Jordan was not the obvious path. In 1984, Nike was in the dumps. We were getting our butts kicked by Reebok. Basketball, one of Nike's biggest categories, was especially hurting, despite the fact that nearly three-fourths of all NBA players were wearing Nike. But nobody thought of us as a basketball company. Converse was who you thought of, because it had players like Larry Bird, Magic Johnson, Isiah Thomas, and Dr. J.

Sonny Vaccaro, our basketball expert, suggested we sign Michael Jordan, a junior at North Carolina. Sonny knew basketball like nobody else in the world, and he convinced Rob it would be better to sign one great player than ten average ones. We knew about Jordan because he'd hit the headlines beating Georgetown with "that" shot, but when you played for UNC under Dean Smith, it was tough to stand out, which meant he didn't get much playing time and so wasn't an obvious choice. We also assumed that because Carolina was a Converse school, he's gonna be a Converse guy. Nobody knew at that time that he wore adidas in practice and everywhere else off court. So all we knew was that, at that point, it wasn't, "We're going to get Michael Jordan"; it was "We're going to get a guy," whoever that guy was to be. We didn't know who this Jordan kid was, but Sonny kept pushing for him. It wasn't until later, when we actually met him, that we realized just how special he really was. Rob felt Jordan could be the catalyst to give Nike the authenticity it needed as a true basketball brand, so we set out to do whatever it would take to sign him.

Rob and I went to meet Michael's agents, Donald Dell and David Falk, at the ProServ offices in Washington, DC. It was August and, at the weekend, they turned off the air conditioning. So it was about 100 degrees in the room, and Rob was profusely sweating. We were sitting around talking about how we wanted to do things differently and give Michael his own brand when David Falk said, "I have an idea for a name: Air Jordan." Rob looked at me and said, "What'a ya think?" I liked it, but I was worried about the fact there was already a Jordan Airlines. Both Rob and Falk said that they were lawyers and not to worry about it, and so we settled on Air Jordan. I realized years later, when I was watching a film of the '84 Olympics basketball, that we weren't the first with the name at all, because there was a guy in the crowd with a banner that said "Air Jordan." So we weren't the first, it was some fan.

Opposite: Michael Jordan, Peter Moore, and Howard White preparing for a photo shoot

"WE DIDN'T KNOW WHO THIS JORDAN KID WAS, BUT SONNY KEPT PUSHING FOR HIM. IT WASN'T UNTIL LATER, WHEN WE ACTUALLY MET HIM, THAT WE REALIZED JUST HOW SPECIAL HE REALLY WAS."

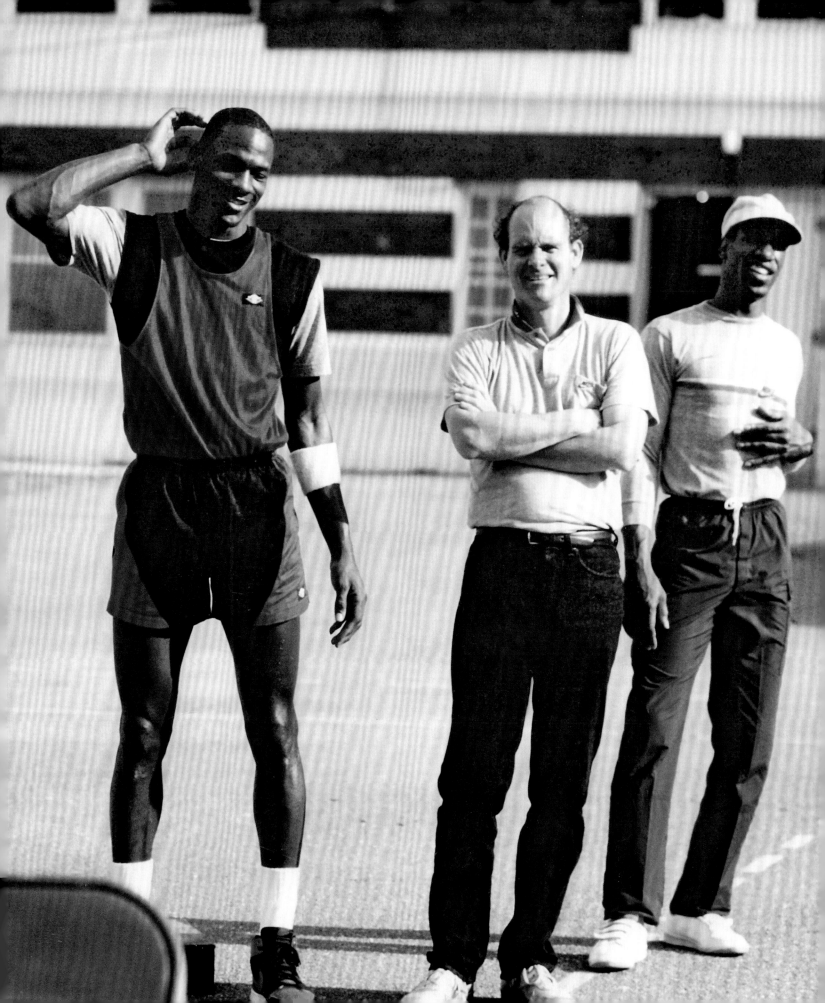

The next thing we did was to bring Michael out to Portland to show him the campus. It was nothing special at that time; we were just a two building company. I thought he'd be bored. But we wanted to introduce him to Phil Knight and to give a presentation on what we were going to do with him. We put on such a dog and pony show for the kid. I did designs for shoes and clothes. We had ad concepts, posters, videos—you name it. Everything was tied to the red and black colors of his team, the Chicago Bulls.

After the meeting in Washington, I began to sketch some ideas for a logo. On the plane back to Portland, I saw a stewardess give a kid this little pin. They were plastic wings, replicas of the pins that pilots wear. I asked the stewardess if I could have one of the pins. She kind of looked at me like I was a jerk but gave me the wings. I began to draw the winged basketball logo on a cocktail napkin. I showed it to Rob and he said, "Yeah, that's it." Sadly, I don't know what happened to that napkin.

In the meeting with Michael and his family, we told him how he was going to be the most important player in the game, how he had his own logo, how no one had ever done anything like this before. It was the first time anyone had created a signature line for a basketball player. But he didn't give anything away. He listened. We could see he was interested, but he didn't show if he liked anything we were showing him. Michael hadn't wanted to come to Oregon in the first place. He said he'd come when he was playing the Blazers, but his parents had forced him. So we knew we had a job to impress him. One thing we did was put Michael and his parents in Rob's limousine, which had a TV. We had put together a video. It was all Michael's highlights cut to the Pointers Sisters's "Jump." At the end, it said "Air Jordan" with the wings logo. **Afterward, Mrs. Jordan said "This won't be any problem," meaning that they were convinced that Nike was the place to go. But I think the reason he signed with Nike was more than just the money. We showed him we knew exactly what he was all about.** And let's face it. Rob could be awfully persuasive.

Once he'd signed, for the Air Jordan launch to coincide with Michael's NBA debut, we would have to create the line in a fraction of the usual time: just nine months. An immense task. **Rob and I formed the first of what would be known at Nike as a "launch group," a small team that worked outside the timelines and restrictions of the normal design and development system.** I was in charge of design—everything from store displays and ads to shoes and clothing.

When it came to his shoes, Michael really knew what he wanted. At Carolina, his Coach, Dean Smith, was a Converse guy, and he was like drill sergeant, so Michael had to wear Converse on court. But the shoe he really liked was the adidas Forum—to the point that he was in the Forum in practice and right up until game time. He liked adidas basketball shoes because they had a low to the ground design, which he said gave him great court feel. He wanted the Air Jordan to have the same feel.

"I ASKED THE STEWARDESS IF I COULD HAVE ONE OF THE PINS. SHE KIND OF LOOKED AT ME LIKE I WAS A JERK BUT GAVE ME THE WINGS AND I BEGAN TO DRAW THE WINGED BASKETBALL LOGO ON A COCKTAIL NAPKIN. I SHOWED IT TO ROB AND HE SAID, 'YEAH, THAT'S IT.'"

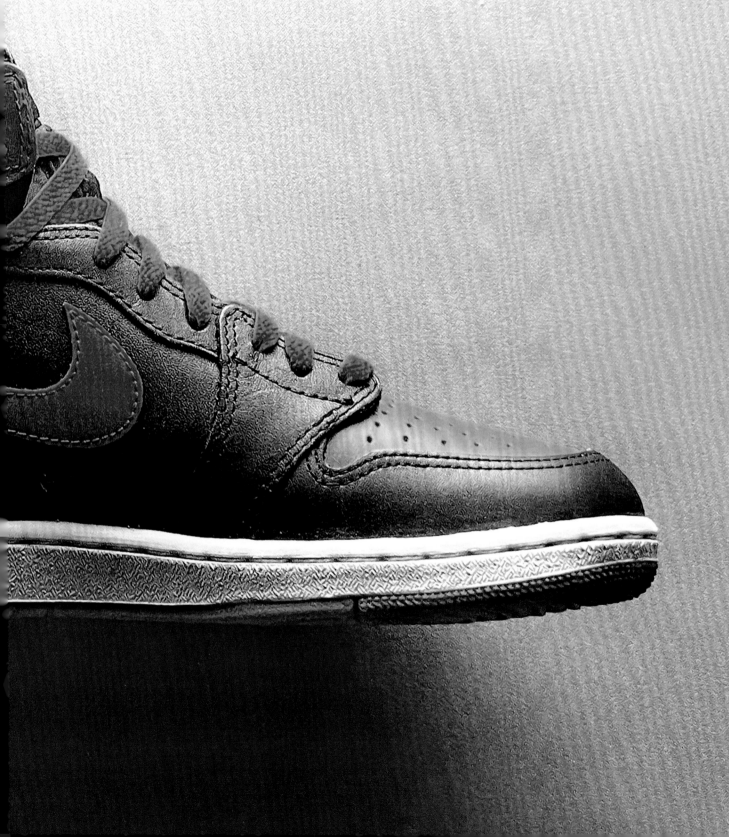

"THOSE ARE THE DEVIL'S COLORS."

MICHAEL JORDAN

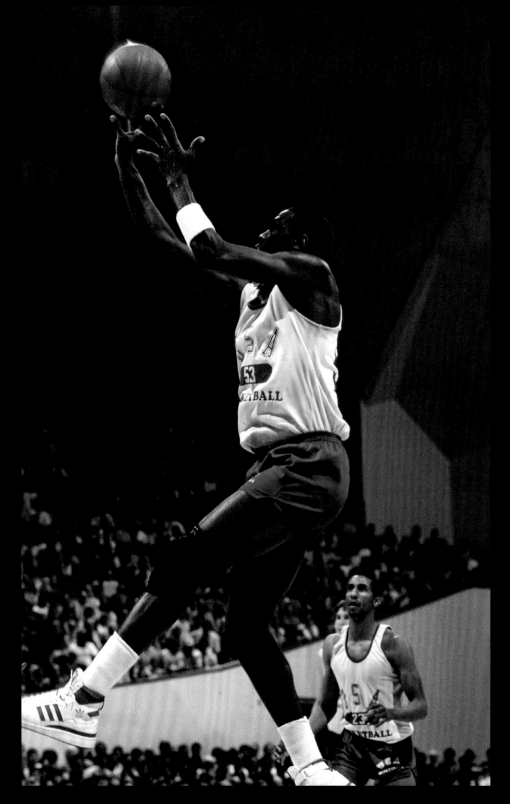

Michael Jordan playing in adidas Forums during the 1984 US Olympic basketball trials

He was very wary of Air at first, because he thought it would make the shoe too high. He was scared about rolling his ankle, but I said we'd keep it as low to the ground as possible. So we designed the cup sole to be as low as possible and created an Air capsule that was as thin as we could get it. Knowing how much Michael liked the Forum, when I sat down to design what the Air Jordan shoe could look like I placed the belt up at the collar that comes round from the heel to the upper eye stays, which was influenced by the "X" crosspiece on the Forum.

He liked the adidas shoes so much that even though we offered him more money to sign with Nike, all adidas had to do was invite him to Germany and I think he would have signed. But they didn't. Years later, when Rob and I went over to adidas the first time, one of the first things I asked was why they didn't sign Jordan. They said it was because they already had the MVP, Kareem Abdul-Jabbar, and that they wouldn't have had any idea what to do with him anyway. He was just another rookie player to them. I said, "Well, thank God." Later, when I understood just what kind of trouble adidas was in at that time it was obvious that even if they had signed Michael, he would have just been another NBA star. They wouldn't have done what we did at Nike, and Air Jordan would never exist.

The original concept of the Air Jordan shoe was to have a home shoe and an away shoe. Back then, it was a whole new way of doing things. Rob's point was, if you were going to have one shoe for sale, why not have two? I took an existing outsole and drew up different color combinations and styles for the upper. Then I sat down with Michael to pick the two styles he liked best. I started off the meeting by saying, **"Michael, let's break the color barrier. Let's do a predominantly black shoe with red details." At that time, all basketball shoes were white with maybe a small bit of color.** I sketched him all the different colorways, which were always red, black, and white, but he didn't want red, black, and white. And he said, "I want Carolina blue and white." I said to him, "But you can't wear Carolina blue and white. I mean you can wear it on the street, but you can't wear it in the game. The Bulls color are a red, white, and black." So he said, "Those are the devils colors." I said, "Well you better have a conversation with (Chicago Bulls owner) Jerry Reinsdorf because I can't change the Bulls's colors." He told me he would, but I don't think he ever did.

The shoes weren't ready when Michael went to New York for a pre-season game, so we had him in another Air shoe in the line that he picked out of the catalog, the Air Ship, but colored up in black and red. He was warming up at Madison Square Garden and fifty kids came running down from the bleachers and started yelling, "Michael, what are those?" That's the first time we knew how big this thing was. But NBA regulations were clear: all shoes worn by a team must be of uniform color. NBA Commissioner David Stern threatened to ban the shoes, warning the Bulls that if Jordan wore them in a regular season game, they'd be fined $5,000. But Stern didn't realize it wasn't the production model, so he wanted to ban a shoe that wasn't the shoe.

"HE LIKED THE ADIDAS SHOES SO MUCH THAT EVEN THOUGH WE OFFERED HIM MORE MONEY TO SIGN WITH NIKE, ALL ADIDAS HAD TO DO WAS INVITE HIM TO GERMANY AND I THINK HE WOULD HAVE SIGNED. BUT THEY DIDN'T."

The thing was we had on the water probably 25,000 to 30,000 pairs of shoes in the black and red, so we had to figure out what we were going to do. If Michael wasn't going to play in the shoe, that was a big problem. **But Rob's marketing genius swung into action. He told the Bulls not to worry and that if Michael wears the shoes and they're fined, Nike will pay, because he knew that every kid on the street was going to want a shoe that has been banned by the NBA**. So we needed to do something quick. I was working on ideas, and I had Chiat\Day and even Wieden+Kennedy working on ideas. And we only had 24 hours. So we shot a commercial.

As the Bulls were playing in Oakland, we arranged to do a shoot over in San Francisco. Chiat\Day had come up with a script, and we had apparel ready. We got a special deal with the Bulls to use Michael for half a day. We told them it would be the only time we'd use him during the season, which didn't end up being true, but it's what we told them because we had to do the ad. It wasn't going to be physical anyway. All Michael needed to do was stand there and bounce the ball, and then we'd slap black bars on the shoes in post. So the ad went out with the strap line, "Fortunately, the NBA can't stop you from wearing them." We sold out the 30,000, and I think another 50,000 on top of that. It seemed like every kid in the world wanted a pair of them after that. So Rob sent David Stern a Thank You note, and Stern until the day he died claimed the whole thing was a marketing scam, which wasn't true. It was Rob seeing an opportunity and jumping on it.

A story from that time that tells you something about what Michael was like then was that I said to him, "Michael, we're in San Francisco. There are a lot of great places to eat. We can take you to a famous restaurant or something." But he said, "No, can we go bowling?" I just laughed at him and said, "You want to go bowling?!" So another Nike guy, Michael Doherty, Michael and I went bowling in Oakland, in a very sketchy bowling alley not far from the hotel. So we bowled for a couple of hours and then we noticed there were pool tables. Michael said, "Let's play pool!" So we started to play pool, and then that's when one of the locals started to figure out who this guy was and, of course, then everyone wanted to play pool against Michael. So that's when we left. But that was typical Michael. He would much rather go do something competitive than do something fancy. It was the same with golf. Once we played pretty much a whole day, and he was two hours late for a meeting with Phil Knight. I'm sure Knight still holds it against me to this day. But when Michael wanted to play, he really wanted to play.

Opposite: Michael Jordan prepping for the "Banned" commercial shoot
Following: Michael Jordan during an apparel photo shoot in a Chicago schoolyard

"SO THE AD WENT OUT WITH THE STRAP LINE, 'FORTUNATELY, THE NBA CAN'T STOP YOU FROM WEARING THEM,' AND WE SOLD OUT THE 30,000, AND I THINK ANOTHER 50,000 ON TOP OF THAT."

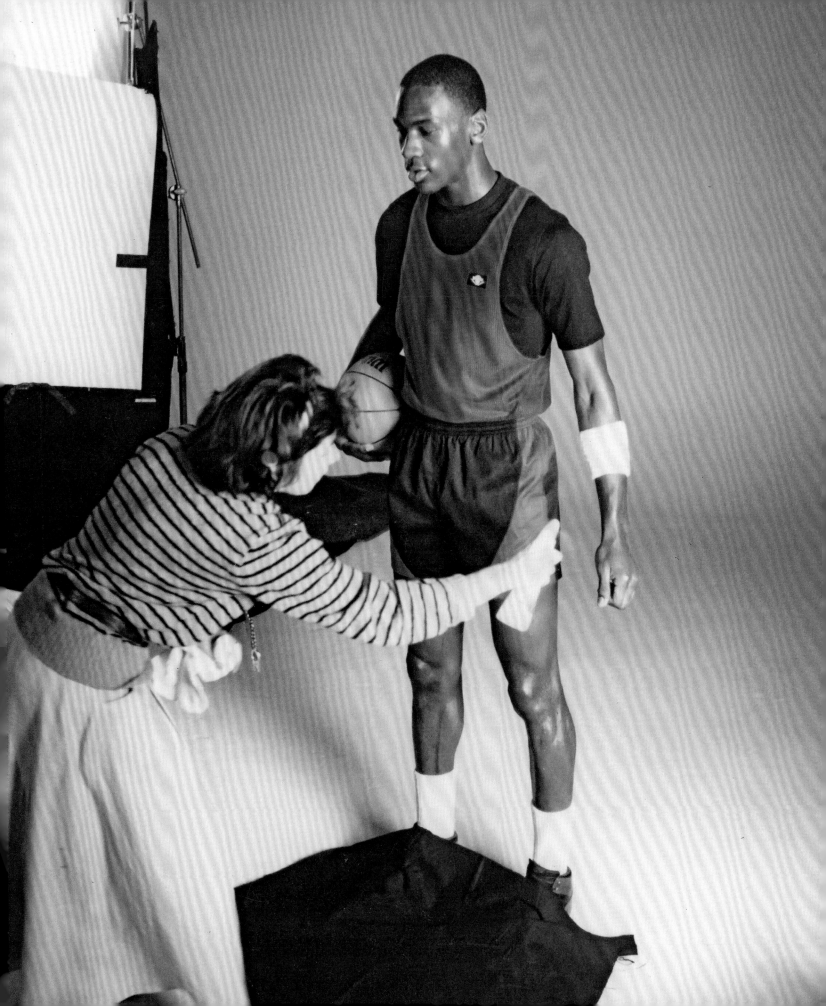

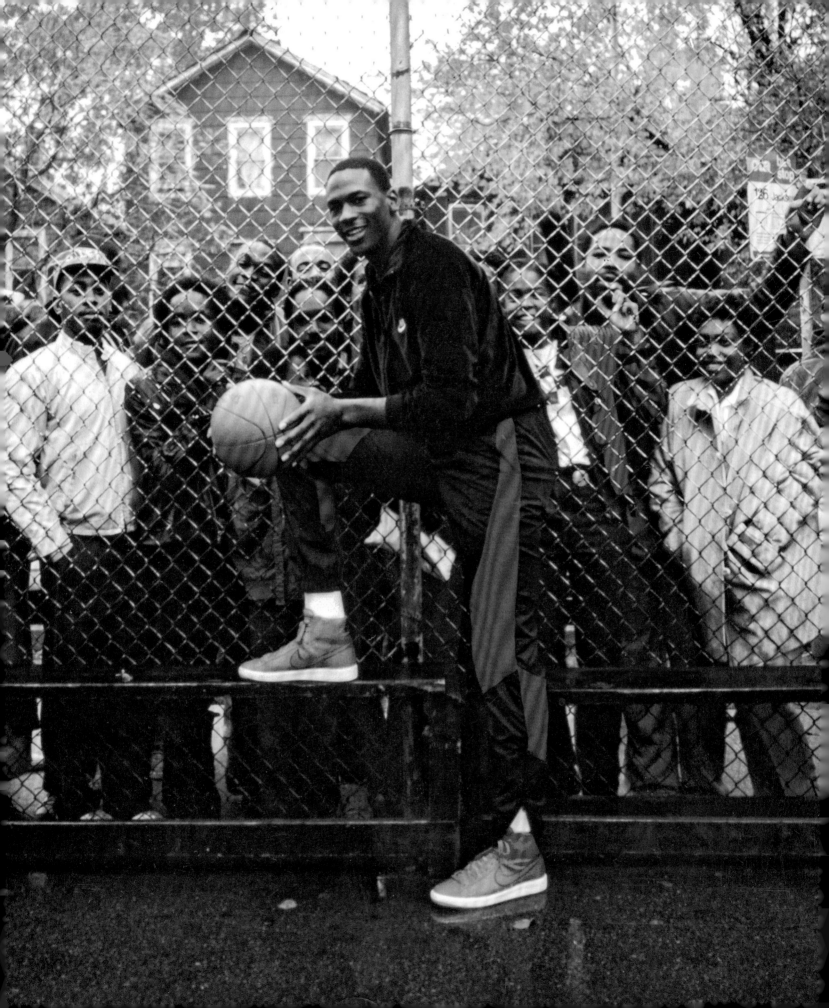

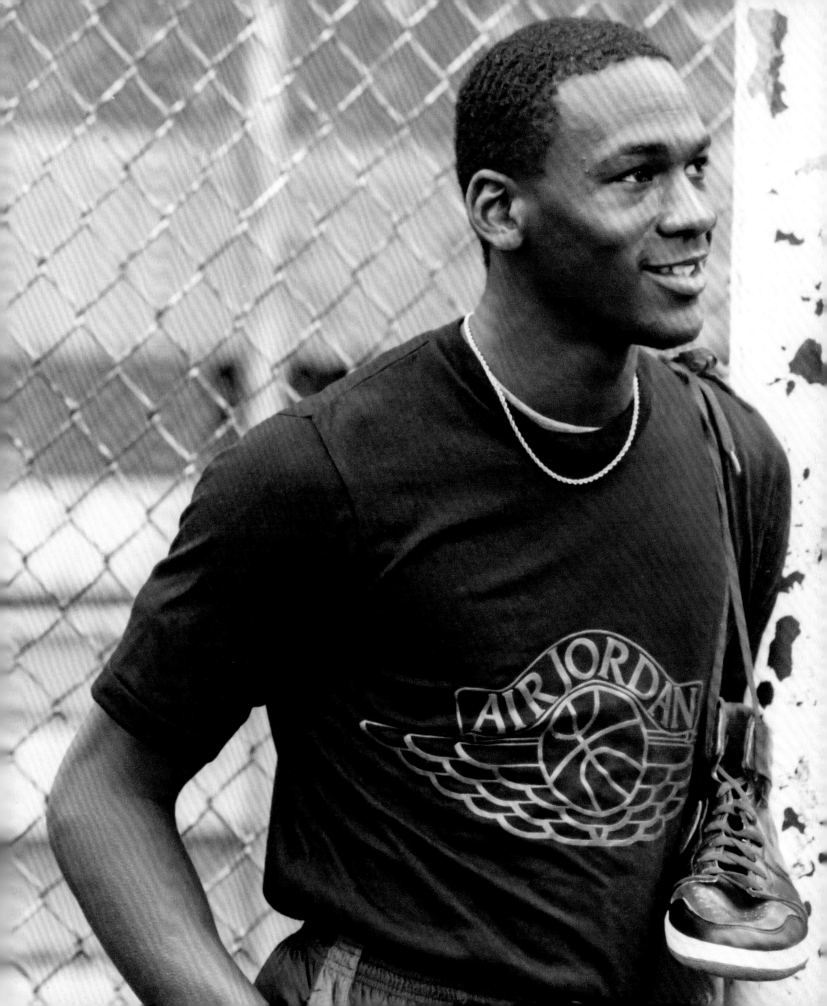

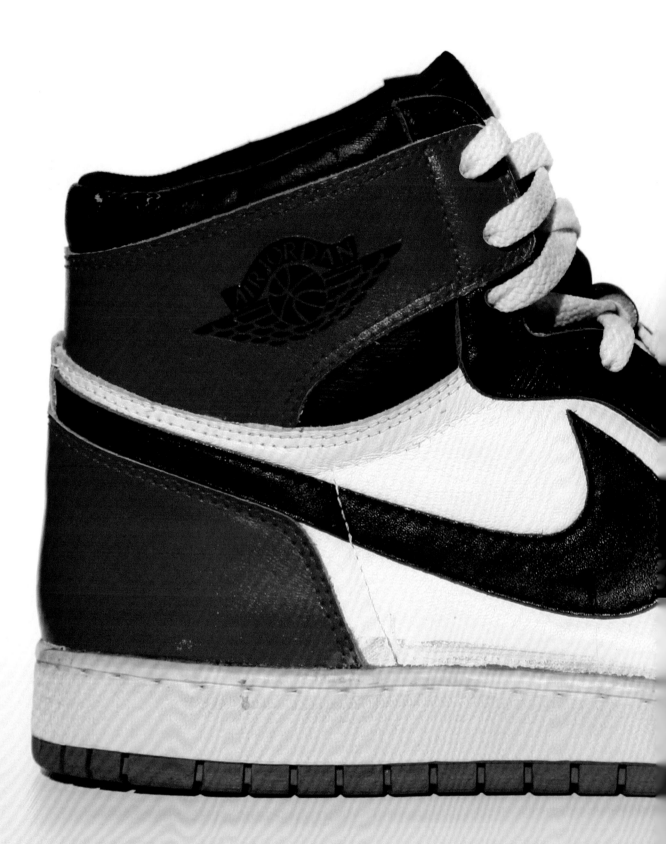

Original Air Jordan 1 "Black Toe" production sample

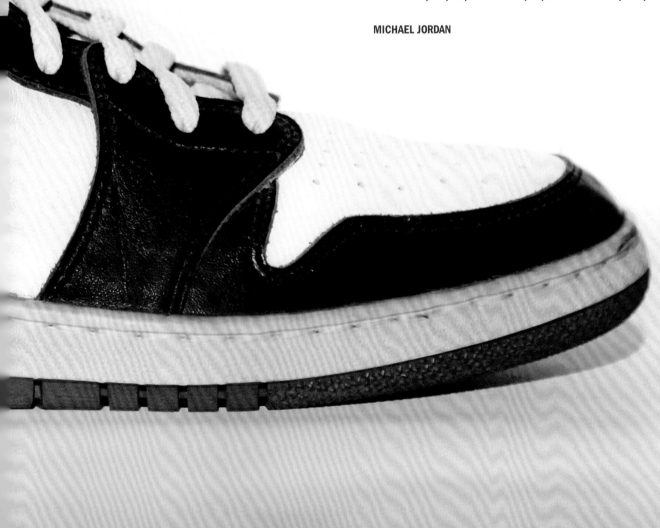

FROM DRIVEN FROM WITHIN *BY MICHAEL JORDAN:*

The first Air Jordan shoe was the first time anyone had applied multiple colors. When I first saw it, I said, "I'm not wearing that shoe, I'll look like a clown." Peter Moore, who designed the first two shoes, told me to just look at the shoe. "Put it on and look at it. Spend some time with it. If the shoe doesn't grow on you, we'll change it." The more I looked at the shoes, the more they started to grow on me. I told Peter, "Every time I wear these shoes in practice, my teammates come up to me and tell me they are the ugliest looking shoes they have ever seen." He says, "Guess what they are doing? They're looking at them. No matter what they are saying, they are paying attention." That changed my whole perspective. First and foremost, the shoes had to perform the way I wanted them to perform. How they looked was a whole different issue, because you have to think about marketing strategy. You want people to pay attention. If you see somebody walking down the street in pink shoes, you are going to look at them. That's exactly what happened with the first shoe.

Peter Moore and Rob Strasser took the absurdness of what shoes could look like, put them on Michael Jordan, and let him go out and play. Now those shoes had their own style and substance. Peter and Rob changed Nike's perspective by helping the company feel comfortable with the idea of being way out there, different, design leaders in the market. They helped push the company into the contemporary culture.

MICHAEL JORDAN

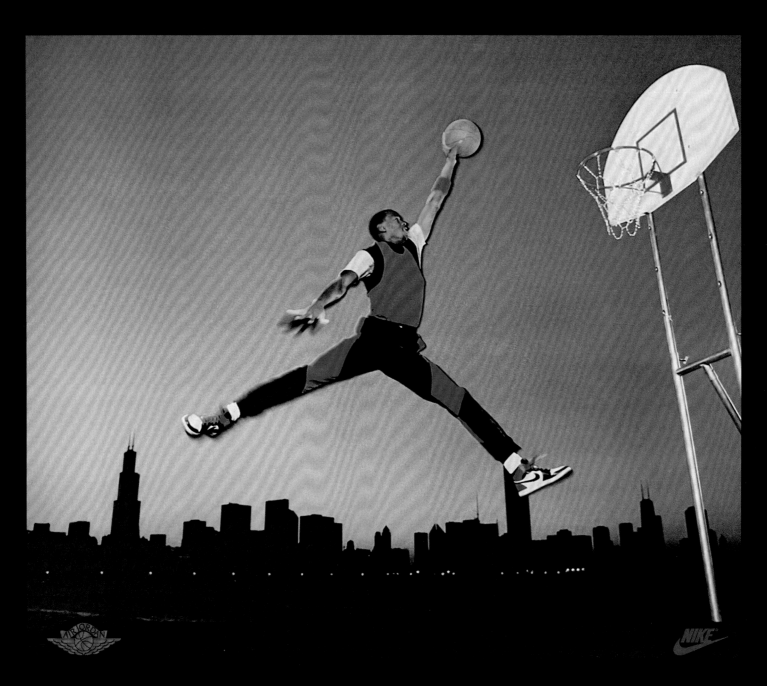

The Chicago skyline "Jump" poster

"IT WAS JUST A PARKING LOT, AND WE WERE THERE NO MORE THAN TWENTY MINUTES BECAUSE MICHAEL HAD TO GET BACK TO PRACTICE OR WHATEVER. IT BECAME ONE OF THE MOST FAMOUS SPORTING IMAGES OF ALL TIME."

The first photo shoots we did with Michael were in Chicago when he was in town to go to camp, so it was right before his first season. The first one we did was on the basketball court of a school yard, and it was really about the apparel that we were offering as part of the Jordan line. There were a lot of people around but we hadn't publicized it, so most didn't know who he was because he was still a rookie.

For the "Jump" poster, I wanted to capture Michael in his signature move flying across the Chicago skyline. I'd seen a similar photograph in *Life* magazine's Olympic issue in which Michael was jumping to a hoop that was thirty feet in the air. Nike bought the rights to use the photograph, but I didn't use it. However, there's no question it provided some inspiration because I had no idea Michael could even do that. **So when we needed to do something special to announce that Michael was coming to Chicago, I thought I'd get him to do that move over the Chicago skyline.**

I knew a place where there's an observatory with a park where we could do a shoot with the city skyline in the background. The photographer was Chuck Kuhn. Chuck went and bought a basketball stanchion and rented a van, and we drove up to this place. We put the stanchion together, told Michael to go at it three times, folded up the stanchion, and were out of there. It was just a parking lot, and we were there no more than twenty minutes because Michael had to get back to practice or whatever. It became one of the most famous sporting images of all time. We didn't have a license or a permit or anything. There were some people around, but nobody paid any attention to it at all.

I first got to know Peter and Rob Strasser when I came to Nike in 1982 as the East Coast basketball rep and I was working with Moses Malone. I loved those guys. They looked out for me and really helped me rise up. What was incredible for me was that they always respected my opinions, and in doing so made me realize I could be someone.

A lot of people talk about "the legendary" Peter Moore. I know I've always got on the AJ1s he did. When he designed those, he started a brand that's worth $5 billion today. But to me he wasn't "the legendary" Peter Moore. **He was the Peter Moore who believed in me. He was the Peter Moore who gave me hope. He was the Peter Moore who said I could fly.** That's the real Peter Moore. There I was,

a little boy from Hampton, Virgina, who came out to Oregon. And he was the Peter Moore who said, "H, you can be the best at this. I really mean that." Truth is Peter may have said that to every person he came in to contact with, but it meant everything to me. **That was Peter. He gave us all the wind beneath our wings.**

When I was asked to say something about Peter, I asked Michael what he thought I should say. He said to me, "You know what to say. He was just one of those all time great dudes." For a man who doesn't give many compliments, that's high praise from MJ.

HOWARD "H" WHITE VICE PRESIDENT, JORDAN BRAND

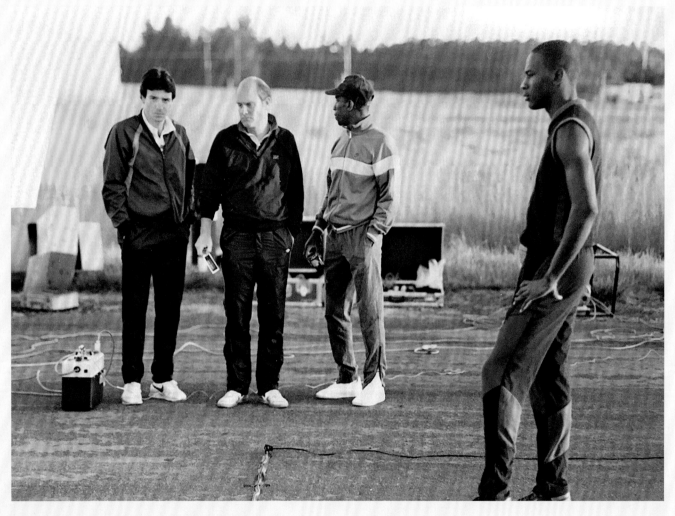

Above and opposite: "H" with Peter Moore, Mike Caster, and Michael Jordan for the sunrise McMinnville Airport poster shoot

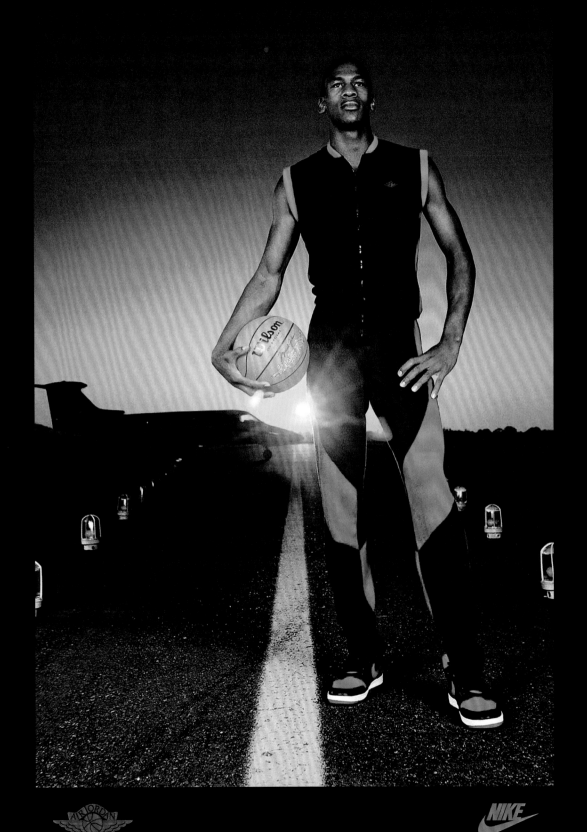

I was sitting there kind of hanging out with Peter and he said, "I just saw a movie called She's Gotta Have It, by this new director Spike Lee." I said, "Really? It's pretty obscure you know." Peter said, "I just saw it, and I'm gonna call Michael and tell him to go see it." And he was just taken by this film, and then he reached out to Spike Lee and the rest is history. Because of the inspiration from that movie came the Mars Blackmon thing. Wieden+Kennedy took off with that, but I remember the seed that was planted on that was when Peter went to see that movie. I remember thinking, "Ok, so you can draw from a lot of different influences to do what you do. It doesn't have to be 'I'm a footwear designer, so I'm just gonna look at shoes,'" which really stuck with me.

MICHAEL DOHERTY FMR CREATIVE DIRECTOR, GLOBAL BRAND PRESENTATIONS, NIKE

Air Jordan, from its inception, was far more than a signature shoe. **We wanted to change the way athletes were marketed. It sounds so simple now, but it broke all the rules for how our industry operated. Nobody had taken a player, created shoes and apparel that actually tied to his style, and then launched it all at once—with advertising, POS, packaging, the whole deal.**

The complete Air Jordan package landed in stores in April 1985 and, from the first day, it was a rocket ship, selling more than $100 million in its first year. But the shoe was not a big success with retailers at first. We showed it to Footlocker, expecting them to buy 10,000 to 20,000 pairs. They bought 5,000. So we went to the small inner city retailers. They bought them all. So then the shoe was launched and it was on the shelves. They opened their doors and there were so many kids lined up that Floyd Huff, president of Footlocker, called Phil Knight and said, "What did you do to us?" Knight said, "I'll connect you with Rob Strasser." Strasser picked up the phone and said, "We showed it to your guys; they only ordered 5,000 pairs." This guy, the president of Footlocker said, "I want 50,000 pairs. Can you get them for me?" So now we had to start making shoes like crazy, and it went on and on like that for the whole year.

Rob's vision for Air Jordan was to continually update the product by introducing a new shoe frequently—at least once a year. At first, we just did color updates. There was a black and blue Air Jordan that, frankly, was not so hot. As Air Jordan moved into its second year, I teamed up with Bruce Kilgore, who designed the Air Force 1, to produce a shoe called the Imagination, which was a radical departure from its predecessor. The first shoe had really been a rush job. That's not to say it wasn't a great shoe, but it was based on the Dunk, a model we were also developing at the time aimed at the collegiate buyers. For the Jordan II, we had time so we wanted to do something different. Something very stylish, very clean, very elegant. It was all white with red trim, had an expensive looking upper with an exotic iguana texture, and a beautiful injection molded heel piece. It was like nothing else—a really original and refined looking shoe. We had the shoe made in Italy, which made it outrageously expensive but reflected its appeal, but it also meant the shoe was late. Michael got injured he so didn't wear the shoe much anyway, but it was in the II that he scored 63 points against the Celtics. No one had taken athletic shoes to this level of elegance. Yet, it sat on the shelves and died. It was a shoe ahead of its time.

By the fourth season, we decided to take the entire Air Jordan look to a different level. We needed to sophisticate the image. The market was changing, and the wings were starting to look juvenile. Michael was going to press conferences looking like the president of a corporation, but I was putting captain's wings on his shoes. It just didn't work. Part of this need for change stemmed from the sheer success of Air Jordan. Fueled by Michael's phenomenal exploits on the court and Nike's marketing, the Air Jordan line had grown to a business within a business, with sales greater than many US companies. So what you had was no longer just the cool kids wearing them. It was the not-so-cool kids, their little brothers and sisters—you name it. So there was the risk that if we didn't keep the thing moving, the appeal would die down.

"AIR JORDAN, FROM ITS INCEPTION, WAS FAR MORE THAN A SIGNATURE SHOE. WE WANTED TO CHANGE THE WAY ATHLETES WERE MARKETED."

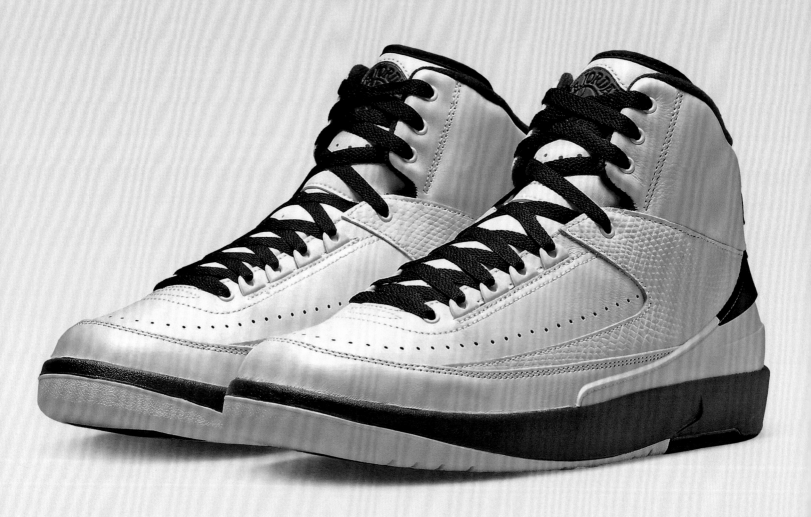

Air Jordan 2 "Imagination"

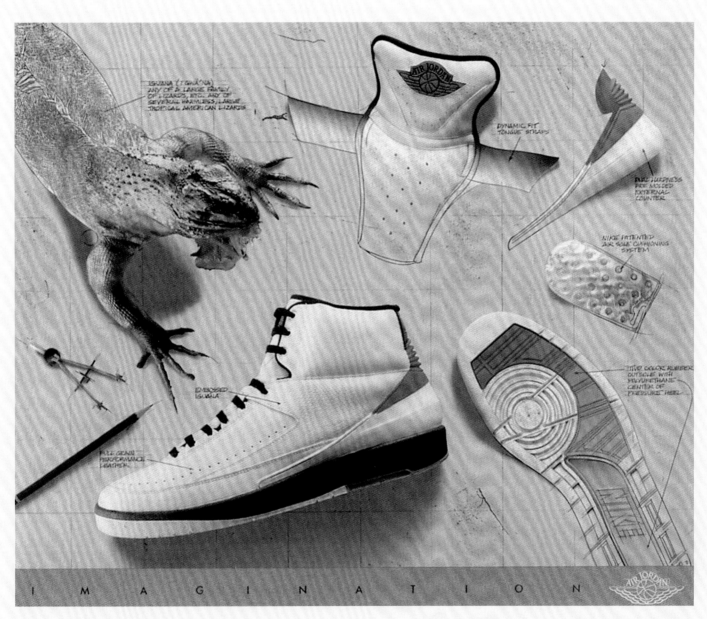

Air Jordan 2 "Imagination" poster (1987)

The concept for a newer, more sophisticated Air Jordan started with Michael himself. He'd done a deal with two guys he met in Chicago who owned a men's outfitters, Bigsby and Kruthers, so that they could use him in advertising. They would show him how to dress. That's when he started turning up to news conferences in Armani suits, because they told him, "Don't just go out there sweaty. Take a shower. Calm down. Be professional. Put on your suit and go to the meeting." And he did.

He had started developing a rather sophisticated taste, style, and appearance, which meant the wings just looked way out of place. I also noticed something that upset everybody at Nike was that he was wearing a lot of Ralph Lauren, with the polo player logo. **So I had this idea that we would create a symbol that would be his polo player, and I said to Michael, "If you do this right, you could become the Black Ralph Lauren. You could have your own men's sportswear stores."** So I took a cue from his signature leap on the poster. There was a designer in the office who was already using a tiny silhouette of it in Michael's newsletter as a story sign-off that I liked, so I retraced it, detailed it, and that became the Jumpman logo—a silhouette of Michael in flight. It's still instantly recognizable. **You see it half an inch tall on a shirt and you know exactly who it is.** It also had a simplicity and elegance that could cover a wide range of clothes and shoes.

We didn't have the time to get it on to the Jordan II. It was too late. But Tinker put it on the Jordan III. On II, it would have been perfect, but the timing didn't work. It was the logo that became the symbol of the man and the line—an image that continues to the present.

Opposite: The instantly recognizable Jumpman logo

"I SAID TO MICHAEL, IF YOU DO THIS RIGHT, YOU COULD BECOME THE BLACK RALPH LAUREN."

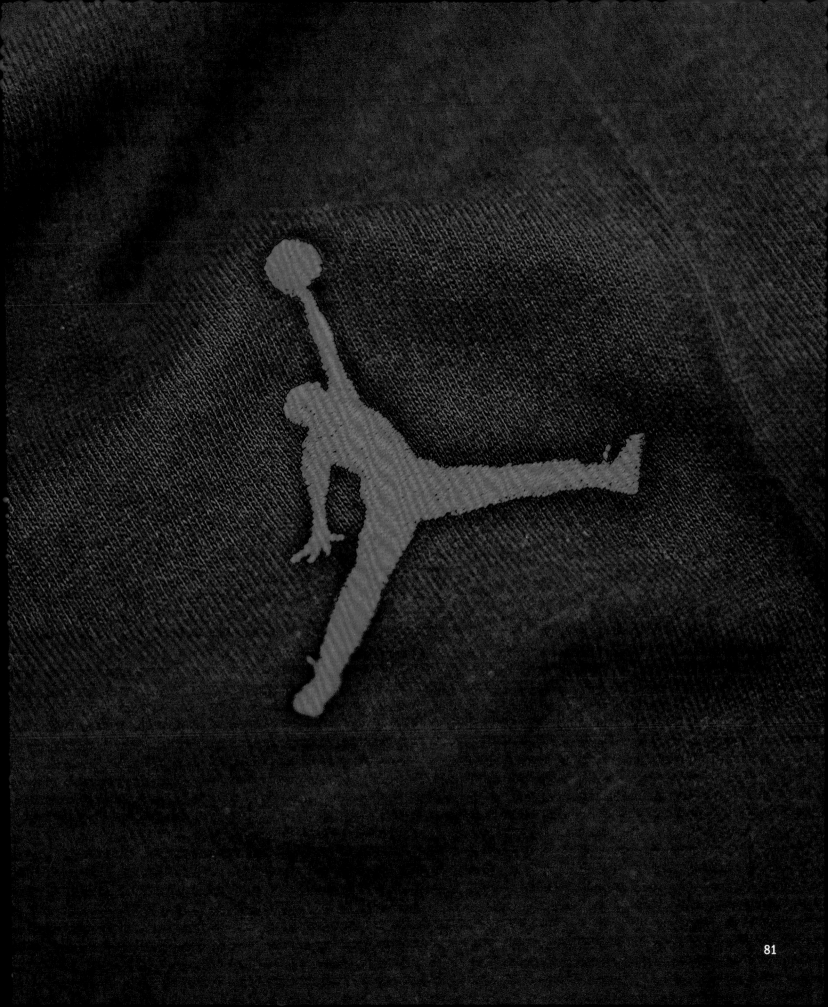

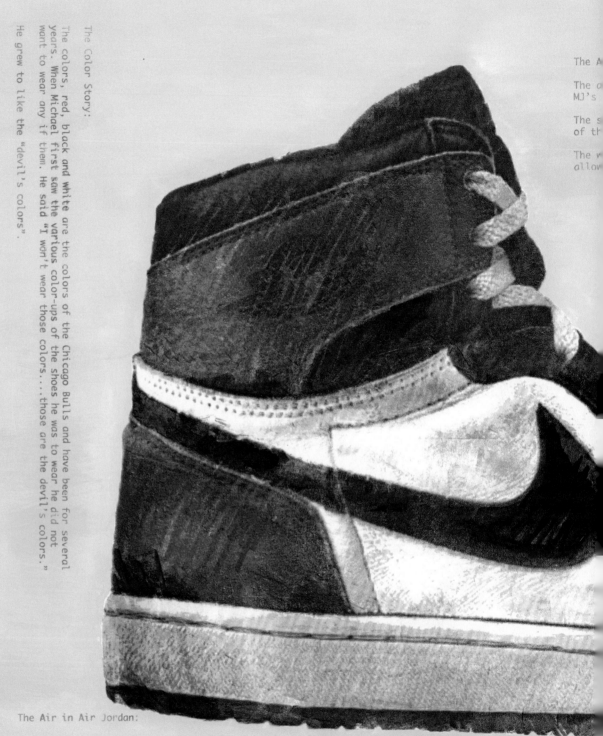

The Color Story:

The colors, red, black and white are the colors of the Chicago Bulls and have been for several years. When Michael first saw the various color-ups of the shoes he was to wear he did not want to wear any if them. He said "I won't wear those colors....those are the devil's colors."

He grew to like the "devil's colors".

The Air in Air Jordan:

The years of Air Jordan the air was found in the heel of the shoe. It is an en-capsuled air bag that sits inside the rubber cup sole. Did it make or help him jump higher.......Absolutely!

Air Jordan 1 "Black Toe" by Peter Moore

Strap:

strap is a borrowed idea taken from the famous adidas Forum. The Forum was
ite shoe before Nike.

not only served as an ankle support strap, it also added to the multicolor ability
e.

concept was to create, not only a great basketball shoe, but also a canvas that would
a great variety of unique color combinations.

Close to The Floor:

The shoe looks low and narrow
in the toe. MJ wanted to feel
close to the floor so the whole
shoe is low and the toe box is
lower than most.

This was accomplished by reducing
the amount of cushioning foam, but
after 84 games of professional
basketball Michael's feet were
sore and tired.

The cushioning was put back in
for AJ-2.

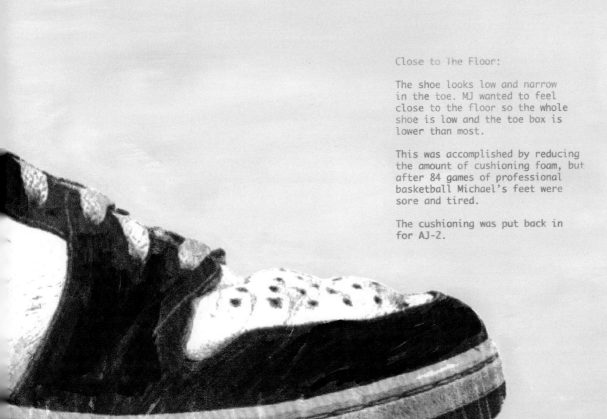

Nike Air Max air capsule unit

BETTING THE FARM ON IT

NIKE AIR 1986–1987

BY 1985, NIKE WAS IN A BATTLE with Reebok to be number one. And we were losing. We just weren't seen as hot any more. The LA Games in '84 for Nike was a huge success from an advertising and brand point of view, but Nike had no products to sell. And it showed. It was the worst year in Nike's history up to that point.

We realized you can't have great brand campaigns without great products. But for whatever reason, I dunno, maybe Phil Knight did a deal with the devil or something, Nike was always a lucky company. A blessed company. Everything that should've gone wrong went right, and everything that was supposed to go right went better. That was definitely true of Air.

They had moved the research department from New Hampshire to Portland. So these guys were sitting around the table showing Rob and me all the things they did. The last thing they had, they said, "No, we don't want to show that shoe. It's a gimmick," but I said "Wait a minute. There's no right or wrong here. Let's see it." And the shoe had a window in the heel, it was all plasticky. The guy working on it said, "You can see the air-bag." That was the problem from the beginning: you couldn't see the air bag. Nobody knew what this air thing was. So I said, "That's a hell of an idea, if we can make it look good and you can see the bag." But they were worried people would stick pins in it and it would pop. I said, "Who cares? That's not the point." There was a sort of mini-technological consumer revolution thing going on with computers and cars, so products became all technical and innovative. There were more Apple computers being sold than ever before—more BMWs, more Sony Walkmans—people were in love with technology. **All it was was a hole in the sole that showed the bag, but that was the difference.**

We had a young designer by the name of Tinker Hatfield, who I was hiding from Phil Knight. Phil wanted to fire him—I can't remember why—but Rob saw something in him, so he asked me to keep him out of Phil's gaze at Nike Design. So I let Tinker and a developer, Bill Peterson, loose on the project, and they came up with a prototype that was the first "Visible Air" shoe. There were plenty at Nike who thought it was a waste of time though. The term "marketing gimmick" just wouldn't go away, and they thought showing it would just expose that gimmick. But Rob and I felt there was something going on with it, so we told Tinker to ignore the flak and just keep going on it.

Although Air had debuted back in 1978 in the Tailwind and we'd had success with it in the Air Force 1, you couldn't see it, so nobody knew what the hell it was. **Visible Air finally gave us the ability to show off the technology. Rob thought we should create a sub-brand, a small line that would represent the single best product from every category and create a halo effect over the rest of the brand.** We realized that what we had was a chance to rebirth the whole Nike brand and to do it as a performance brand: Nike Air.

"THE GUY WHO WAS WORKING ON IT SAID, 'YOU CAN SEE THE AIR-BAG.' THAT WAS THE PROBLEM FROM THE BEGINNING: YOU COULDN'T SEE THE AIR BAG. NOBODY KNEW WHAT THIS AIR THING WAS. SO I SAID, 'THAT'S A HELL OF AN IDEA.'"

FIG. I.

FIG. 2.

FIG. 3.

Nike "Visible Air" patent registration

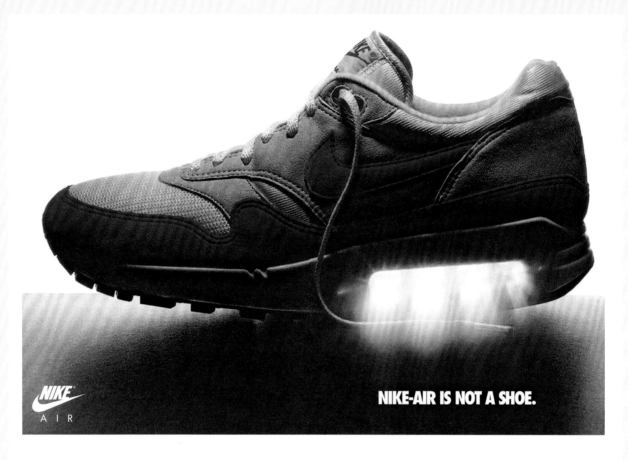

NIKE-AIR IS NOT A SHOE.

IT'S A REVOLUTION.

Like many revolutionary ideas, NIKE-AIR® cushioning is simple. Yet, as a feat of engineering, it remains unmatched. Even eight years after we first introduced it.

NIKE-AIR cushioning is a patented system. It consists of a special gas, pressurized inside a tough, flexible, urethane skin.

Called an Air-Sole® unit, this is what provides the spring-like cushioning. Because after each step or jump, the Air-Sole unit springs back to its original shape.

It provides, far and away, the best cushioning available. Cushioning that reduces the chance of shock-related injury to the bones, muscles, and tendons of the foot and lower leg. Cushioning that can reduce the muscular energy it takes to run, walk or jump.

But perhaps most importantly, NIKE-AIR cushioning never compacts. It cushions as well after 500 miles as it does after the first.

After years of improvements, of new designs, and new applica-tions, we're still uncovering more potential for NIKE-AIR cushioning.

For instance, our studies showed that we could improve the level of cushioning by enlarging the Air-Sole system. As a result, the new Air Max contains three times more air under the heel than any previous Nike shoe.

We're using separate Air-Sole units under the heel and forefoot of many shoes, to improve flexibility. We're using new systems in combination with Air-Sole units to provide more support. More stability.

NIKE-AIR cushion-ing in shoes for all kinds of athletic activities. It's in every one of the Nike shoes you see on these pages.

All this takes research. Experimentation. Challenges worthy of the most capable scien-tists and engineers in their fields.

You can see some of their work right here. And more on the next page.

"Nike Air is Not A Shoe" advertisement (1987)

"WE WERE BETTING THE FARM ON NIKE AIR. THE PLAN WAS TO THROW NIKE'S ENTIRE AD BUDGET INTO THE CAMPAIGN. IT WOULD BE THE MOST MONEY EVER SPENT ON ONE CAMPAIGN IN ATHLETIC SHOE HISTORY."

Like we did with the Air Jordan, we put together a speed group to manage the compressed timetable. At the center of attention were the two biggest innovations in the line: the Air Max, the first visible Air shoe, and the Air Trainer, the first cross-training shoe. **Cross-training was a whole new category that emerged during the Nike Air project. It started as a performance shoe, but it eventually replaced aerobic shoes as a street look.**

The challenge of launching Nike Air was compounded by an internal power struggle. It wasn't a fun time. We sensed we were doing the right thing, but not everybody felt that way. There was a lot of infighting. It certainly wasn't a case of the whole company pulling together toward a common goal. And on top of that, the stakes were enormous. We were betting the farm on Nike Air. The plan was to throw Nike's entire ad budget into the campaign. It would be the most money ever spent on one campaign in athletic shoe history.

In response to the revolution in shoe design, our ad agency, Wieden+Kennedy, came up with a TV spot called "Revolution," based on The Beatles song. Using a grainy, handheld film technique, the idea was to show quick cuts of famous and unknown athletes interspersed with cuts of the shoes.

When we flew to LA to approve the nearly finished commercial, I found the agency had left the shoe completely out of the spot. To me, that was the whole revolution: Visible Air. Without it, it seemed like we were just doing an art piece. And at that point, we couldn't afford to do art. When I left the edit room at three in the morning, the problem was still unresolved. I arrived early the next day with changes in mind that helped lead to a solution. It ended up being one of the most controversial and memorable commercials of all time. The Beatles's record company even tried to sue us for using the "Revolution" song. It only gave us even more press.

In 1987, Phil Knight would credit Nike Air with giving the company the best quarterly performance in its history. Nike Air pulled the entire brand back up to the top, and we took the number one position back from Reebok.

Nike Air "Revolution" TV commercial (1987)

Something that I don't think Peter gets enough credit for was his influence on the "Revolution" commercial. It was like nothing ever seen from a sports brand before. But the real story of it is that if Peter had not been involved in it, people would not still be talking about it today. There was so much riding on that commercial. It was for the launch of Nike Air, but when we came out of the rough cut, I said to myself, "You know, Cindy, you should be fired," because it had gone so far astray from what it was supposed to be that it was a disaster. But in came Peter. **He stayed up all night figuring out what was wrong with it. The next morning, he went back to the edit house and sat with the art director and the editor and, bit by bit, they molded it into something that became that incredible commercial. Nobody ever talks about that because the agencies always get the credit for it, but "Revolution" would have been totally forgotten if Peter hadn't fixed it.** *Often people tend to get really excited about a new concept or a new way of doing something. They tend to get wrapped up in the newness and hipness of it, and sometimes they lose sight of what they're actually trying to do. But Peter was so grounded in the essentials of good design and communication that he had the ability to cut through the bullshit and bring it back so it could fulfill its purpose.*

CINDY YOSHIMURA, FMR. ADVERTISING MANAGER, NIKE & ADIDAS

CAN WE TALK?

You may have heard reports that NIKE is being sued by the Beatles.

That's not exactly true.

NIKE, along with our ad agency and EMI--Capitol Records, is being sued by Apple Records. Apple says we used the Beatles' recording of "Revo-lution" without permission.

The fact is, we negotiated and paid for all the legal rights to use "Revolution" in our ads. And we did so with the active support and encouragement of Yoko Ono Lennon. We also believe we've shown a good deal of sensitivity and respect in our use of "Revolution", and in how we've conducted the entire campaign.

So why are we being sued? We believe it's because we make good press. "Beatles Sue NIKE" is a much stronger headline than "Apple Sues EMI-Capitol for the Third Time. Frankly, we feel were a publicity pawn in a long-standing legal battle between two record companies.

But the last thing we want to do is upset the Beatles over the use of their music. That's why we've asked them to discuss the issue with us face-to-face. No lawyers, critics, or self-appointed spokespersons.

Because the issue goes beyond legalisms. This ad campaign is about the fitness revolution in America, and the move toward a healthier way of life.

We think that's a message to be proud of.

"Can We Talk?" editorial (1987)

A

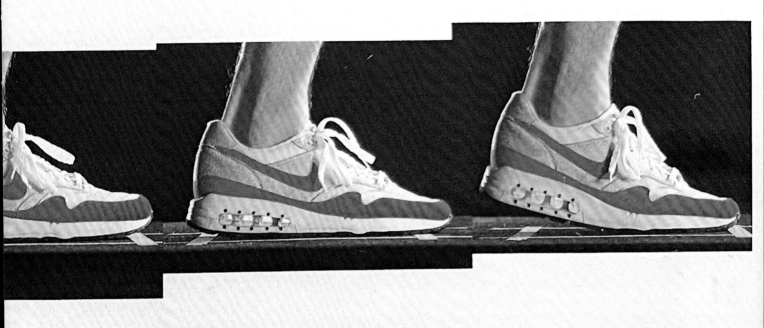

HAT NEVER ENDS.

R

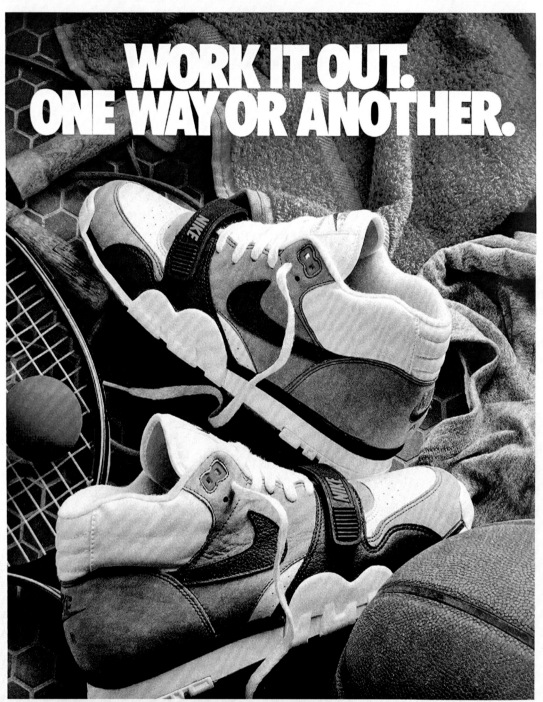

WORK IT OUT.
ONE WAY OR ANOTHER.

More and more, people are turning to cross-training. With workouts that include not only running, but weight training, basketball and other court sports. So Nike has specifically designed a shoe to meet the requirements of all these sports. The Air Trainer.

Flexible enough for quick cuts or sudden stops. Stable enough for the court. And Nike-Air® cushioning to reduce the impact you make under every condition. Cushioning that never wears down. Never gives in.

The Air Trainer. Now you can do it all. And do it well. Come to the Stripes.

NIKE
A I R

Air Trainer "Work It Out, One Way or Another" advertisement (1987)

Naysayers exist in every company or organization, and it's hard to believe it now, but in the mid '80s, there were plenty of people at Nike who really didn't believe in Visible Air.

There were five shoes I'd been working on: the Air Max, the Air Revolution, the Air Trainer, the Air Safari, and the Air Sock. The first two had Visible Air on them. I'd thought them all up, briefed them myself, brought all these sketches in, and said to Peter and Rob, "This is what I think we should be doing."

The problem was that, at the time, Nike was laying people off left, right, and center, and I was disliked by certain people because I had learned a fearlessness from Peter and would speak up. **When everyone was telling me I was wrong, I stood up for my ideas—a situation I would find myself in often during my career, and that came from watching Peter do the same.**

But since I'd come up with these ideas without going through the proper channels (marketing, merchandising and sales), there were anonymous notes put on my door saying, "You shouldn't be here" and "Speed group? You're a speed bump."

Mark Parker and Sandy Bodecker, who were the developers, also got the same treatment. We were pariahs, and there were VPs who literally wanted the three of us fired because they thought Visible Air was a complete waste of time. But not Peter and Rob. They were the only people who really protected and supported us, and who really believed in us and defended us. I still remember them coming into the office and Rob saying to Mark and me, "I don't know what the fuck you guys are doing, but I'm looking around and we've got nothing else as good as this, so I'm betting the farm on you.'"

When the Air pack proved to be a massive hit for Nike, it vindicated us and proved that the faith that Peter and Rob had in us had been justified all along.

TINKER HATFIELD VP FOR DESIGN & SPECIAL PROJECTS, NIKE

Nike Air Max 1 "Big Bubble" (2023)

GETTING "THE GUY"

SPORTS INCORPORATED 1987–1993

FROM THE MOMENT I became creative director at Nike, almost everything I did was as part of a team, me and Rob. He and I. Either I'd start the sentence and he'd finish it, or he'd start the sentence and I'd finish it. But after we launched Nike Air, we felt like we were heading in a different direction than the company. It was losing its entrepreneurial spirit and becoming a "corporation."

Most people think we left together, but Rob left three months earlier than I did. He'd just reached a dead end with Phil Knight. He had a tremendous loyalty to Phil but, like me, he saw the company going one way when we felt it needed to go another. I was downtown in Nike Design, and Phil wanted me to come to Beaverton and move into the main building. But there were people there that I just knew weren't on the same wavelength as me. They were analysts, and I was an entrepreneur. Nowhere was there anybody who I felt would understand what my vision was of Nike, or even what I thought Phil's vision of Nike was. I had a great love for the brand because I'd been part of building it into something, but it just seemed like it was time to try something new.

I respected Phil. I thought he was a genius. He saw a way to do things differently, and he was very smart in how he let people go do their thing but kept a leash on it. He understood how to use Asia better. His genius is not a particular thing, it was an overall thing. But I felt committed to Rob. **Rob was a genius too. He found ways to get things done, kept them going through the political maze of the company, and would call bullshit bullshit. He was my offensive tackle and could clear the way for good ideas and get them done.**

Rob and I had been talking about starting a sports marketing company together for a while, so in September '87, I made the jump, quit Nike, and cofounded Sports Incorporated. Our mission statement was "to build ideas into brands and brands into businesses." The idea was to replicate what we had done with Michael Jordan and Air, working through a whole process of how you approach a problem. Sports Inc. was a way to refine that and do it for lots of different brands rather than just one, by finding niches in the markets we knew something about, then building brands to fill them or taking existing brands and reshaping them to fit the market needs.

We started in a tiny office above a bar in Northeast Portland. The original group were all ex-Nike people. Besides Rob and me, there was Mary McGoldrick, an apparel person; Owen Clemens, the office manager; and Howard Allred, a finance guy. We were later joined by even more ex-Nike people. It was a far cry from where we'd come from. None of us really knew what we were getting into, but it was exciting. We couldn't even pay anyone for a couple of months. Mary not only gave up a salary, she gave half her furniture so that we could furnish the office.

"THE IDEA WAS TO REPLICATE WHAT WE HAD DONE WITH MICHAEL JORDAN AND AIR, WORKING THROUGH A WHOLE PROCESS OF HOW YOU APPROACH A PROBLEM. SPORTS INC. WAS A WAY TO REFINE THAT AND DO IT FOR LOTS OF DIFFERENT BRANDS RATHER THAN JUST ONE."

Sports Incorporated

Building Ideas into Brands,

Brands into Businesses.

Not long before Rob and I left Nike, we pitched the idea to Michael Jordan that he should create a casual wear brand. Both he and his parents liked the idea, but when we pitched it to Phil Knight, he was only interested if he thought it was going to be a $100 million dollar plus business, which we were sure it would be. Knight kind of got behind it, but not fully, and when we realized that it could be the whole Air situation again, where it was a fight to make it happen, it became one of the reasons that Rob decided to call it quits at Nike.

Michael still liked the idea though, and we were still close to him. So after I'd joined Rob, we met up with him to talk about starting up this sportswear thing. His contract was going to be up at Nike the following year, so he'd be free to start up his own business or even go with another shoe company. People think Rob and I made a play to pull Michael away from Nike. I know it's what Phil Knight still believes but, in fact, pretty much the reverse was true. The plan Rob and I pitched to Michael was that we would do everything for him but make the stuff. He would re-sign with Nike, and some of the products would be co-branded Jordan and Nike, but some would just be Jordan. So Michael would still be with Nike. We weren't trying to cut them out of the deal, but Rob and I would manage the whole thing. **When we talked to Michael about it, we even put together a kind of annual report for him, to show him where he'd be in 2020. So alongside this apparel thing, he'd be involved in player representation, travel agencies and a lot of different sports ventures, but the idea was that he owned the company.** We thought Phil might go for it, and we arranged a meeting with him, Michael, Rob, and me to pitch the idea to him. It wasn't a pleasant meeting. And it was, frankly, a stupid idea on our part, knowing Phil Knight as we knew him. He just doesn't give up, unless its his decision to give up, so of course he said no.

Looking at it in hindsight, from his point of view, he'd just lost two guys who had brought him the biggest home run in the industry. And now they come and tell him they want to take his No. 1 athlete away and create his own products on their own? I could clearly see why he was pissed with us. But, at the time, Michael was pushing hard. He wasn't happy at Nike. It sounds crazy now, but there were people at Nike who still believed it was a running company. They had no time for him, let alone basketball, and he knew it. To make it worse, he only knew Rob, me and a couple of other guys, and they'd all just left. But the reality was that he couldn't completely up sticks from Nike to come and be his own guy with us. At Nike, he was probably making twenty million dollars a year. We just weren't in a position to guarantee him what Nike could, which having been unable to convince Knight our plan could work, is why we told Michael to stay with Nike. By all accounts, it worked out for him.

"PEOPLE THINK ROB AND I MADE A PLAY TO PULL MICHAEL AWAY FROM NIKE. I KNOW IT'S WHAT PHIL KNIGHT STILL BELIEVES BUT, IN FACT, PRETTY MUCH THE REVERSE WAS TRUE."

Rob Strasser and Michael Jordan

Rob and Peter with Sports Inc. client and NBA star Dikembe Mutombo

Natural Sport products for Brown Shoe Company

"WE BELIEVED THE PROCESS FOR SOLVING PROBLEMS WAS ALWAYS THE SAME: YOU DESIGN PRODUCTS AND COMMUNICATE THEM NOT FOR A GROUP BUT FOR ONE PERSON."

Our first clients at Sports Inc. were pretty diverse: Brown Shoe Company, TaylorMade Golf, Benetton, PF Flyer, and the State of Oregon. Although they were all very different brands, they faced similar issues. **We believed the process for solving problems was always the same: you design products and communicate them not for a group but for one person. The role model that you think everybody's going to emulate. You build a profile of that person, what they do, what they like, what they hate. That's the person you focus on and create for and, if you get it right for the one guy, the rest of the target will follow.**

In the case of Brown Shoe Company's Naturalizer Division, the "guy" was a 45-year-old woman looking for a way to get fit but wasn't comfortable in an aerobics class or jogging. So we created Natural Sport, a new brand of performance walking shoes that capitalized on Naturalizer's strengths: quality and fit. The Natural Sport concept was a total design and marketing package—from product, packaging, and logo design to advertising and sales tools. Walking was something these women could relate to and get excited about.

The athletic brands were already doing walking shoes, but they were coming at it from a sports angle. The Naturalizer customers weren't going to go buy high-tech walking shoes from a skinny 18-year-old runner. But they were perfectly comfortable buying what was maybe their first athletic shoe from a brand they already knew.

Another early client, TaylorMade Golf, posed a different problem: marketing high-tech clubs (metal woods) to a sport that cherished tradition. I thought TaylorMade's existing ad slogan, "The Art of Golf," was a good starting point. I worked with painter Bernie Fuchs to create a campaign that would capture the excitement and emotion of the sport. Being a golfer, Fuchs brought real integrity to his work. I'd call him and say, "You know the seventh hole at Cypress Point, where you come down the hill? I want something that feels like that." And he'd know exactly what I was talking about. And anybody who knows golf would say, "Is that Cypress Point?" Not because it was a photographic reproduction, but because the painting captured the feeling of that hole, that moment.

The best example of "getting the guy" was with VanGrack. We could see that sports was becoming immersed in popular culture. It was a way of life, the way people dressed, and how they were thinking, especially among young urban Black kids. So we partnered up with Mark Van Grack, a shoe retailer in Washington, DC to create a fashion brand for the urban youth market.

Everything we did with Van Grack was based on something we saw happening with our consumer. It was never about my style or my vision. Each season's collection was designed around a changing theme that reflected the changes in the kids' lives. When rap first came out, before it was mainstream, these kids were into it. Our products then were flashy, aggressive, kind of "look-at-me." When they turned to cleaner looks and started dressing up, VanGrack became simpler and more sophisticated. When kids started paying attention to their African heritage and you saw a lot of traditional African motifs appeared in their hairstyles, music, etc., we found ways to use traditional tribal colors and patterns in the line.

The problem was VanGrack was such a roller coaster. It almost bled Sports Incorporated dry. There was so much risk in doing VanGrack—much more than we ever realized. **Starting an athletic brand from scratch in the late '80s was just not a simple proposition. It taught me a lot, about what it takes to start a company and what it takes to run a company.**

VanGrack wasn't just a design project on somebody else's nickel. It was a whole company. At one point, Sports Incorporated was up to about 40 people and three-fourths of them were working on VanGrack. We did the development, the sourcing, the production. We had a sales force. We did our own advertising. **Mostly, it taught me the unbelievable importance of brand equity.** You can look at other companies like Reebok and Nike, and see they learned the same thing. Nike especially had tremendous difficulties trying to start entirely new brands and, as a result, they ended up expanding by buying other existing brands. **In this business, it's always better to build on something that's already there or, in the case of adidas, (which we did later) to rebuild than to start from zero.**

> "EVERYTHING WE DID WITH VANGRACK WAS BASED ON SOMETHING WE SAW HAPPENING WITH OUR CONSUMER. IT WAS NEVER ABOUT MY STYLE OR MY VISION."

VanGrack poster from an advertising campaign featuring photography by kids from inner city high schools

Above: Apparel and shoes from the VanGrack launch range
Left: VanGrack poster

From top to bottom: Logo designs for Buster Brown, Greg Norman, and PF Flyer

Brand design for Africa's first NBA star, Dikembe Mutombo, who worked with Peter at Sports Inc. and adidas

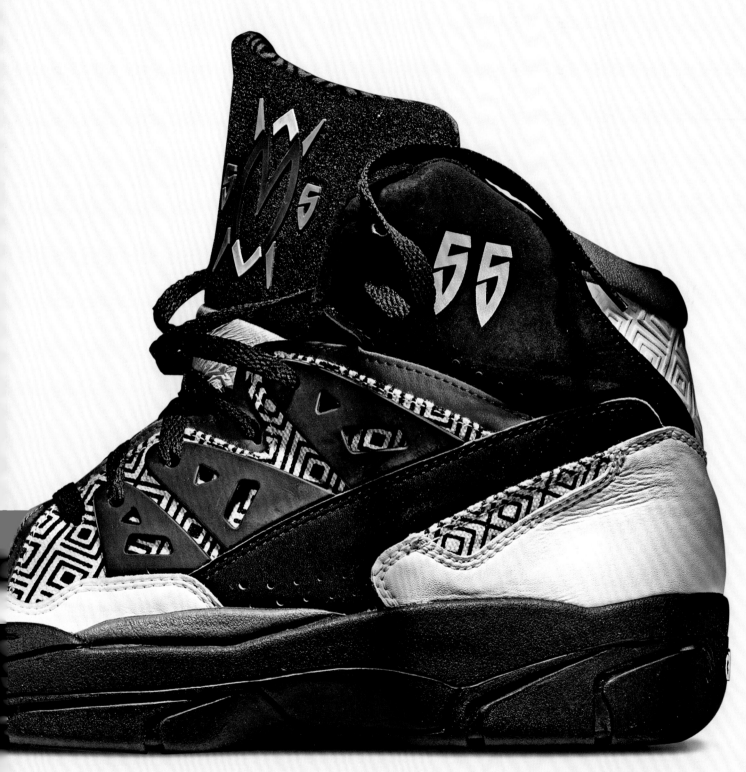

Mutombo's first adidas shoe, designed by Guy Marshall, based on the Mutombo family cloth pattern

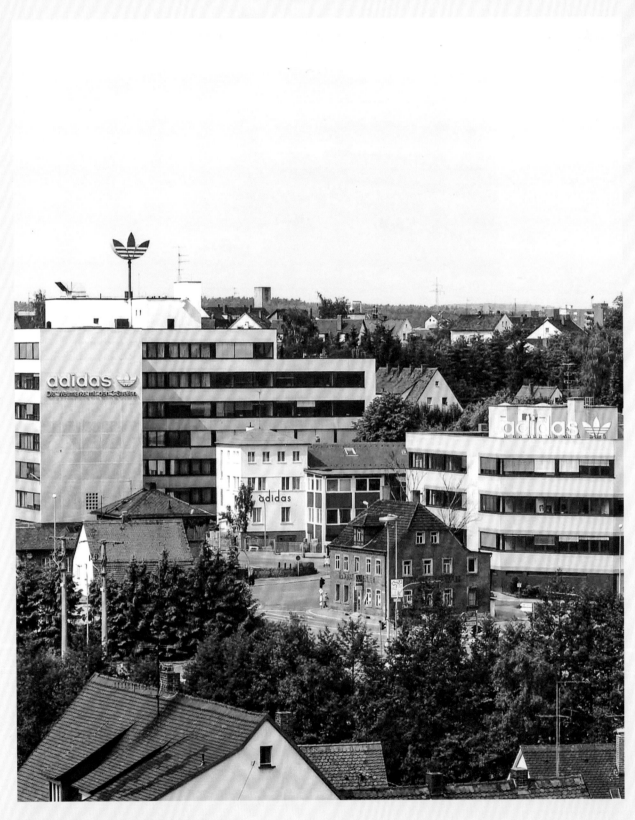

The original adidas headquarters in Herzogenaurach, Germany

WE'RE GOING TO GERMANY!

ADIDAS 1989

A LOT OF PEOPLE think that Rob and I moved straight from Nike to adidas, but when we started Sports Inc., they were probably the last brand we'd have thought of working with.

The adidas story started for us when Rob got a call from the then president or CEO, or whatever the hell they called him then, and Rob said to me, "I got a call from René Jäggi." I said, "What's a René Jäggi?" Rob explained and said "We gotta go meet him in Chicago." I flat out said, "I'm not going."

You have to understand that we'd been raised by Nike to hate adidas and everything they stood for. They were the enemy. It had been our life's mission to take them down. And Rob and I had been the lead cheerleaders in rallying Nike to do that. In the Nike office, we even had a giant poster of Wimbledon after it had been bombed during the war with the title, "Brought to you by the people that wear three stripes." Rob even blew up a giant adidas shoe at a sales conference once. They were the bad guys, and now he wanted us to go see them? No. It wasn't happening.

But Rob was desperate to get back into working with a big sports brand again, so went off to Chicago to go see Jäggi without me. Sure enough, he came back and said, "We're going to Germany!" But I didn't want to go to Germany. But we went to Germany. Under protest.

We arrived in Munich the night before, got up early the next morning, and drove to Herzogenaurach, where both adidas and Puma are based. It was foggy, grey, and cold. By the time we got there, it wasn't dark, but it wasn't quite bright dawn either. There was this blue glow in the sky. And as we got closer, I saw that this blue glow was a giant revolving adidas Trefoil mark sitting up on top of the headquarters building. Well, to me it had the same effect as if it were the old trademark, if you know what I mean. So I turned to Strasser and said, "Rob, we gotta get the hell outta here! Please, think about this!"

"YOU HAVE TO UNDERSTAND THAT WE'D BEEN RAISED BY NIKE TO HATE ADIDAS AND EVERYTHING THEY STOOD FOR. THEY WERE THE ENEMY. IT HAD BEEN OUR LIFE'S MISSION TO TAKE THEM DOWN."

adidas

DIE WELTMARKE

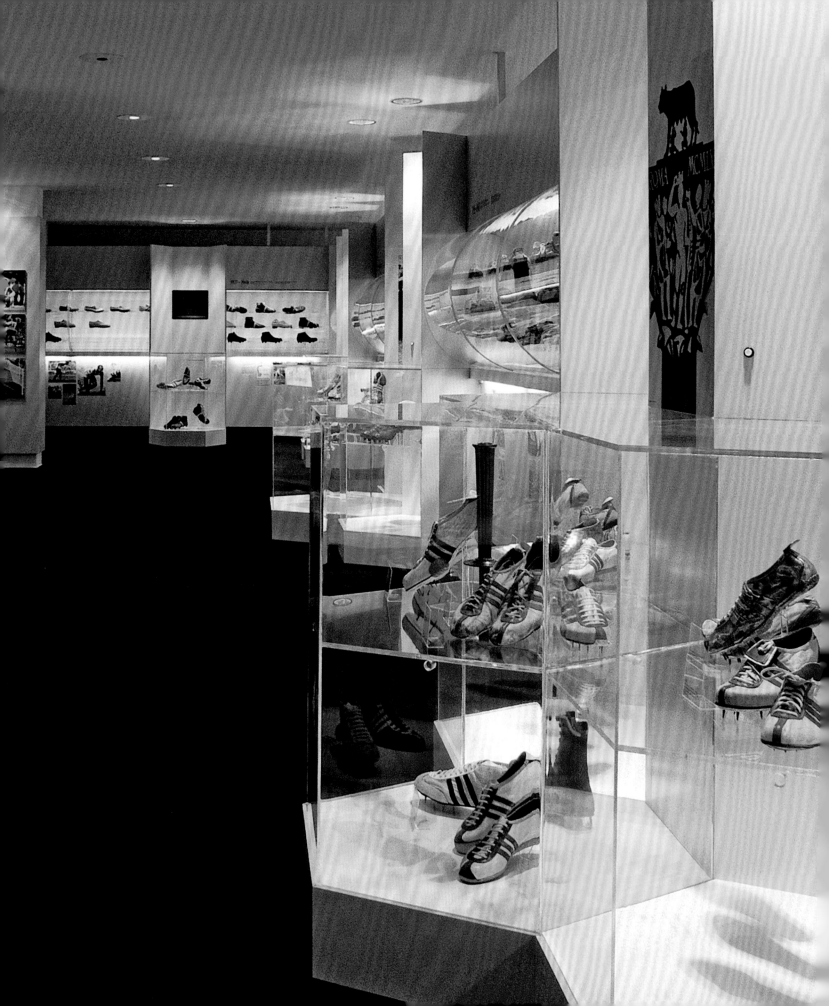

"BY THE END OF THE TOUR, I'M CRYING. IT HAD DAWNED ON ME THAT THIS COMPANY WAS THE LIFE'S WORK OF ONE MAN, ADI DASSLER. ALL THE IDEAS THAT I THOUGHT NIKE HAD INVENTED, THIS GUY HAD, BEFORE PHIL KNIGHT WAS EVEN OUT OF DIAPERS."

Anyway, he didn't listen. Rob's wife Julie, who had come with us, wanted to go and see the cemetery where both Adi Dassler, the founder of adidas, and his brother Rudi, the founder of Puma, are both buried. The crazy thing was that these two brothers were such rivals that Adi was buried on one side of the cemetery, and Rudi was buried about as far apart as could be on the other side. That was the first sign to me that there was something more to this town than just shoe making.

The next day they sent a car to pick us up from our hotel. When we got to adidas, it was clear that they didn't want anybody to know we were there. It was an unannounced visit by two Nike guys who just kicked their ass. And we really had kicked their ass, because this was not the adidas we had spent years fearing. So I'm still thinking, "Why? Why are we here?" But something crazy happened.

In that building at the time, up on second floor, they had a small museum for guests to go through. So this guy, Peter Rduch, takes us through this thing and, by the end of the tour, I'm crying. It had dawned on me that this company was the life's work of one man, Adi Dassler. All the ideas that I thought Nike had invented, this guy had before Phil Knight was even out of diapers. And it was like an epiphany moment for me. A real eye opener. In truth, at that moment, I still didn't really give a shit about the company, but I was blown away by the man.

After the museum tour, we had a couple more meetings with Jäggi and Peter Rduch, and it was clear why they wanted to see us. The brand was fucked. The Dasslers were no longer running the company and it was a mess. They wanted us to help them out of it. When we left, Jäggi said he wanted to work with us and he wanted us to come back with a proposal.

So we went home, and Rob and I sat down. Rob said, "What do you think?" For Rob, it was a way he could show Nike, but I just didn't have an axe to grind with Nike like Rob did with Knight. But he was a very convincing individual. **So I told him that if they wanted us, then let's help them. But it had to be our way, or no way.**

Opposite: The museum where Peter first experienced his adidas epiphany

Aside from maybe the Olympic rings, the adidas Trefoil is probably the most recognizable symbol in sports. But when Rob and I began working with adidas, the Trefoil represented to us all that was wrong with the brand.

The story we had heard at Nike was that because the 3-Stripes branding on adidas-sponsored athletes was considered too strong by the Olympic Committee, Horst Dassler did a deal with the president of the International Olympic Committee, allowing them to instead use a mark, and so they came up with the Trefoil. So to us the Trefoil was all about corruption in sport. We hated all that because we'd built Nike as an antiestablishment brand. I later found out the story wasn't true. At the time, it still represented everything that adidas was in the past, not what it needed to be.

It had to go.

"WHEN ROB AND I BEGAN WORKING WITH ADIDAS, THE TREFOIL REPRESENTED TO US ALL THAT WAS WRONG WITH THE BRAND."

Right: The revolving Trefoil that once topped the original adidas headquarters building and now rests in the grounds at the adidas campus in Herzogenaurach.

The adidas Equipment Fall/Winter 1991/1992 brochure that featured a seal created from artwork by Peter, inspired by Adi Dassler

EVERYTHING THAT IS ESSENTIAL. AND NOTHING THAT IS NOT.

ADIDAS EQUIPMENT 1991–1996

DOING THE ONCE UNTHINKABLE, Rob and I went back to Germany and began looking at the adidas problem, which was huge. They had guys in suits and ties with job titles that made them sound like they were the masters of the world, but they didn't do shit. They had a design department that was told what to do and made to do it—no creative freedom at all—led by marketing people who had no sense of what their customers really needed. It was a pale shadow of the company it had once been. Rob and I realized the solution was a simple one: bring Adi back.

Adidas didn't know what to do because they didn't know who they were anymore. They'd forgotten. So we had to take this company back to when Adi Dassler was making the best sports equipment in the world and build upon that. We knew we couldn't fix it in one day. It was going to take years to clean the mess up, and it was going to take a cultural change that we weren't even sure they would accept. But we decided the only way forward was to go back—back to adidas's roots and build in the same way Dassler would build.

We called this new concept "Equipment." Why? Because Adi Dassler was the equipment manager of the world. It was clear as day that Adi's aim from day one was to provide athletes with the very best sporting equipment he could. It was everything that is essential, and nothing that is not. You don't buy a bulldozer to do anything but bulldoze. You don't drive it to the drive-in. It's a no-bullshit piece of equipment that does something very specific. So a tennis shoe was going to be a piece of equipment to play tennis in. A running shoe was going to be purely a shoe to go running in. It was the essence of everything we'd been inspired by in the museum, and we really believed that it shouldn't just be history. It should be what adidas was still doing today. It was time to cut out all the crap, all the fashiony stuff, the confused sports lifestyle ranges and the weird colognes, and go back to doing what built the brand in the first place. Equipment would be the best of adidas.

> "IT WAS TIME TO CUT OUT ALL THE CRAP, ALL THE FASHIONY STUFF, THE CONFUSED SPORTS LIFESTYLE RANGES, THE WEIRD COLOGNES, AND GO BACK TO DOING WHAT BUILT THE BRAND IN THE FIRST PLACE."

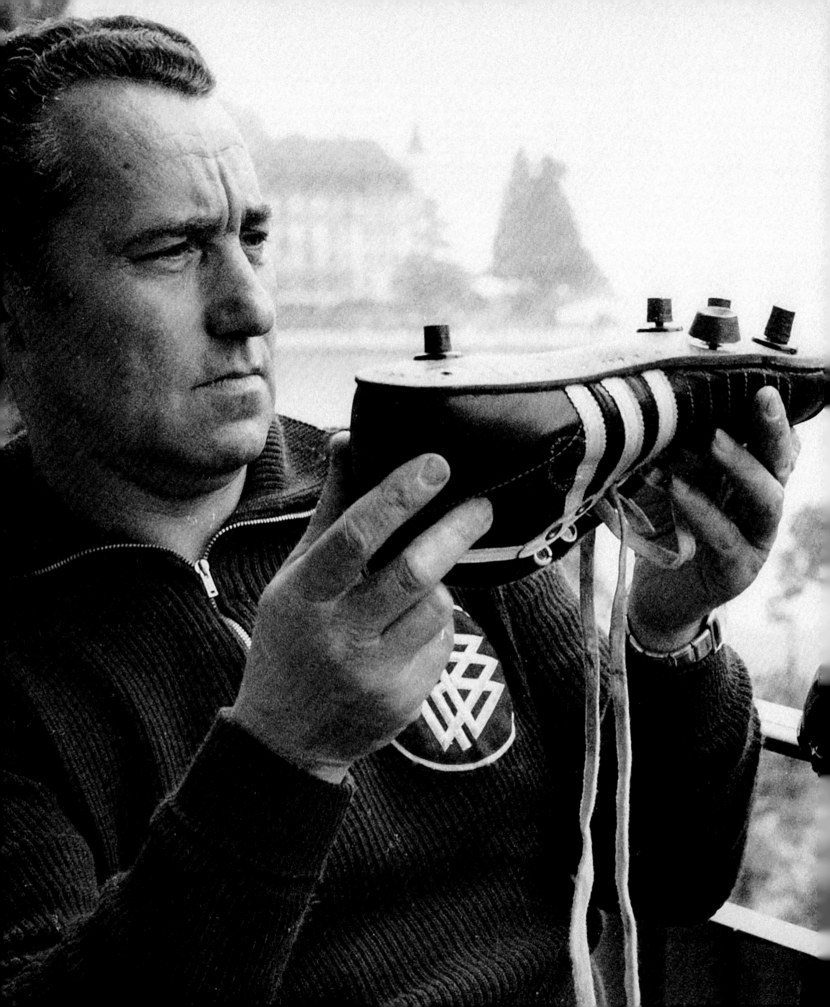

"YOU'VE GOT TO GET BACK THERE. THAT'S THE SPIRIT, THE HEART OF THIS WHOLE BRAND, RIGHT THERE IN THIS PICTURE. THAT'S IT. THAT'S ALL YOU HAVE TO DO."

Rob and I went to Germany to present the plan to Jäggi and the top guys. The concept of Equipment was far more than just a product range. It was a philosophy, a comprehensive model, and road map that we were sure would get adidas out of the mess it was in by changing the mindset of the entire company.

During the pitch, we showed them a picture of Adi Dassler holding up a soccer boot and said, "You've got to get back there. That's the spirit, the heart of this whole brand, right there in this picture. That's it. That's all you have to do."

But there were some in that room who struggled to understand it. It was clear that I already had a target on my back. I was trying to convince these guys about design in terms of form follows function, and they were trying to do more fashion shoes. It was a struggle. **My philosophy, the one I'd followed my whole career, was that the way a product looked was determined by what it did.** So every detail had a function and provided some benefit to the wearer. It was the way Adi Dassler had designed, so it was how Equipment would be designed.

After the presentation, Jäggi was still not fully sold, but he soon got on board in a big way. Thankfully, Peter Rduch got what we were proposing. He almost cried. I realized then that while it'd be a battle to convince everyone, there were those who'd get it in a second, because it was already in their hearts. We did a deal with Jäggi, and Rob and I went back to Portland to start putting together a plan that would define exactly what Equipment was, how it work, and how we would roll it out. We knew it wasn't going to be easy, but the challenge of trying to turn this ship around excited us.

Opposite: The inspiration for Equipment, adidas founder Adi Dassler

As part of the Equipment presentation, I had designed a range of shoes, but it wasn't just a bunch of shoes I was showing them. It was also the kind of attitude that defined them as Equipment. They didn't understand the idea at all, but they made one smart decision: they put me together with their lead designer in France, Jacques Chassaing. At first, I think he may have thought, "Oh, Jesus. This guy's just a one hit wonder, and now he thinks he can tell me how to do this?" But I made it clear to him that I wasn't here to tell him how to do his job. I needed his help, and he jumped right on board. People think I'm a shoemaker, but I'm really not. Jacques is a real, classically trained shoemaker from the days when a designer had to do everything from the first drawings to cutting the leather patterns. He took the boards I'd put together and he and his team made them a reality.

To emphasize the idea of essential, I felt we should take away all the color. At that time, designers loved to play with color and to decorate shoes with it, but to me, it was bullshit, lipstick on a pig. I didn't want "I don't like the color" to even be a decision. I wanted to take as much subjectivity out of it as possible. We cut it down to black, white, gray, and a special color we called "Equipment green." It was a shade I'd found in a Pantone industrial paint book. It was deliberately a pain in the ass to match, because the idea was that it would be like Coca-Cola's secret formula—a color no one could replicate. The combination of black and green was athletic and fresh. Everyone uses green today, but back then they didn't, which also made it fresh in terms of usage. The uniqueness of the shade was also intended to become part of the image and a transition away from adidas's traditional blue, which at the time was the ugliest blue on the planet.

With the first Equipment collection, because we needed to get the shoes out fast, some of them were based on existing but upgraded models. But for the '93 collection, most of them were designed from the ground up, and so are in many ways the most pure executions of the Equipment philosophy. Over time it got diluted, so the '93 models are for me probably the best Equipment shoes we did. The fact they still sell today is testament to that.

Opposite: Equipment Fall/Winter 1991–1992 shoes

"AS PART OF THE EQUIPMENT PRESENTATION, I HAD DESIGNED A RANGE OF SHOES, BUT IT WASN'T JUST A BUNCH OF SHOES I WAS SHOWING THEM. IT WAS ALSO THE KIND OF ATTITUDE THAT DEFINED THEM AS EQUIPMENT."

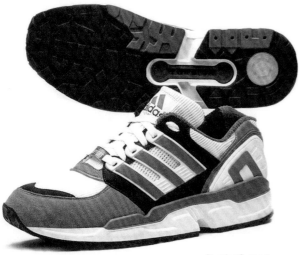

Running Support

Running Cushion

Racing

Tennis Hard Court Lo

Golf

Basketball Hi

Equipment Support 1993

"I DIDN'T WANT 'I DON'T LIKE THE COLOR' TO EVEN BE A DECISION. I WANTED TO TAKE AS MUCH SUBJECTIVITY OUT OF IT AS POSSIBLE."

One of the ideas we had for Equipment was a range of shoes called Adventure. At that time, the outdoor category wasn't the big deal it is today, but I designed an outdoor shoe you could boulder in, hike in, or ride a mountain bike in. Outdoor recreation was just starting to become a big thing, as people wanted an alternative to the gym. **We saw Adventure becoming to the '90s what cross-training and aerobics had been to the '80s, and we intended to make the category our own.**

Adidas already had form in the serious trekking category and had outfitted adventurers like Reinhold Messner before, so we saw it as natural territory for the brand. The first shoes, the Adventure Hi and Adventure Mid, were kind of like outdoor cross-trainers for people who wanted to do a bit of everything from light hiking to kayaking. For the more serious outdoor activities, we also created an Equipment Trekking shoe for people who wanted a more rugged mountaineering style boot.

"OUTDOOR RECREATION WAS JUST STARTING TO BECOME A BIG THING, AS PEOPLE WANTED AN ALTERNATIVE TO THE GYM."

Equipment Adventure Mid

Equipment Adventure Mid featured in the Equipment Spring/Summer 1992 catalog

I was in the first meeting when Rob and Peter came to Germany at the end of 1989 to meet René Jäggi about what could be done together. Peter and Rob asked to see the latest products, so Jäggi gave me a call and said, "Please come up with your shoe bag." So I went up to the fifth floor with the very latest adidas Torsion prototype. It was just a fantastic meeting—firstly just to meet Peter and Rob, but also because they were so interested in the product. I wasn't used to that kind of situation where big bosses were so into product like Peter was, so it was a great experience to be able to talk to them about what we were doing and to get their feedback.

And then the whole Equipment story started. Before they fully joined adidas, Rob and Peter remained consultants until February '93, and there was a small team in the company who worked with them to manage Equipment. It was a great honor to work on the project because it was focused on repositioning the brand and bringing back Adi Dassler. **The idea that Peter had from the very beginning was that it needed to be a small range that showcased the best of what adidas can do.** Peter and Rob asked me who the best product guys were within the company, and we put together a list and they all came to Herzo. It was a complete new team of young, crazy people.

Peter was very much involved in the design of the Equipment products, and he was very strict in the beginning. "It's only black, green, and white and the shades of grey. That's it. No exceptions." In this industry, there is always the question of how much lifestyle do you do. How much do you move away from true sports? Peter really tried to balance that very carefully. **He understood that you need to be a lifestyle brand, because lifestyle is an easy sale compared to performance, but that you should never forget where you come from or forget the athlete.**

Peter believed you need to know exactly who you make products for. So he always had a sort of a brief for every product or for every advertisement in which he clearly said it's for that guy or this guy. It wasn't vague, like "It's for a teenager or a woman between twenty-six and thirty-two." No, it was, "This is Ina, She's twenty-seven. That's the last book she read and that's what she wears." So you had a very clear picture of who you were making a product for. That first guy was me! He asked me, "What do you wear?" So I brought a pair of jeans, and I showed him where the wear was. So we made jeans with a leather patch in the saddle!

In the beginning, we also did adidas Adventure. Peter's idea was it's not mountaineering or trekking or hiking. It was sort of outdoor cross-training, outdoor products that people can use to walk, hike, mountain bike or a little bit of climbing. Eventually, we built a whole new category around that. And the first Adventure shoe, Peter designed that himself.

The first reactions to Equipment in the company were very different. When Peter and Rob first presented it to the company, I think I've never seen a crowd of a thousand people being that excited. Of course, there were people who freaked out. Two former Nike guys coming to Germany and teaching us about adidas? I mean, that's crazy, right? But there were also people who saw it as an opportunity and were excited. The special thing about Peter was that he never said it was his concept. He said it was Adi Dassler's. "He just gave it to me." Of course, there were people complaining about it. You know, "Green doesn't sell," or "We need the same thing in blue." But eventually, I think they were welcomed by everyone.

BERND WAHLER FMR CHIEF MARKETING OFFICER, ADIDAS

Equipment Adventure apparel range Fall/Winter 1991–1992

Equipment apparel range

Ian Rush in Liverpool FC's Equipment Green away strip

The evolution of the Equipment logo came following the realization that we needed to show the world we had something new. The fact that everyone knew the adidas name and recognized the trademark wasn't enough. We needed a new message and a new symbol to show the world that the brand and the company were alive again.

We couldn't put the Trefoil on it because it represented the past and it was still on millions of other products. And we couldn't put the word mark on it alone because it had no emotion. **I could never understand why the name and the 3-Stripes were never connected.** So I was trying to come up with something and nothing was quite working, but then I was looking at a left side tennis shoe on the lateral side and the way the stripes are never the same length. I thought, "Oh, that could work." And I always thought the 3-Stripes with the Equipment word mark would be more interesting than this Trefoil thing. So I did it. And everybody by that point had drank the Kool-Aid and was okay with it.

Although it started as the Equipment logo, it eventually became the Performance logo. **When we introduced it, we tried it on Originals products but it just didn't work. So the Trefoil was brought back, meaning the Performance logo, Trefoil, and 3-Stripes lived side by side.** From an identity point of view, that was confusing. At one point years later, I told adidas to kill the Performance logo and go back to the Trefoil, but they didn't want to lose that either. There are worse things to worry about than having three immediately recognizable marks to identify your company, especially when they mean so much to people.

Opposite: The evolution and inspiration behind the design of the adidas Equipment and Performance logos

"I WAS TRYING TO COME UP WITH SOMETHING AND NOTHING WAS QUITE WORKING, BUT THEN I WAS LOOKING AT A LEFT SIDE TENNIS SHOE ON THE LATERAL SIDE... AND I THOUGHT, 'OH, THAT COULD WORK.'"

STRIPES ON A
TENNIS SHOE...
LEFT SHOE / LATERAL SIDE.

CENTER
STRIPES

WORD MARK

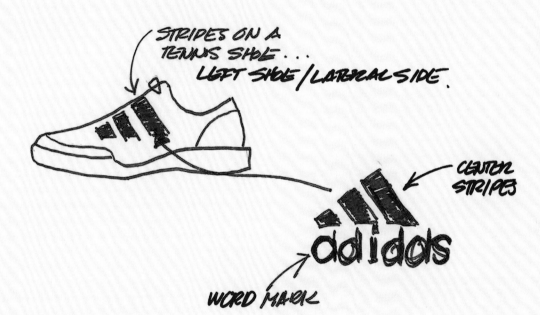

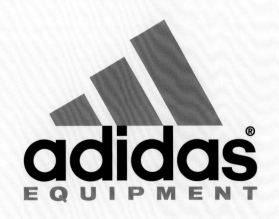

Equipment

In every sport
there is the essential.
What is needed
to compete and win.

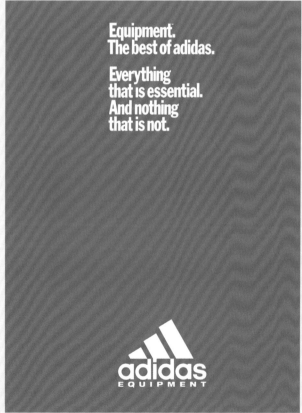

Equipment.
The best of adidas.

Everything
that is essential.
And nothing
that is not.

adidas
EQUIPMENT

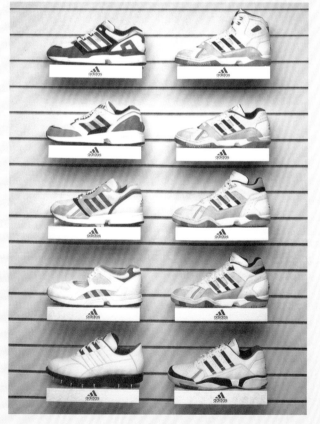

Pages from the Fall/Winter 1991–1992 adidas Equipment catalog

Needs.

Shock absorption	Dämpfung	Absorption des chocs
Comfort	Komfort	Confort
Efficiency	Leistungsfähigkeit	Efficacité
Injury prevention	Verletzungsschutz	Prévention des blessures
Durability	Haltbarkeit	Longévité

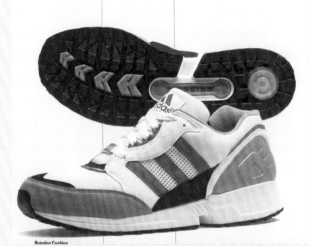

Running Cushion

Essentials.

The goal of adidas Equipment is simple and constant—to make the best products for sport. Each product is designed to meet the essential needs of athletes: performance, protection, comfort, and quality. The design principle is "form follows function"—the way a product looks is determined by what it does. Each feature provides an understandable, real benefit to the consumer, not just something added on to increase price or create a new look. Every sport has its special needs, and adidas Equipment addresses these with a wide range of innovative features.

The Torsion System

Torsion allows the foot to move freely as nature intended it, while providing the necessary control to prevent injury. The forefoot and rearfoot move independently of each other—just as a bare foot moves. Combined with this freedom, however, the Torsion bar provides the proper amount of control and guidance to keep the foot from over-twisting. Torsion is a response to the need for the foot to go through its normal range of motion. The Torsion system is a result of the ongoing research and development that is fundamental to adidas' commitment to helping athletes perform better and more safely.

Riemen

Riemen, the name for the new adidas midfoot support system, surrounds the foot from beneath, holding it snug to the upper of the shoe. Riemen, German for straps, offer superior midfoot support for improved protection and performance.

Shock Absorption

For most sports, cushioning and shock absorption are primary needs of a shoe. Protection from repeated pounding on roads, courts, and fields is an essential element in all adidas Equipment models. The system of features that add up to better cushioning are:

Soft Cell
A cushioning unit strategically placed in the heel area to absorb shock.

PU Midsole
This proven material provides superb, lasting shock absorption.

Where extra cushioning is needed, softer PU inserts have been added or the PU has been combined with other materials like EVA to further improve cushioning.

Outsole Designs
For each sport, outsole designs have been created specifically to enhance shock absorption as well as performance.

Comfort

The adidas Fit
Comfort and performance both start with fit. For over a half century, adidas has set industry standards for outstanding fit.

Comfortable Materials
adidas Equipment products have been designed with the proper materials to improve comfort and minimize weight.

Durability

Quality is basic to adidas products. Existing materials have been strengthened and improved, while new materials have been developed to better resist abrasion and wear longer. Construction features like vamp stitching, riveting, toe bumpers, and toe overlays contribute to shoes that last.

In textiles, triple-needle stitching and flatlock seams combine to improve durability. Extra heavyweight fabrications in jerseys, fleece, and cotton have been tested for low shrinkage and strength.

Das Ziel von adidas Equipment ist einfach und unveränderlich: die besten Produkte für den Sport herzustellen. Jedes Produkt ist so gestaltet, daß es den grundlegenden Ansprüchen des Sportler nach Schutz, Bequemlichkeit, Qualität und Leistung gerecht wird. Das zugrundeliegende Gestaltungsprinzip ist "form follows function"—d.h., die Gestalt eines Produktes wird durch seinen Verwendungszweck bestimmt. Jedes Detail hat eine funktionelle Bedeutung und einen reellen Nutzen für den Käufer. Nichts wurde hinzugefügt, um lediglich den Preis zu erhöhen oder eine bestimmte Optik zu erreichen. Jede Sportart stellt spezifische Anforderungen. Um diese optimal erfüllen zu können, hat adidas eine Vielzahl von innovativen Konstruktionsmerkmalen entwickelt:

Das adidas-Torsion-System

adidas Torsion erlaubt dem Fuß, sich frei und natürlich zu bewegen und beugt durch die entsprechende Kontrolle der Torsionsbewegung einer Verletzungsgefahr vor. Vorder- und Rückfuß bewegen sich unabhängig voneinander; geradeso wie beim Barfuß laufen. So wird durch die natürliche Beanspruchung von Sehnen und Bändern die Leistungsfähigkeit erhöht und die Gefahr des Umknickens reduziert. Das adidas Torsion System ist ein Ergebnis der fortlaufenden Entwicklungs- und Forschungsarbeit von adidas. Sportlern eine bessere und sicherere Ausübung ihres Sportes zu ermöglichen.

Riemen

Die neu entwickelten Riemen umschließen den Mittelfuß von beiden Seiten und sorgen so für hervorragende Paßform und Stabilität. Damit gewährleisten sie einen verbesserten Schutz und tragen wesentlich zur Leistungssteigerung bei.

Dämpfung

Bei den meisten Sportarten sind Komfort und Dämpfung die wichtigsten Anforderungen an einen Schuh. Ein entscheidendes Merkmal aller adidas Equipment Modelle ist deshalb die hervorragende Dämpfungseigenschaft, insbesondere auf hartem Untergrund. Folgende System-

Torsion Bar
Torsion-Stab
Barre de Torsion

Riemen

adidas.

Equipment.

"AT FIRST, WE HAD SMALL BUDGETS, WHICH MEANT WE COULDN'T USE FAMOUS ATHLETES, SO WE DECIDED TO USE IMAGES OF REAL BUT UNKNOWN ATHLETES WHO LOOKED PASSIONATE BUT WITH A NO-BULLSHIT ATTITUDE."

The design language of Equipment reflected the idea of essential. From the cardboard covered marketing brochure and shoe boxes to the style of the advertising, it was a no bullshit, very honest look. The adidas catalogs and marketing collateral in the years before were garish and full of people who looked like they were getting ready to go to a nightclub rather than compete. Everything under the Equipment banner had to say performance and reflect the idea of "Everything that is essential, and nothing that is not."

To that end, I wanted a look where you'd see a style of photography and know right away it was Equipment. At first, we had small budgets, which meant we couldn't use famous athletes, so we decided to use images of real but unknown athletes who looked passionate but with a no-bullshit attitude. There was a *Sports Illustrated* photographer I had used at Nike, Brian Lanker. He was great at getting the emotion out of an athlete, which was exactly what I wanted. He was also kind of ruthless.

There was a photo shoot where the scene was some guys rebounding for a basketball. Brian was ordering them to endlessly rebound and finally after an hour of them being into it, he looked at me and said, **"Don't say anything. Just be calm."** Then he pulled out a roll of film and put it in the camera. **He'd had no film in the camera for more than an hour. But when he did start shooting, it meant the results were very real, to say the least. By the time they were done after an hour and a half of this thing, it looked damned authentic. Perfect for Equipment.**

Another time, he was shooting an Irish amateur rugby team, and he was hosing them down to create fake rain. He had them scrumming and scrumming. Finally, at the point of exhaustion, Brian said, "One more, just one more." As a team, they turned around and mooned him. When Nike opened an office in Frankfurt, I wanted to use the shot and put it on a billboard in the airport so that whenever the Nike guys arrived, they'd see it with the line, "adidas welcomes Nike to Europe." Naturally, the comms guys wouldn't let me though.

Opposite and following: Examples of photography from Equipment catalogs 1991–1994

Soccer.

Equipment.

Adventure.

Equipment.

Tennis.

Equipment.

Running.

Equipment.

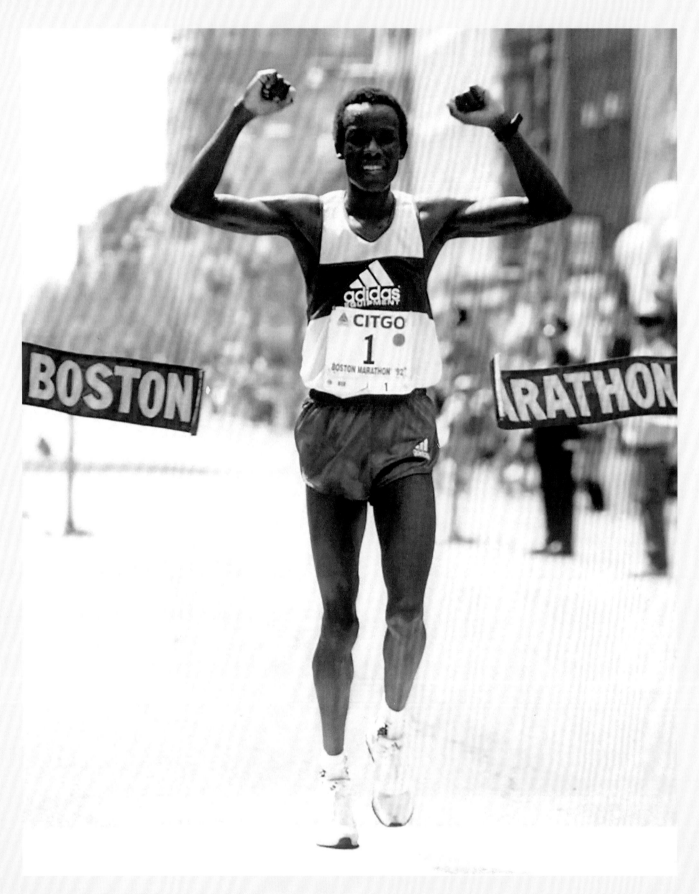

Ibrahim Hussein winning the 1991 Boston Marathon in Equipment apparel

The first time I met Peter was when Rob Strasser asked me to be director of development for Running. He said he wanted me to be the center of running culture at adidas, which meant he wanted me to deal with athletes and make adidas a running brand, not a track and field brand.

At first, Peter was this mysterious character who didn't say much, but I discovered the way you really got to know him was over a glass of red wine. The first thing we worked on together was the launch of Equipment in the United States. We wanted to paint Boston green. At the 1991 Boston Marathon, Ibrahim Hussein was our guy. So over two and half months we put together a racing uniform for him. We made 2,000 jackets for the race in green, black, and white. There were only about 8,000 runners in total at the time, but they were all gone in a day and a half. The support crew all wore Equipment jackets, so Equipment green was everywhere. Ibrahim's winning the race in Equipment really launched it there, and he did the same thing again in '92. **In those days, the idea of taking over a town like Boston for the whole weekend just didn't happen. I can remember the excitement of both Peter and Rob. Everyone was blown away by their vision.**

A few years later in '94, there was a big 15K race in Portland called the River City Classic. Peter came over to me and asked, "What do you think of this idea? **You know how they have the blue line at the New York City Marathon and the runners follow the line? How about we put the 3-Stripes down? Three blue lines through the race course in Downtown Portland?**" And I said, "Sounds good, but how you gonna get the paint off?" He replied, "Oh, it's a special paint. It'll come off in a couple of days. You know how it rains in Portland."

So we put down 15 kilometers—that's more than 9 miles—of 3-Stripes through the city of Portland. Six weeks later, they were still there. The newspapers were complaining of motorists getting confused by them, so we had to get one of these cleaning trucks to remove the whole 9 miles of these 3-Stripes off the street. So, in actual fact, this special paint Peter was talking about wasn't special at all. It was just ordinary paint, but it was the best advertisement for adidas you could make in Portland, literally painting the town with 3-Stripes!"

ADRIAN LEEK FMR VP CREATION CENTER NORTH AMERICA, ADIDAS

The adidas 3-Stripes that refused to wash away from the streets of Portland

Rob used to use the term "rudderless" to describe adidas before Equipment. They certainly had the engine, but they were all over the place in terms of direction. I can't say Equipment was a 100% success in terms of a product range but, as a philosophy and set of principles, it gave adidas the rudder it needed and a model it could build on to get back to where it needed to be.

As we discovered, part of the problem was not just that adidas had not only forgotten where it had come from but also forgotten it was a sports company. **It had a lot of guys who knew about shoes and apparel, but it had fewer who knew about sports.** We wanted adidas to be a true sports brand, so the solution was to split the company into units based on sport. So we had Tennis, Running, Basketball, etc., and we called those "businesses," because that's what they really were. You were in the business of tennis, the business of basketball, the business of soccer. **Now, if you put a business man in charge of all these sports, the results aren't nearly as good as if you put a guy in there who maybe doesn't know much about business but knows everything else about sports. So the business unit managers we put in charge really knew what the heart and soul of their sport was.**

Not everyone believed in Equipment but, for the most part, it worked. With the exception of perhaps basketball, Equipment made adidas a player again in most of the sports in which it had lost ground—not just through better products but, through better definition of why people should buy them. They were the same reasons they'd bought them when Adi Dassler was making them, which adidas had forgotten about.

That's not to say there weren't still problems, but the difference was that there were principles and directions put in place through Equipment that everyone could follow to find solutions to problems. Eventually, Equipment as a separate business unit ceased to be and it was absorbed into all the others, with Equipment products becoming the flagship of each sport category.

When you really boil it down, all Rob and I did with Equipment was remind adidas who they were and that what had made Adi successful back then could make adidas successful today. If nothing else, Equipment gave adidas back its purpose and mission.

"ALL ROB AND I DID WITH EQUIPMENT WAS REMIND ADIDAS WHO THEY WERE AND THAT WHAT HAD MADE ADI SUCCESSFUL BACK THEN COULD MAKE ADIDAS SUCCESSFUL TODAY."

adidas Welcomes Nike To Europe

The welcome poster that never happened, featuring photographer Brian Lanker's "moon" shot

Sean Wotherspoon's colorful take on the Equipment Support '93 (2022)

Fans hold up their adidas Superstars during a Run-DMC concert at Madison Square Garden

THE PAST BECOMES THE FUTURE

ADIDAS ORIGINALS 1991

I WAS PRETTY CONFIDENT that Equipment would be a success. Rob felt it would be too, but he also felt that it wasn't going to be big enough of a success to deliver the immediate revenue that we needed. We needed a cash cow.

When Rob and I first came to Herzogenaurach and looked around the archive, we realized that, at that moment, adidas' best was in its past. It had these incredible shoes that had been the best sports shoes of their day, but now kids were wearing them on the streets as everyday fashion.

Many of them were still made of hard or corrected leather, and they used that because support-wise and functionally they were better, but these shoes were no longer used for sports. They were casual shoes. Run-DMC was the perfect example of what had happened. They had taken a basketball shoe—the shell toe—and turned it into a street shoe. They sold the hell out of them.

So Rob said, "You know, there are still kids in America running around with these shoes on. We ought to remake them and make them more comfortable, make them in softer leathers, and introduce like three at a time every quarter we would introduce three new 'Originals.'"

It made sense because all the patterns and tooling already existed (or so we thought). We knew there were people out there who still loved the shoes, and we would make them softer and more comfortable. It didn't turn out to be quite as easy as that because, for some of the shoes, we couldn't find the molds and patterns. People had thought when the shoe was done, it was done, so they stored them who knew where, or even got rid of them. But it became very important, so we had them search for them or remake them.

Opposite: Darryl "DMC" McDaniels, Jam Master J, and Joseph "Run" Simmons of Run-DMC sporting adidas Superstars

"RUN-DMC WAS THE PERFECT EXAMPLE OF WHAT HAD HAPPENED. THEY'D TAKEN A BASKETBALL SHOE—THE SHELL TOE—AND TURNED IT INTO A STREET SHOE. THEY SOLD THE HELL OUT OF THEM."

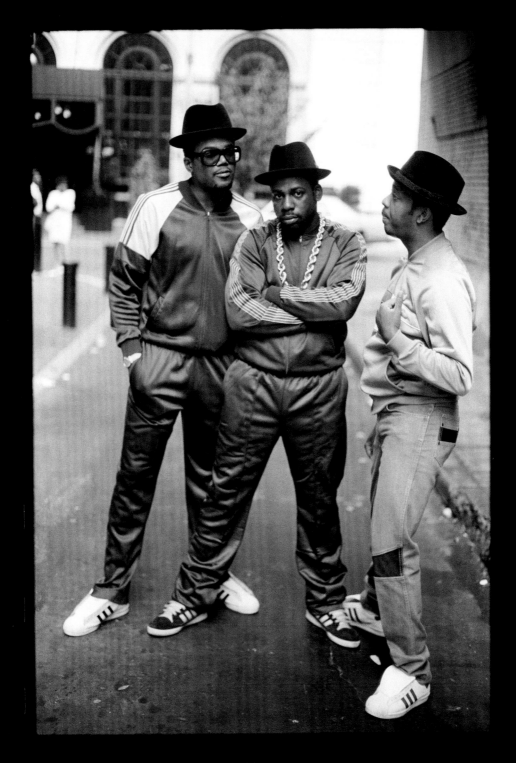

King DMC is 3 Stripes for life!
Peter Moore creatively always reps it right!
My Adidas walked through concert doors
I represent My Adidas like Peter Moore!
Subs and tweeters me and My Adidas
I take the stage in My Adidas with a passion like Peter's!!!

DARRYL MCDANIELS RUN-DMC

Stan Smith

Pro Model

Superstar

Country

Gazelle

Samba

"ORIGINALS WAS AS MUCH RESPONSIBLE FOR THE TURNAROUND OF ADIDAS AS EQUIPMENT WAS. THE PAST BECAME THE FUTURE."

We did five or six shoes in the first range. **They were all what Rob called, "Get laid shoes." The Country, Stan Smith, Superstar, Samba, and Gazelle.** The important thing was that while we wanted to make them more comfortable to wear, we had to retain the character that made them appeal to people in the first place. So externally, the changes were fairly minimal. We changed the tongue logos on some of them to show that something new was going on, but it was a relatively small alteration.

It was a success, far more immediate in America than Equipment was, and a huge success in Europe as well. It certainly wasn't in our imagination that it would be that big or would end up becoming its own division, but, importantly at that time, it was an instant way to gain sales, which is what adidas needed at that time to help build Equipment and fuel the whole changeover within the company. So the truth is Originals was as much responsible for the turnaround of adidas as Equipment was. The past became the future.

Signed Originals era Stan Smith

When Peter Moore and Rob Strasser came to adidas, part of their plan to revive adidas was the concept of Originals. During their first trip to Herzogenaurach, when they visited the company museum, they were astonished to see the story of the company laid out before them in the form of many of its greatest shoes—some of them made by Adi Dassler himself. They realized they had been part of some of the greatest moments in sporting history and that they had once been loved and worn by millions. It was time to bring them back.

Named Originals, Rob and Peter's idea was to create a collection of adidas shoes that had once been state of the art sports shoes but had now since been adopted as modern streetwear classics. While it wasn't the first time that we had brought back popular shoes, the difference with Originals was that they would be updated to modern standards of comfort.

The first time they spoke about it was during a meeting they called on Corpus Christi in June. In those days, religious holidays were usually strictly observed in Germany, so for them to call a meeting on a holiday wasn't exactly well received. But as we would discover, the more we worked with them, **we learned to Rob and Peter rules and traditions were there to be broken or swept aside.** In the meeting room were adidas classics that it was felt could potentially be the start of the Originals lineup. For a shoe to considered an Original, it had to have sporting origins, be a proven success in the past, and be fairly easy for us to update. Peter's and Rob's example from their time at Nike was the Cortez. It was a running shoe that had been one of Nike's first models and had been designed in the '60s by Nike cofounder Bill Bowerman. Updated over time, it remained a big seller.

With the classic models we looked at, the most important consideration was how we could increase the levels of quality and comfort to meet the needs of the modern day wearer, while also maintaining the same shape and construction. This was especially important because fans of the shoes had grown so familiar with them over time that any significant changes could potentially deter them from purchasing the remakes. The other consideration was that when these shoes were originally made, they were designed to be comfortable for playing sports in, but not necessarily for streetwear. People now had higher expectations. To evolve them into streetwear, we started by looking at how we could increase the padding of the shoe, especially in the tongue and quarter lining. Depending on the shoe, originally they would have been made from PVC, but we changed to spongier or softer materials to increase the feeling of comfort to make the shoe less performance-orientated and more suitable for casual wear.

In some cases, to denote the update to the shoe, we changed the label on the tongue (for example on the Stan Smith). The crude drawing of Stan's face, which had been on the shoe since the '70s, was replaced with a simple textile label with the linear adidas word mark. However, any other changes were kept to a minimum to ensure that the original shape and character of the shoe was not lost.

The differences from the classic shoes were in the colors that we introduced, which were more fashion-friendly, and in the materials, which included softer and smoother leathers, suede, and, in some cases such as on the Superstar and Pro Model, we introduced a waxy leather. When the range was launched in Fall/Winter 1991, the debut Originals collection included the Stan Smith, Official, Superstar, Samba, Gripper, Marathon Trainer, and VIP. To make them distinct, the Originals line was sold in its own style of box in naked cardboard wrapped with black 3-Stripes.

We were pretty sure Originals would be a success and, in some markets, it proved even more successful than Equipment. But I doubt even Peter and Rob could have envisioned it would eventually become an entire division of adidas.

JACQUES CHASSAING FMR HEAD OF FOOTWEAR DESIGN, ADIDAS

1991 Originals launch catalog featuring Stan Smith on the cover

When we came up with Originals, we tried to put the Performance logo on them and, frankly, they looked like stepchildren. So the Trefoil lived again and never went away. The argument over the replacement of the Trefoil with the Performance logo still rages to this day and probably always will. I thought people wouldn't care, but it turned out I was wrong. Very wrong. It was like trying to remove the icon of a religious movement. I know there are die-hards out there who won't wear anything adidas that doesn't have the Trefoil on it. To them, I'll always be the guy who tried to kill the Trefoil, but you know what? I'm also the guy who brought it back.

"I'LL ALWAYS BE THE GUY WHO TRIED TO KILL THE TREFOIL, BUT YOU KNOW WHAT? I'M ALSO THE GUY WHO BROUGHT IT BACK."

adidas Originals

adidas Equipment will be complemented by adidas Originals.

These were the leading sport shoes of their time. They were the adidas Equipment of the 60's and 70's, just as adidas Equipment today will generate the originals of the year 2000. Originals will remind retailers of our heritage of innovation.

But the one constant in the world is change. Let us manage change to our advantage, not just pretend it doesn't happen.

1. Profile of an Original

 A. Still look like real sport shoes, but they've evolved into shoes worn for street-wear.

 B. Generated big volume over a long period of time in at least one major market.

 C. Simple, clean styles.

 D. Lower quality today than when they were introduced.

 E. Volume price points.

2. The First Offering

 The first offering will cover several

different sport silhouettes e.g. tennis; running; basketball; football; training.

 A. Stan Smith (Tennis)

 B. Super Star/Pro (Basketball)

 C. Samba (Football)

 D. Country (Running)

 E. Gazelle (Training)

3. The Job

 A. The questions to ask always are:

 1.) "the thing(s) that make this a street shoe is _____".

 2.) "we could increase sales by _____".

 B. Modernize the quality, comfort, materials, features and design/branding details.

 C. The model for success is the job that Nike has done with the 20 year-old Cortez.

 D. The danger to avoid is in changing the character of the shoe that has created a long run on demand.

4. The Issues

 Comfort
 Materials
 Features
 Design Details
 Sourcing

5. The Test

 Easy. Build samples, look at them and show people. If we like it, we do it.

 An argument that says "don't change a winner" is not enough to stop development.

6. Launch

 adidas Originals will be launched as a compliment to adidas Equipment. Originals will have special packaging and merchandising support, but no advertising support. In addition to increased sales from improved product, a focus on adidas originals will remind retailers of the company's heritage of innovation.

First memo that led to the birth of adidas Originals

Almost 25 years since it was born, does Originals still mean the same thing to people? I guess it goes in cycles. You can't hold on to something. There's no point. Culture changes, values change, perspectives change, and they should. And you see it with the brand. The moment that Peter came into adidas, for example, the brand had years of not having much competition and then suddenly had massive competition. It lost its way and tried to do too many things. And two guys came in and just said, "You know what to do, you're just not doing it," and they recentered the brand with Equipment and the first Originals collection.

Then in 1999 and 2000, when Originals was relaunched, it felt like another pioneering moment when all these things are going on in the world, but we said, "If we're true to ourselves, then we can do Originals, we can do fashion, we can do sport, and we won't compromise our brand because we'll be true to ourselves in all of those arenas." I think we did it very well.

From 1997 to 1998, through to about 2003, you had two mindsets. One was super high-tech expensive running sneakers, and the other was thrifting Gazelles, Sambas, and Superstars. Those two trains of thought were happening at the same time, which was really interesting. So, if you look at running products from adidas from the early 2000s, it was getting as many super futuristic technologies as you could on to the shoe. And then on the other hand, you had these super basic memories coming from Originals. There was something about the archive of adidas, which was just inseparable from music culture of the '70s through to late '90s. It was authentic in fashion and what we started through collaboration. So Originals was 100% about the archive and its connection to culture. But then somewhere along the lines, we got success, we got a bit fuzzy, and then we needed to pull back again. And the next time we really pulled back was in 2014 and 2015, and we really recentered. Again, we had that amazing moment.

For me, 2014 felt like 1999 and 2000 again: amazing moments of confidence and anything was possible. These are the moments I've enjoyed the most of the brand. And right now, it feels like that again, where you have that moment to reset and say, **"You know what? The world has changed, and culture has changed, but culture wants us to be authentic and true to our brand. They don't, however, want us to sit in the past."** Look at Samba right now. It's right that a new generation is making it its own. We can't hold on to it in our own particular favorite moments of our youth, because otherwise you have to hold it where it came from on the day it was drawn. So I think it's good that these things reinvent, but it's always this recentering back to who we are as a brand. That's what Peter taught us the first time around, and I've seen moments of that happen again. I very much believe now is one of those moments when it's not so much what someone did, but what their mindset was that is so important. I don't think Peter would really want us to be dwelling on the past. I think he would want us to be confident about the brand's future, and that's how I always interpret that mindset.

NIC GALWAY SVP CREATIVE DIRECTION, ADIDAS

Opposite: adidas Originals x Humanrace Samba

Original artwork by Peter Moore of Steel Bridge, one of the twelve connecting west and east Portland

THE NEW WORLD

ADIDAS AMERICA 1993

TO MAKE EQUIPMENT a reality, Rob and I realized that trying to do things from Sports Inc. in Portland was never going to be realistic, so Rob moved to Germany temporarily to oversee the project while I flew to Germany every month to work with the adidas designers, developers, and marketing people. It quickly became clear to us that, although our focus was on Equipment, we would have to effect change throughout the company if we were to get adidas back on its feet and have our influence spread beyond just the Equipment project.

It didn't help that the ownership of the company was also uncertain as several potential buyers emerged, meaning we could never be sure who would ultimately be driving the thing and if they would share our vision for the future. That didn't dampen our enthusiasm though. There was a point where Rob and I realized we had become more adidas than Sports Inc. It felt like home. We felt so strongly about the brand that it had become all-consuming. Rob and I were increasingly involved in making major decisions, from the creation of sports-based business units to the future home of the company (the latter being whether the company should stay in Herzogenaurach or move to a major city).

The thing you have to understand about Herzo is it's basically a little town in the middle of nowhere that just happens to have three of Germany's most famous companies in it: adidas, Puma and Schaeffler, a car parts manufacturer. Getting there used to be a nightmare because it's miles away from a major city. Only Nuremberg is close by. So the question was if adidas really had global ambitions, did its future lie in a glorified village? Adding to the problem was that the company was effectively split between Herzo and Landersheim in France, where Horst Dassler had run adidas France, and the two operations were effectively in competition with each other. It didn't make sense.

We hired a firm called Fuchslocher to look at the benefits of moving—not just to a bigger city in Germany, but perhaps even to another country. They looked at Barcelona, Frankfurt, Paris, Milan, and even New York. **But after a lot of debate and arguments, the only sensible decision was to stay right where we were. Sure, Herzo was Nowheresville, but it was where Adi Dassler had started the company, which meant something special. Our advantage was in our heritage, so it made no sense to move away from the place that heritage came from.**

With Equipment and the ensuing organizational changes beginning to have a positive effect, the adidas management made Rob and me an offer we couldn't refuse: to buy Sports Inc. and merge it into its US and Canadian operations. For us, it was the ideal situation because it would allow us to continue to play a key role in the global future of adidas while also focusing on the US market.

Opposite: Map of Herzogenaurach from the 1949 adidas catalog

"THERE WAS A POINT WHERE ROB AND I REALIZED WE HAD BECOME MORE ADIDAS THAN SPORTS INC... WE FELT SO STRONGLY ABOUT THE BRAND THAT IT HAD BECOME ALL-CONSUMING."

Adolf Dassler Spezial-Sportschuhfabrik HERZOGENAURACH am Bahnhof

The adidas America office in North East Portland

As we learned with the potential relocation of the adidas headquarters, where you are in the world has a huge effect on your business and, more importantly, your culture. At the time, adidas's US operations were located in Warren, New Jersey, and in Spartanburg, South Carolina. Neither of those locations was beneficial or even desirable. They were just there. So we started with the fact that adidas was talking to two guys who came from Nike, and that was in Portland, Oregon. **Portland was already becoming the hub of the US athletic footwear industry, which meant it had great access to talent. It was also five hours closer to Asia, compared to the East Coast. So Portland became the home of adidas America.** Admittedly, part of the reason was entirely selfish but, even more so, it just made sense from a business point of view.

The next question was where in the city we should be. Dividing the city east to west is the Willamette River. Nike was in the west, so we decided to be in the east. Much like how adidas and Puma used to be separated by the river in Herzogenaurach, we had the same thing in Portland. The other reason was that to me adidas belonged in the blue collar Northeast because Adi Dassler was a blue collar kind of guy. Nike was in the West, where all the money is. They were show time, and we certainly weren't that, so the Northeast was where we settled.

In the United States, adidas had a lot of people but no sales of any significance. The problem was they were trying to operate as a big company, like they were in Europe. But they weren't one, so we refused to treat it like one. **Instead, we decided to treat it like a start-up, not a famous old brand because, in America, adidas was nothing.** It was forgotten. If it hadn't been for Run-DMC, I doubt they would even be in the US. There were losing money left, right, and center. $20 million a year. **You can't have everyone in luxury offices when you're losing that kind of money, so instead we had a very unglamorous industrial office. The only luxury, if you could call it that, was a basketball court. We were a sports company so of course, we should have a basketball court.** And besides, it rains a lot in Portland, so it had to be indoors.

It was incredibly important to us that every person who worked at adidas America should feel that it wasn't just a job but a crusade. We wanted to show the world that a once-great brand could be great once again by doing the right things and by caring. Rob and I were able to bring together a team of some of the brightest marketing, design, and development people from around the world. Everyone was given a chance to see how good they could be, and most of them proved to be world class. Many of them are still in the industry today. The kind of culture we created was like nothing else. A prime example was the Saturday classes, a kind of academy our design team ran. We went out into the neighborhood of North Portland, a primarily Black community, and we brought kids in who were interested in being shoe designers and taught them the fundamentals of the shoe design businesses. There are about five of those kids still in the industry today.

"IT WAS INCREDIBLY IMPORTANT TO US THAT EVERY PERSON WHO WORKED AT ADIDAS AMERICA SHOULD FEEL THAT IT WASN'T JUST A JOB, BUT A CRUSADE."

The passion, drive, and culture we had at adidas America immediately began to make a difference and, after our second season, sales in North America jumped by 75%. But just when we thought the future looked bright, both the company and I were dealt a crushing blow when Rob suffered a fatal heart attack after a sales conference in Germany.

I still have a tough time talking about Rob. It's an emotional thing. We'd achieved crazy things together. Despite being very different people, somehow it just worked. We did have a lot in common, but we saw a lot of things very differently, which Rob respected because I wasn't coming from the perspective of an accountant or a lawyer. I came from a creative view which meant there was an unpredictability that he appreciated. I was also one of the few people who wasn't afraid of him. I could get nasty if I needed to defend my point of view, which meant we could get into a lot of arguments, but it was never personal. We could have a real screaming match, and then two seconds later go for a burger and beer together.

What made Rob special was that he loved solutions that weren't the obvious solutions, or obvious solutions delivered in an unusual way. **He hated normal. I used to tell him I was a problem solver, not a designer. Which is a good excuse for being a shitty designer. He wanted us to continue doing things outside the box. Jordan and Air were completely outside the box. He wanted to keep good ideas away from committees, and put dynamic teams together and literally tell them, "Just do it."** He always used to say, "Can't a guy be a guy?" He didn't want to be important or the president. He just wanted to be the person in the middle making things happen. He had such a magnetic personality. People were drawn to him. But when he got pissed, you knew about it. He became 400 pounds of anger. People left the room and ran. It meant people thought he was a monster. He didn't get the nickname "Rolling Thunder" for nothing, but when you got to know him, he was really a teddy bear.

People still ask me why Rob left Nike. To this day, I don't really know. He had tremendous loyalty to Phil Knight but, after they got to a loggerheads point, Phil was worried about Rob becoming bigger than he was. Yet all his life at Nike, all Rob wanted to do was make Phil king of the castle. Even after we had started at adidas, if Phil had called him and said "Rob, Nike is in trouble. I need you back," he would have been on the very next flight to Portland.

The fact Rob died of a heart attack at just 46 years old was, frankly, not a big surprise. He was a big guy and didn't take care of himself. But for all his slobbery, and as frumpy and grumpy as he was, he was a brilliant marketer and an even better guy. It was his life, and he led it his way. After he passed, I was appointed CEO of adidas America. The reality was I just wasn't CEO material, not the way Rob was. As creative director, I was confident to make creative decisions—to say yes when it was right, or no when it wasn't. But as a CEO, your job is to be a mediator, a person who makes others come to agreement. You're not really making decisions or directing anything. Within days of becoming CEO, I had people coming to see me about their personal issues. What the hell did I know about helping people with their marriages or relationships?! Two years after accepting the position, I stood down and returned to focusing on being adidas's creative director.

"WHAT MADE ROB SPECIAL WAS THAT HE LOVED SOLUTIONS THAT WEREN'T THE OBVIOUS SOLUTIONS, OR OBVIOUS SOLUTIONS DELIVERED IN AN UNUSUAL WAY. HE HATED NORMAL."

Drawing of Rob Strasser (1947–1993) by Peter Moore

DENIM AND
HOT DOGS

TEAM USA FIFA WORLD CUP 1994

AS A CREATIVE PERSON, what gets you up in the morning is reaction. In my world, if you have a strong reaction, that's a positive. They're awake and paying attention. There was and is so much bland, price point product in the market that I think people are numb from it all, and so it's hard to get their attention. With the shirt we did for the US soccer team in '94, people had a strong reaction.

The design process was not as you might imagine. What went on in those days was almost senseless. We shot from the hip very often, but so did the industry. It was much more like, **"Hey I have an idea, let's be American, let's not try to be European,** or whatever we think real football (soccer) looks like, let's just be American." **That became the direction. Then what does that mean? What's an American fabric? Denim. Great, let's do denim**—but really you can't do real cotton denim, it will be too heavy and not very functional which would be against the adidas brand. Therefore, let's make a shirt and shorts that looks like denim. American kids running around in denim, what could be more American—you could even have them eat hot dogs.

That covered one shirt, but that wasn't enough so we had other shirts, at least one with wavy red stripes. It was like "Dress them in the flag." Once we had the safe option, we did some drawings and laid stars on shirts and distorted them on the Xerox machines by dragging them across the glass as it was scanning. Remember, in '93 computer graphics were not really in existence, at least not in Portland, Oregon. In other words we had to get our hands dirty.

Opposite: US team forward Eric Wynalda celebrating his goal against Switzerland in the 1994 World Cup

"AMERICAN KIDS RUNNING AROUND IN DENIM, WHAT COULD BE MORE AMERICAN— YOU COULD EVEN HAVE THEM EAT HOT DOGS."

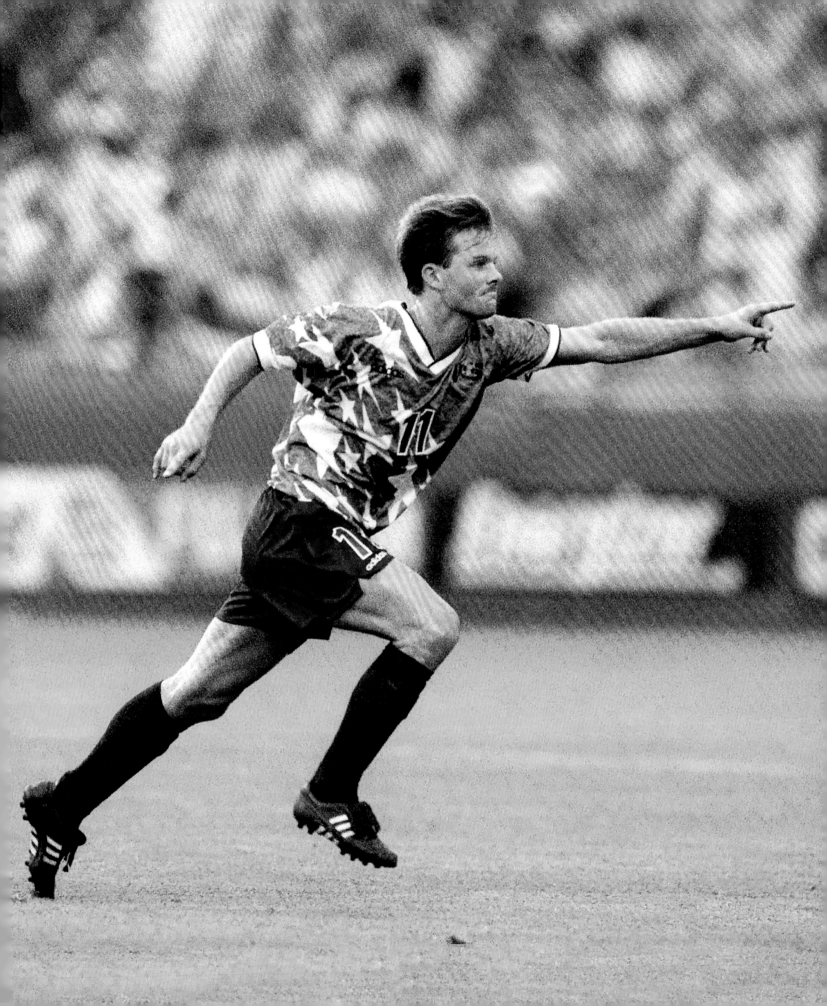

"I COULDN'T CARE LESS WHAT THE ORGANIZATION THOUGHT, I CARED A LOT MORE ABOUT WHAT THE PLAYERS THOUGHT, WHAT THEY REALLY LIKED AND DIDN'T LIKE."

I think the team was pretty much split on the shirts. I believe Alexi (Lalas) liked the denim, but he was kind of a denim guy as I recall. We did a poster of him that was kind of a Grateful Dead look, he was perfect for it. I think the organization was okay with it, but they also knew that they were going to jump from adidas to Nike right after the Cup, so they really were not looking to give us any issues.

I have a feeling that many inside the organization didn't like the shirt because it was not European, and they had a bad case of "European wannabe" in those days. Today, everybody looks the same and you can hardly tell which country is which country.

The main thing about the uniforms were they worked, they were a bit ahead of their time, which might have caused some issues, but not many. As for me, I couldn't care less what the organization thought, I cared a lot more about what the players thought, what they really liked and didn't like, but they were not easy to get to. American bureaucracy even in football (soccer), even in 1994. I am sure it hasn't gotten better.

My opinion about the shirt today is even more positive than it was then. My reasons are simple, and they are the same reasons why we did it in the first place: **it's American. Who else could, or would do a shirt that looked like it was a pair of 501 jeans? Who else would put distorted stars, caused by the speed of the guy wearing the shirt, on a distorted blue field?** Or was that a play on the American Flag? That's up to the viewer, I merely designed the thing.

Opposite and following: Defender Alexi Lalas, who was almost as well known for his music as he was for soccer

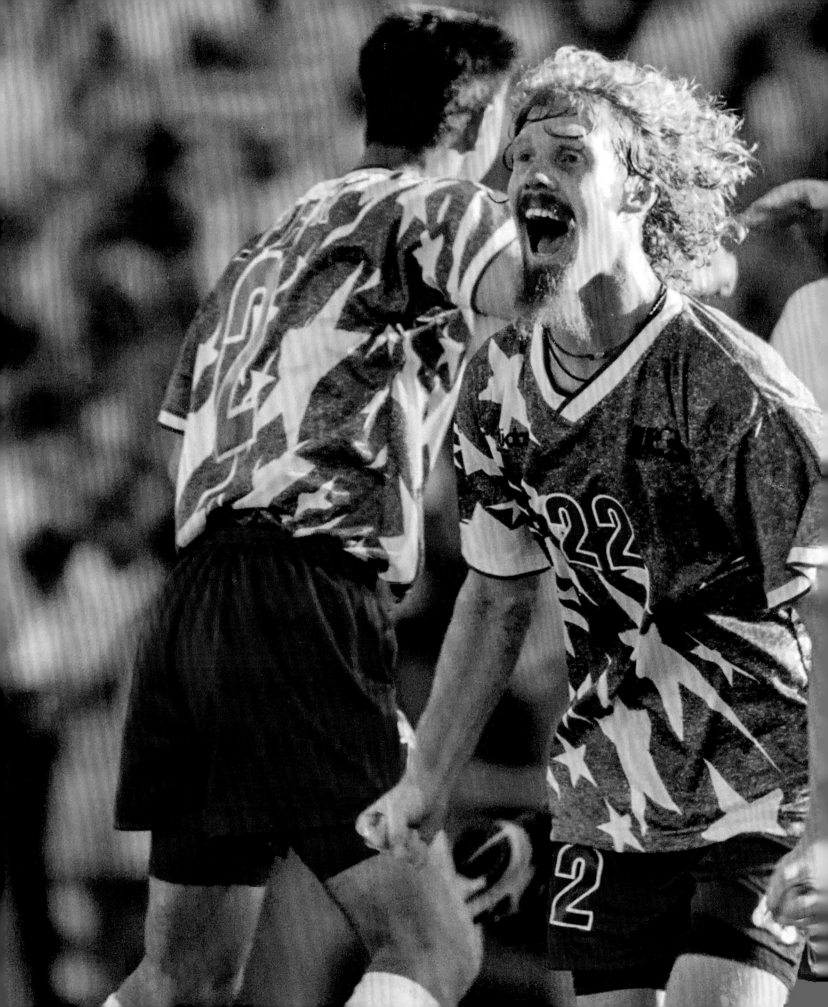

The Feet You Wear logo design by Peter Moore, affectionately known as "Freddy"

LET THE FOOT BE A FOOT

FEET YOU WEAR 1996–2001

D R. SIMON LÜTHI, who was then the head of the research lab at adidas, came to me with this very peculiar-looking shoe model. He said a guy had approached him with an idea about how shoes should be built. Back then, we used to get hundreds of those kind approaches, so I asked Simon what was different about this one. He said, **"Because it's not about the shoe; it's all about the foot."** And when he explained a little bit more about the concept, it really got me thinking. I said to him, "Do whatever you have to sign this guy up, and then let's start developing this thing."

The guy turned out to be this real character by the name of Frampton Ellis. His idea was to create a shoe based on the anatomy of the human foot. When you look at them, your feet are pretty remarkable. They're the oddest-looking things in the world, but they're one of the finest examples of biomechanical engineering you'll ever find. It's a fact that most athletes will tell you that they could perform better barefoot, but the realities of training and competition mean they can't due to risk of injury. The essence of Ellis's idea was to create a shoe that replicated the natural movement of human feet. In simple terms, it allowed the foot to act like a foot.

Right: The original Frampton Ellis prototype shoe

"THE ESSENCE OF ELLIS'S IDEA WAS TO CREATE A SHOE THAT REPLICATED THE NATURAL MOVEMENT OF HUMAN FEET. IN SIMPLE TERMS, IT ALLOWED THE FOOT TO ACT LIKE A FOOT."

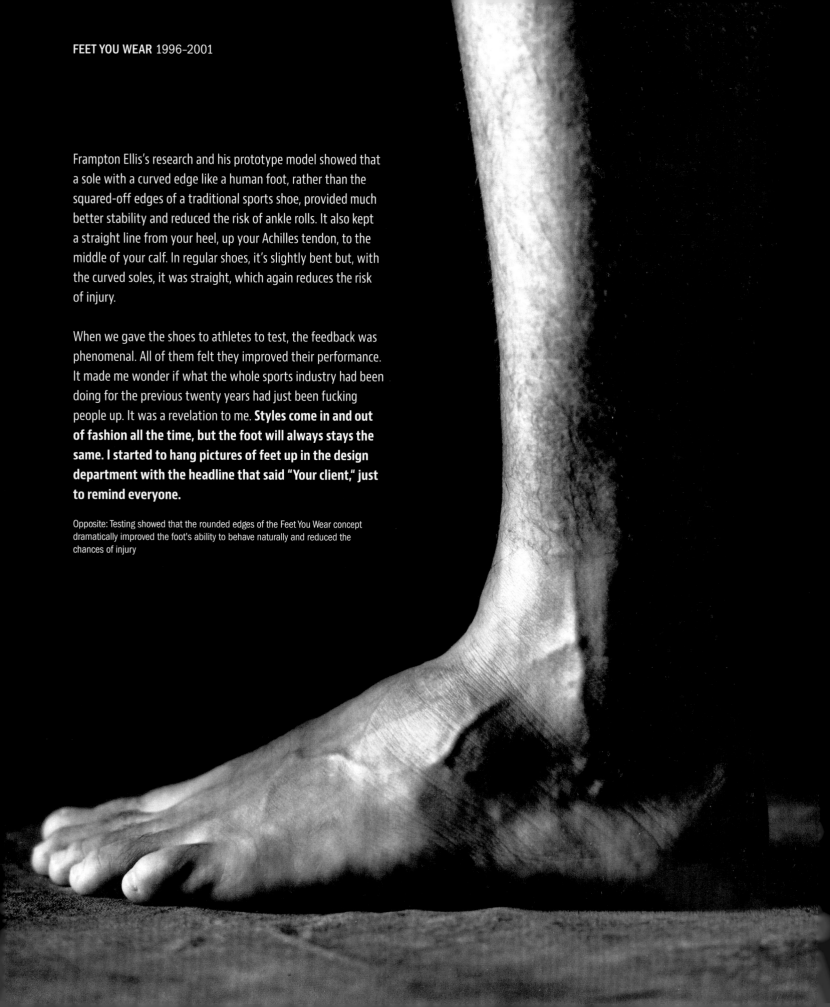

Frampton Ellis's research and his prototype model showed that a sole with a curved edge like a human foot, rather than the squared-off edges of a traditional sports shoe, provided much better stability and reduced the risk of ankle rolls. It also kept a straight line from your heel, up your Achilles tendon, to the middle of your calf. In regular shoes, it's slightly bent but, with the curved soles, it was straight, which again reduces the risk of injury.

When we gave the shoes to athletes to test, the feedback was phenomenal. All of them felt they improved their performance. It made me wonder if what the whole sports industry had been doing for the previous twenty years had just been fucking people up. It was a revelation to me. **Styles come in and out of fashion all the time, but the foot will always stays the same. I started to hang pictures of feet up in the design department with the headline that said "Your client," just to remind everyone.**

Opposite: Testing showed that the rounded edges of the Feet You Wear concept dramatically improved the foot's ability to behave naturally and reduced the chances of injury

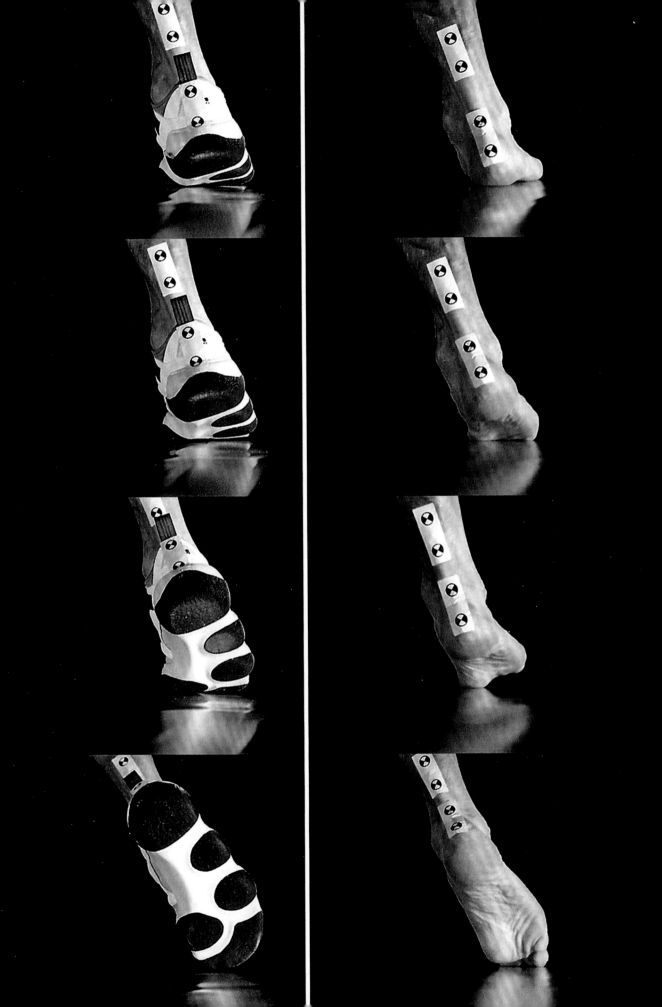

The Equipment Integral tennis shoe was the first Feet You Wear shoe we did. **It was like no other shoe at the time and the perfect example to me of form follows function, fantastic aesthetics being the result of designing for ultimate performance.**

For a lot of shoes and technologies, you have to make up a story to go with it but, for this one, we didn't have to make up a story. The story was what it looked like—namely, the human foot. Hence, the name we came up with, which was at first Barefoot, but it turned out that someone had trademarked it. So after a lot of rounds of trying to come up with something, we finally settled on Feet You Wear.

Equipment Tennis Integral

Equipment Integral.

State of the art tennis shoe. For players who need the quickness and stability provided by barefoot technology. Lightweight at only 395 grams with the adi-wear outsole compound and adiPRENE cushioning inserts.

Equipment Indoor Light.

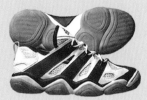

A shoe for the competitive volleyball player who needs stability, cushioning and lightweight performance of barefoot technology. The shoe is also great for court sports such as squash and badminton. Functional stripes attached to speed lacing enhance mid-foot support. adiPRENE in the heel provides cushioning and the ceramic coated toe-cap makes it bulletproof-durable.

Equipment Indoor Stabil.

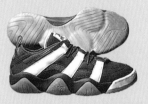

The Handball Spezial of the '90's, for the competitive player who need stability and cushioning for the highest level of the sport. Excellent cushioning via fore and rear-foot adiPRENE inserts. Like the Equipment Indoor Light it has midfoot stability through straps and speed lacing system and durability of the ceramic coated toe cap.

Equipment 40.

For the athlete who needs the support and stability of barefoot technology for training on turf. At only 340 grams it's lightweight and flexible.

Equipment Top Ten 2000.

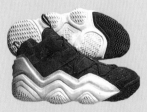

The player's shoe to be worn by Jalen Rose of the Denver Nuggets. As an NBA guard he needs stability and quickness in his shoe. Only barefoot technology can provide both protection and performance in a lightweight package.

Equipment Agility (Claw).

For the hardcore outdoor athlete who is into scrambling and rugged off-trail running and needs a shoe that can grip onto anything that nature dishes out. Barefoot technology maximises grip and stability through adapting to the contours of uneven terrain. The spider tongue provides secure midfoot support.

From the 1996 Feet You Wear launch catalog

Top Ten 2000

Equipment Elevation

Having been in innovation at adidas for many years, when the concept of Feet You Wear came along, it seemed like a very logical direction for us because the idea had always been to let the foot work the way a foot works. It was also a concept that was very much in line with the adidas essence of making what's best for the athlete. So aside from the fact it looked a little strange, it seemed to me a very intuitive concept and made a lot of sense for where we were heading. Lab testing had been very positive too, so it made us all convinced that it had real benefits and could reduce injury and increase performance.

The rounded edges weren't in fact an entirely new concept at adidas. Some of the handball shoes from the '70s and '80s had ribs on corners, and the whole point was to soften the edges to reduce the leverage on your foot and ankle when you're doing lateral movements. We had also worked on a concept we called "Minimal Footwear" in the early '90s which was based around the idea of asking, "What is the absolute minimum I need on my feet to play a sport?" So the idea was something that was already in the adidas lexicon.

The first shoe we did, the EQT Integral, wasn't necessarily the prettiest or the most commercial, but it was probably the purest in terms of being an example of a Feet You Wear shoe. Designers being designers, they naturally wanted to take the original concept and add to it, or put a twist on it to make it their own, but when we did the EQT Elevation, the exercise in my mind was to embrace the original concept 100%—to stick to it without any excuses and see what happened. To that end, we used an anatomic last and made the geometry on the bottom of the shoe faithful to the original concept. If you put it next to Ellis's original prototype, you can see there's direct connection.

As a philosophy for making shoes, it's still pretty damn sound. But as a technology, especially at a time when visible technologies were king, it was a tough sell to the young kid. I always felt that if Reebok or Nike had produced it, it would've blown up. People would have said, "Wow, that's so extreme. So crazy, so cool." But at that time, especially in basketball, when it was coming from us, it just got lost.

One of the modern legacies of Feet You Wear is that it was the first concept that broke the top line of the midsole. The top line was always fairly fixed. Maybe it was undulating, or had a flex groove, but those wrap-up peaks you see on Feet You Wear, was a look that didn't exist before. As designers, we're influenced by everything that we see, especially when it's cool and new, so that was pretty quickly adopted by the other brands to the point it became the status quo in the 2000s. Today those side wall shapes are pretty common, but I'm pretty sure it started with Feet You Wear.

That legacy has been borne out in recent times with young designers with whom worked. They were so attracted to those shoes, especially when we did collabs, because they're very unique. People love to look backwards for inspiration, and Feet You Wear is still stand out. One of the Yeezy shoes used the Feet You Wear outsole. It wasn't even a modern interpretation. It was the original design straight out of the catalog, but the kids thought it was a cool new design. Only us old timers knew it wasn't. It wasn't that long ago that some of our basketball guys were playing with Feet You Wear shapes and forms. They went back into the archive and pulled out the old shoes, reinterpreted and modernized them, and those shoes did really well. That actually put a lot of pressure on the Performance basketball teams because people were asking, "Why aren't you doing cool stuff like this?" It was funny to see it come back around full circle.

As we found, just because it's a great idea doesn't always mean it's going to be a success. The world is filled with great products that just didn't sell. It's just the way it goes. At the time, Feet You Wear just didn't resonate with the consumer, but it remains a great idea.

PAUL GAUDIO FMR GLOBAL CREATIVE DIRECTOR, ADIDAS

CHARACTER
FOR
"BARNS FOOT"
HAPPY FOOT.

PRODUCT
WHERE
MOBBOTS IN
HOTEL.
TOWING.

Opposite and above: The evolution of and final version of "Freddy." Peter Moore's intention was to design a logo that was fun but also visually explained the Feet You Wear concept

"I'LL NEVER STOP SAYING IT, FEET YOU WEAR IS BY FAR THE BEST TECHNOLOGY THAT I EVER WORKED ON."

Feet You Wear had a bright but ultimately short life. There were a lot reasons. Firstly, it was a nightmare to manufacture. It was so ahead of its time that we didn't have the processes available to make it at a reasonable cost, so we had to make compromises, which is never a good place to be coming from. It caused a huge political stink between Portland and Herzo. It didn't help that business types and numbers people had also gotten involved.

There were also big arguments over how to market it, because to sell it you really had to educate the buyer what the benefits were. The problem we had was that our real customers were aged between sixteen and twenty. They aren't patient people. It was hard, so people just wanted to move on to something new and easier to sell. Eventually, it just got left on a shelf, but not before we made some ground-breaking products. **The fact that a lot of our rivals copied it and made it work was proof that it was fundamentally a game changer.** There would have been no Vibram Five Fingers or Nike Free if it weren't for Feet You Wear.

I'll never stop saying it. Feet You Wear is by far the best technology on which I ever worked. Better than Air. Air is just a cushioning device. It came along at a time when everyone in the industry was selling gimmicks, which were great for marketing but really didn't impact performance, only fashion. Feet You Wear was certainly no gimmick. It was based on science, and its legacy can be seen in the fact that if you look at most modern sports shoes, they have rounded edges. **If nothing else, it laid the foundation for the future of sports shoe design.** It's just a shame that we were too ahead of the game with it.

Opposite: Feet You Wear technology was used across multiple sports categories as part of the pinnacle Equipment and Response ranges
Following: Top Ten 2000 advertisement featuring Kobe Bryant (1996)

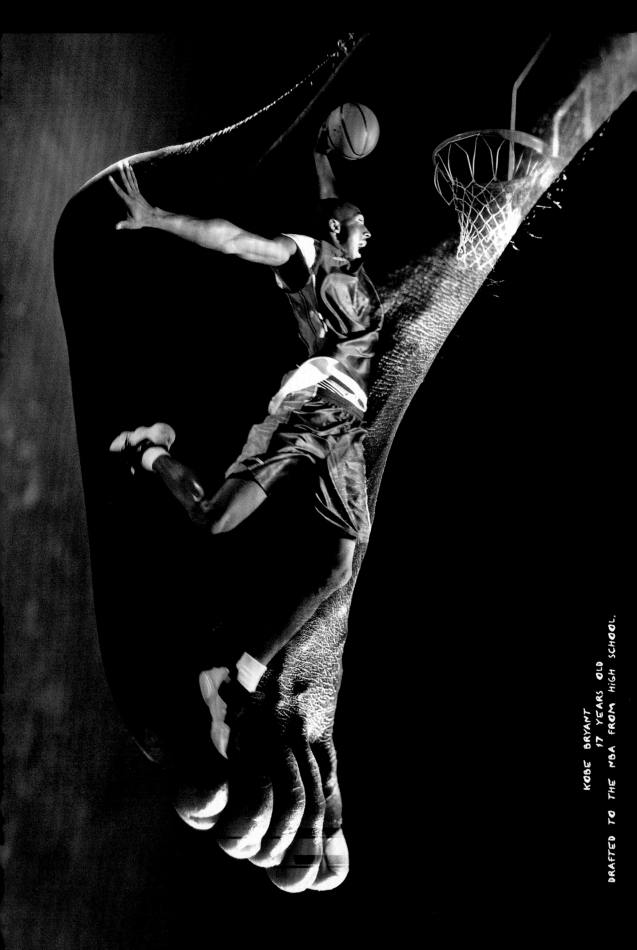

KOBE BRYANT
17 YEARS OLD
DRAFTED TO THE NBA FROM HiGH SCHOOL.

FEET YOU WEAR™

KOBE'S FEET WORK. WE COPIED THEM.

We can't give you Kobe's talent,
but we can give you his feet.
Sort of.

When designing Kobe's shoe, we looked at
his feet. And came to this realization:
the foot is the best
piece of sports equipment ever made.
Which led to a very simple truth.
The closer a shoe design is to the foot,
the better the athlete will perform.

And so we created Feet You Wear.™
A shoe, that is built like your foot,
to work like your foot.

When you jump, the rounded shape and
edge allow your foot to recover stability
when it lands.
And the foot—like sole acts
like your foot to let you cut faster.

Better stability, better agility, better feel.

Which means you perform better.
And, with Kobe Bryant's feet,
who wouldn't?

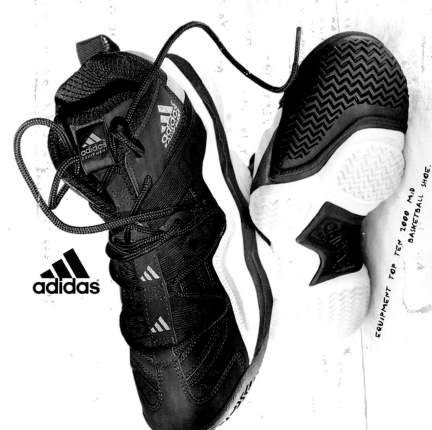

adidas

Equipment Top Ten 2000 Mid
Basketball Shoe.

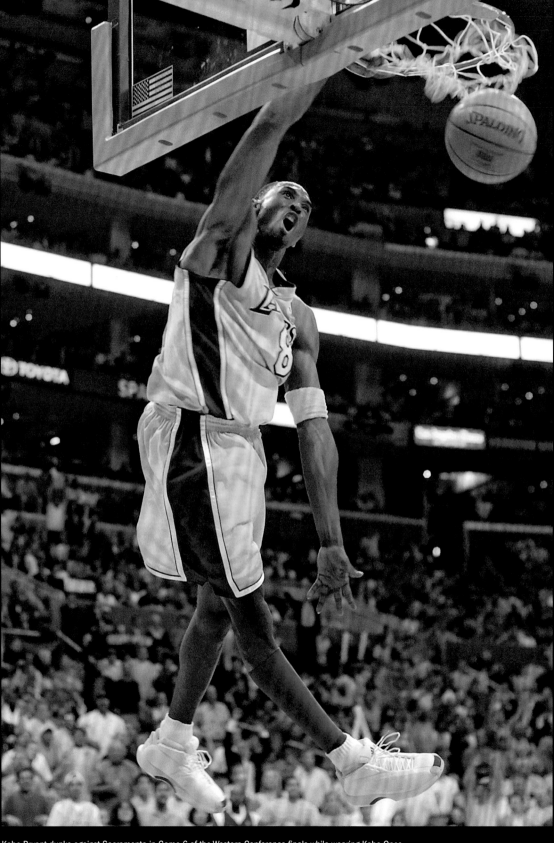

Kobe Bryant dunks against Sacramento in Game 6 of the Western Conference finals while wearing Kobe Ones

CALIFORNIA DREAMIN'

KOBE BRYANT 1996-2002

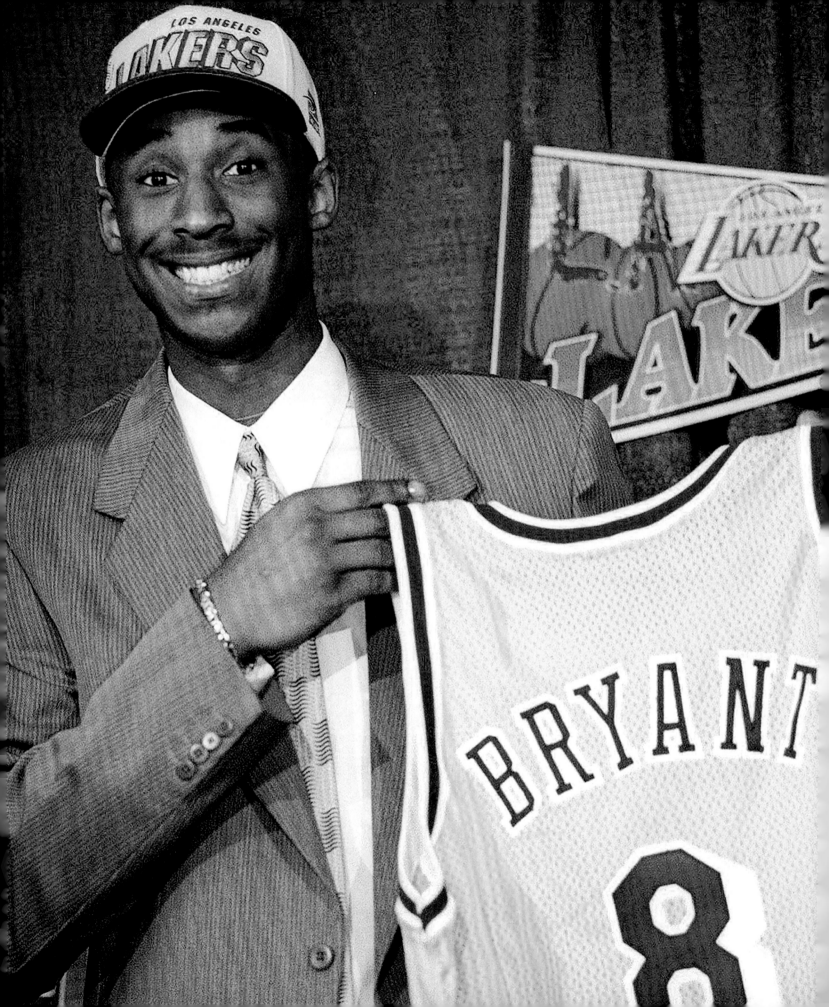

adidas

Date: 16.3.97
To: OWEN C. From: PETER MOORE ROOM FAX IS 716-767-4721
Company: ADIDAS RM 4514
Fax Number: Phone:
Number of Pages (including this cover): 4
Re: FOLLOWING PAGES

541 N.E. 20th Avenue
Suite 207
Portland, Oregon 97232
Telephone 503 230-2920
Fax 503 797-4935

O
PLEASE TYPE THIS UP OR AT LEAST READ THROUGH TO
MAKE SURE IT IS SOMEWHAT UNDERSTANDABLE.
PASS IT ON TO KADIE AND/OR THE APPAREL COMMUNICATIONS
FELLOW (FERDI?) WHO'S IN PORTLAND FROM HERZO, STILL.
KOBE.

THE ADIDAS WORLD IS ABOUT TO MEET KOBE BRYANT.
AMERICA IS JUST FINDING OUT WHAT THE EAST COAST OF AMERICA
HAS KNOWN FOR SOMETIME NOW.
KOBE BRYANT IS VERY, VERY SPECIAL.

FEW PEOPLE BELIEVED THAT A 17 YEAR OLD WOULD BE ABLE
TO SURVIVE THE NBA OF THE 90'S. SURVIVE THE GRUELING
SCHEDULE, PRESSURES OF THE PRESS, THE COACHES, THE GAME,
EVEN TEAMMATES SOME OF WHOM ARE ALMOST TWICE HIS AGE.

SURVIVE.... HOW ABOUT THRIVE...
THE SCHEDULE, THE PRESS, WHICH HE HANDLES LIKE A VETERN.
THE COACHING STAFF WHICH IS TRULY IN AHH, AND TEAM MATES
WHO HAVE ADOPTED "THE KID" AS THEIR OWN.
AS FOR THE GAME... THE NBA GAME IS VERY MUCH TO KOBE'S
LIKING.

WHY IS ALL THIS WORKING?
YES, HE HAS A LIGHTING QUICK FIRST STEP, REMINDING PEOPLE
OF A CERTAIN BULL. YES, HE CAN JUMP OUT OF THE ARENA.
YES, HE HAS RANGE ON HIS JUMP SHOT AND SURE HE'S STILL
GROWING.

BUT, IN TRUTH THERE ARE SEVERAL YOUNGSTERS TODAY THIS MIGHT
DESCRIBE. MAYBE NOT SEVERAL BUT AT LEAST A FEW, AND
MAYBE NOT QUITE SO YOUNG BUT YOUNG NONE THE LESS.
WHAT MAKES KOBE SO SPECIAL... IS KOBE.
THE PERSONALITY, THE KID, THE TRUE SENSE OF FUN AND
PLEASURE IN DOING WHAT HE'S DOING... PLAYING THE GAME
OF BASKETBALL. HE ISN'T AFFRAID TO SHOW IS PLEASURE, HIS
THRILL OF PLAYING AGAINST THE BEST.

MUCH OF THIS IS THE RESULT OF A GREAT FAMILY. A FAMILY
WHICH HAS A GREAT BASKETBALL HERITAGE AND A REAL
RESPECT FOR THE GAME AND FOR PEOPLE.

PUT IT ALL TOGETHER AND YOU HAVE A GREAT ATHLETE, AND A
GREAT KID, AND ADIDAS' CHANCE TO HAVE THE NEXT
TRULY MEANINGFUL STAR IN THE GAME OF BASKETBALL.

Right: Fax from Peter Moore
sharing his excitement
about Kobe Bryant
Opposite: Kobe jokes with
the media after his trade
to the Lakers on draft day
(1996)

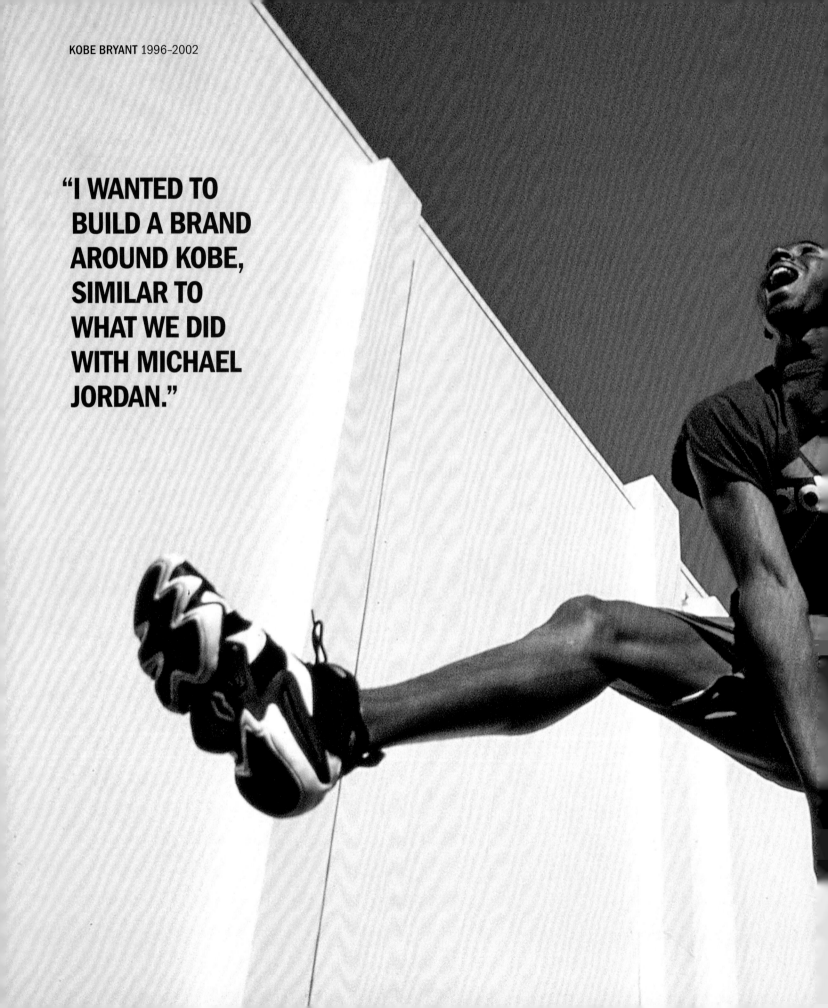

"I WANTED TO BUILD A BRAND AROUND KOBE, SIMILAR TO WHAT WE DID WITH MICHAEL JORDAN."

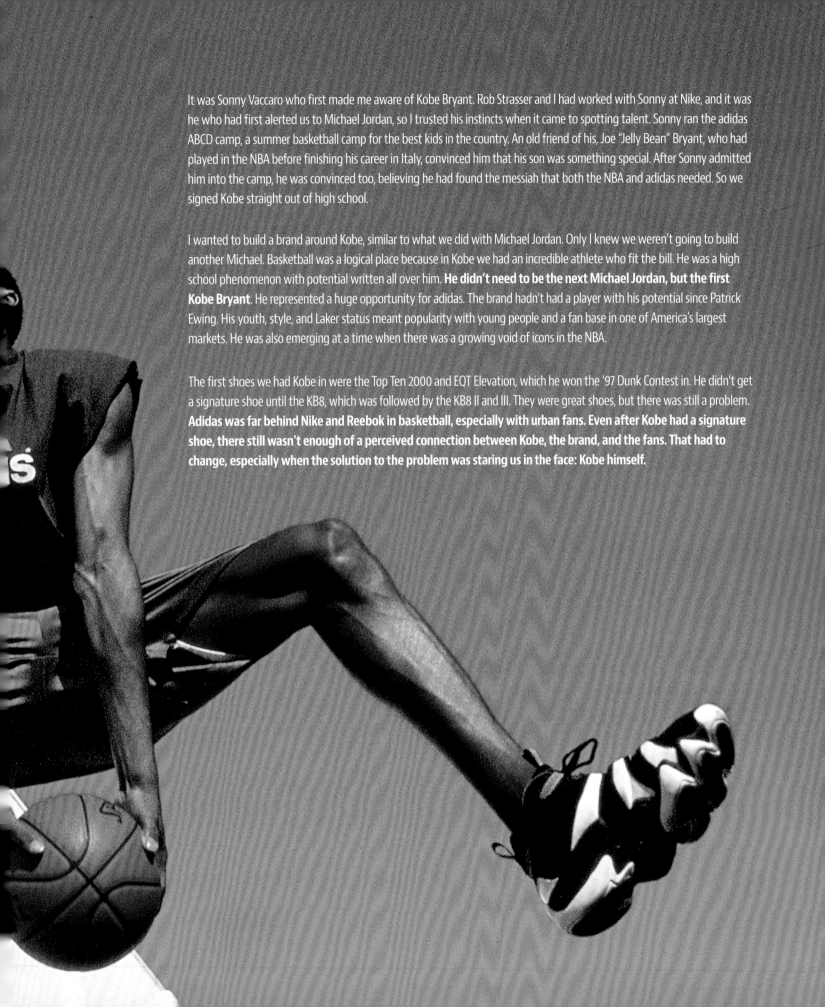

It was Sonny Vaccaro who first made me aware of Kobe Bryant. Rob Strasser and I had worked with Sonny at Nike, and it was he who had first alerted us to Michael Jordan, so I trusted his instincts when it came to spotting talent. Sonny ran the adidas ABCD camp, a summer basketball camp for the best kids in the country. An old friend of his, Joe "Jelly Bean" Bryant, who had played in the NBA before finishing his career in Italy, convinced him that his son was something special. After Sonny admitted him into the camp, he was convinced too, believing he had found the messiah that both the NBA and adidas needed. So we signed Kobe straight out of high school.

I wanted to build a brand around Kobe, similar to what we did with Michael Jordan. Only I knew we weren't going to build another Michael. Basketball was a logical place because in Kobe we had an incredible athlete who fit the bill. He was a high school phenomenon with potential written all over him. **He didn't need to be the next Michael Jordan, but the first Kobe Bryant**. He represented a huge opportunity for adidas. The brand hadn't had a player with his potential since Patrick Ewing. His youth, style, and Laker status meant popularity with young people and a fan base in one of America's largest markets. He was also emerging at a time when there was a growing void of icons in the NBA.

The first shoes we had Kobe in were the Top Ten 2000 and EQT Elevation, which he won the '97 Dunk Contest in. He didn't get a signature shoe until the KB8, which was followed by the KB8 II and III. They were great shoes, but there was still a problem. **Adidas was far behind Nike and Reebok in basketball, especially with urban fans. Even after Kobe had a signature shoe, there still wasn't enough of a perceived connection between Kobe, the brand, and the fans. That had to change, especially when the solution to the problem was staring us in the face: Kobe himself.**

There was something special about Kobe, the person. His upbringing in Italy, his embrace of the Southern Californian lifestyle, the way he played, and even his name, it all gave him a worldly mystique and sophistication like no other NBA player. The first poster we did with Kobe was titled "California Dreamin'" and we shot it on the beach at Pacific Palisades. It captured everything that I believed appealed about Kobe to the fans. **He was a young man living the Southern California lifestyle to the full. It's fun, it's sun, it's fantasy, it's California— everything I wanted at the core of Kobe's brand.**

Around the same time, the death of Feet You Wear meant we had to head in a whole new design direction. The style of Kobe's brand was in part inspired by the auto industry. Car brands never just sell a car, they sell a lifestyle. And in California at the time, it was the same lifestyle that defined Kobe's brand. Cars have always played a big role in California life. From the early '30s convertibles, the hot rods of the '40s and '50s, the mid '50s and '60s custom cars, down through the '70s muscle cars and the foreign influences of the '80s and the '90s exotics, every major car manufacturer in the world had a design studio in Southern California because of this legacy. An article in *USA Today* at the time, titled "The Auto-motive–Cars Are What Really Drive Pop Culture," captured the importance cars had on young people and wider society.

This automotive influence could be described as clean or aerodynamic, but in the context of Kobe, the aesthetic we wanted was as a "California-styled" image. At the time, the Audi TT defined this. **It had European sophistication but was styled in California—an image that appealed to the urban market, and was reflected in the collections of brands like Prada, Gucci and Kenneth Cole. When we discussed it with Kobe, he just got it immediately.**

When it came to designing the shoe, we threw away the rule book. Our design team under the leadership of Paul Gaudio worked with Derek Jenkins and his team from Audi, using the same philosophy they used when developing new cars. Referred to as the Audi Design language, it was based on German simplicity with no frivolous styling. The Audi approach was so key to the design process that, just like a car, the shoe was prototyped by hand sculpting clay models. Unlike a normal shoe, where the design begins from the inside with the last, The Kobe, as we named it, was designed from the outside in, which allowed us to put more focus on the materials and functional performance details.

The influence of Audi Design and the TT was easy to see: the continuous line, a clean surface body side, and a bullet-nosed front. The "grille" was a nod to another design icon: the shell toe from the Superstar. Once Kobe approved the design, Paul brought Eirik Lund Nielsen into the project and they worked together in translating the Audi clay models into a fully functioning basketball shoe. **The final result was exactly what I'd envisioned: a performance shoe that was completely unique and very specific to Kobe.**

Opposite: Kobe with the Audi TT, the car that inspired the design of his Kobe One shoes

"CAR BRANDS NEVER JUST SELL A CAR, THEY SELL A LIFESTYLE. AND IN CALIFORNIA AT THE TIME, IT WAS THE SAME LIFESTYLE THAT DEFINED KOBE'S BRAND."

Above and opposite: Early concept sketches showing the influence of the Audi TT on the design of "The Kobe" shoe

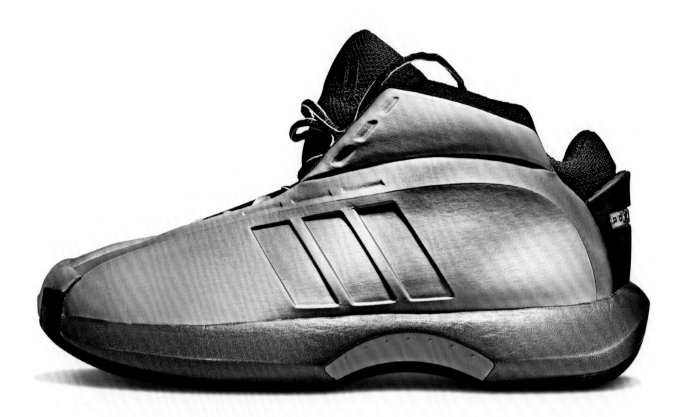

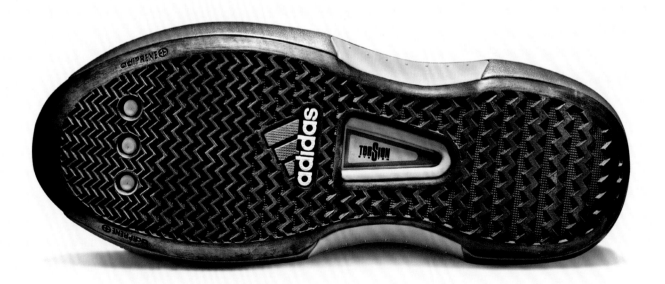

The Kobe

K8B

Above: Original concepts for Kobe Bryant's brand symbol
Opposite: The final silhouette design

"THE THINKING BEHIND THE KOBE SYMBOL WAS TO CREATE SOMETHING THAT WAS MORE THAN JUST ANOTHER BASKETBALL ICON."

The thinking behind the Kobe symbol was to create something that was more than just another basketball icon. When I first began playing with ideas for a symbol, they were initially inspired by the California Dream. I tried ideas based around sunshine, palm trees, Kobe's number eight, and the Lakers brand.

The idea we finally went with didn't begin with California though, it began where Kobe did: with his family. Within the Bryant family, there was a deep interest in African art and their own heritage. During a visit to their home, I was inspired by the collection of interesting pieces of African art that filled the Bryant house. It was this passion for and pride in Africa that became the foundation for the Kobe symbol.

This was then combined with Kobe's unique image to create something that captured the pride, dignity, and presence that Kobe possessed and that a meaningful symbol had. The final piece was to package the symbol in a shape and graphic system that gave them a style and sophistication that matched Kobe's.

I was still very new at adidas when Peter Moore and Paul Gaudio said, "Hey, we want you to work on Kobe." Coming from Norway where we grow up on skis, I had no basketball experience, but I think it was this different background and my having studied transport and industrial design at Art Center is why they chose me.

In truth, I hadn't heard of Peter before joining adidas, but working with him I found he had a strength—to look at things simply and to incorporate unique people and approaches. And after he put the right people in place, he was very hands off. I haven't experienced any other top exec giving that much freedom to potentially fuck it up, especially when it's such a big deal, but it was strict orders from Peter that whatever we do, we do it differently. Typically, footwear is designed from the last and then out, but we started from the outside in. He gave us full freedom to come up with what were effectively concept cars. The brief wasn't, "Make footwear products," at all. The Audi design team created amazing clay models. They were eye-candy, even painted like the Audi TT, which was hot at the time. It was our job to then translate them into footwear.

Kobe's involvement was limited, but he saw early prototypes and gave us his input. He was excited all along. He was super young and so enthusiastic about being with adidas. He gave us the thumbs up on everything. The whole thing was a big deal for us. I think adidas ended up spending fifty million dollars on launch of the Kobe One, and it was a huge success. One of the main goals was to change the image of adidas basketball, to show that we were more than just boring German performance and that we could be American and sexy.

With Kobe Two, we took it too far. Our approach was the same, but we simplified it too much. It became too far removed from what people perceived as footwear. It was also tough to follow Kobe One. You can clearly see the lineage, but I do think Kobe Two is more sophisticated design language wise, and a much better product. With Kobe One, no one had done anything like it before, so we ended up where we ended up. With Kobe Two, we just took it too far out of the real mode of footwear—out into space really.

Peter always took care of his designers, so despite the disappointment of Kobe Two, as far as he was concerned, we couldn't do anything wrong. To this day, it's controversial. When you see comments on social media, people either they love it or hate it. There's no in-between. I've been designing for 25 years and been involved in much more impactful designs, but that is the one project that keeps coming back. It has followed me throughout my career, and I'm happy to have been part of it.

EIRIK LUND NIELSEN FMR SNR DESIGNER - BASKETBALL, ADIDAS

When I first came to adidas, I was hired as a senior graphic designer to work on basketball. I was a Norwegian white guy working on an urban Black market category. It wasn't quite putting a round peg in a square hole, but it was certainly new to me. Adidas had tried to launch Kobe for at least one or two seasons, but it hadn't gone anywhere. We needed to do something new, so Peter decided to assemble a small team and put them in a lock box. Nobody outside was going to know anything, and we would do it strictly his way.

Peter planned it in his classic way. He put together a clear context of who's the customer, what's the vision, and how we execute it. It was a very clear and succinct way of creating a brand around an individual. Ironically, we were creating a competitor to a brand that Peter had created—the Jumpman—but with a very different player. He began looking into the idea of creating a symbol. He wanted to do a silhouette of Kobe, not like the Jumpman logo. It was much more of a personal approach, based around Kobe's face. It became the icon that we used on everything for the Kobe line.

Peter's approach was, first and foremost, know your market. Know the young urban kid in the Untied States and what appeals to them. The other thing was that he wanted to go deep into who Kobe was. Kobe's dad played basketball in Europe, so Kobe grew up playing in Italy and speaking Italian. Compared to other players, he had a sophistication and worldly image, so that was going to be the image that we created around him. **The idea was that he wasn't a lone icon like Jordan but part of a family of adidas athletes. With Nike, it was very individual driven. It's all about the one person. But for Peter, it was much more about building a team of superstars: Kobe alongside Tracy McGrady and Antoine Walker.**

The Kobe campaign was a two-year long effort. We spent seventy-two million dollars and grew sales by 485%. It was unheard at the time. I went to one of the best design schools in the United States, but what I learned there doesn't come close to what I learned from Peter during the years I was at adidas.

HEIN HAUGLAND FMR DESIGN MANAGER, ADIDAS

The first shoe was very different. It looked good, performed good, and, most importantly, Kobe liked it and he performed in it. The second shoe? Not so much. He started the season in it but, once his teammates started making cracks about it, he switched back to Kobe One.

We had a trademark that was interesting, but you really had to know something about the kid to understand it. Maybe it was a little too personal, but it was the right idea. The marketing plan started to come together with television ads, and we started to build some success. **But the Kobe relationship was an example of how fragile these things can be if the footwear doesn't improve each season. Every year, you have to introduce a new shoe, and that shoe has to be better than the shoe that came before.**

The thing we didn't fully realize was in order to build a strong relationship, you have to spend a lot of money. In Jordan's day, it was more than one million dollars for the first ad campaign. It was unheard of in those days to spend that kind of money. For Kobe, it was five, six, or maybe even eight million. That was a stretch for everybody in adidas America, and it was a stretch for everybody in Germany. We had to do it with less money, and the whole thing ended up unraveled.

So, because of a combination of things, the relationship didn't succeed. It started well but, ultimately, it was a missed opportunity. A lot of people think it boils down to the Kobe Two, but it was just part of a much bigger problem that led to the break down of the relationship. Some of the fault I'd have to say was maybe Kobe's, some of the fault was certainly mine, and some was certainly adidas's It was not my most pleasant time at adidas, for sure.

"THE FIRST SHOE WAS VERY DIFFERENT. IT LOOKED GOOD, PERFORMED GOOD, AND, MOST IMPORTANTLY, KOBE LIKED IT AND HE PERFORMED IN IT. THE SECOND SHOE? NOT SO MUCH."

The Kobe Two

The Kobe Three

When I was given the job to design the Kobe Three, I was coming in hot off the tails of Kobe Two. Although it used the same design approach as Kobe One, it had been nowhere as successful. It also didn't help that adidas's relationship with Kobe was beginning to fall apart, so there was extra pressure to get it right because the stakes were so high. The other pressure was that I was working with Peter Moore. I wanted to live up to his expectations!

For Kobe Three, we still had Audi as partners. My role was to interpret their vision as car designers into the shoe. People found the Kobe Two too challenging. They called it "The Toaster," thinking it looked boxy and heavy. So for Kobe Three, I set out to make it much more form-fitting. It was still auto centric, but more fitting to the foot—like it was poured on.

During the design process, I met with Kobe and his wife Vanessa twice to show them concepts and designs. One part of the concept that was an alternative to regular lacing was a unique magnetic closure. Alternative closures were very of the moment, and I thought they were so cool. Kobe's response was, "There's only two players in the league, there's me and Allen Iverson, and Iverson has a zipper on his shoe." What I had proposed was seamless, but he didn't really distinguish the difference between a zipper and the magnetic closure. He felt it was too similar to Iverson's design.

While I was working on Kobe Three, even though we knew Nike was courting Kobe and Peter was doing all he could to keep him on board, I had to approach it like it was going to happen. Even though I was conscious of everything going on in the background, when we realized Kobe was going, it was hugely deflating. Adidas had had so much success with him, but Nike just threw more at him, so sadly the Kobe Three became one of those "What if?" shoes. I know I'm biased, but it was a cool shoe that just came at the wrong time.

CHARLES JOHNSON FMR SNR DESIGNER – BASKETBALL, ADIDAS

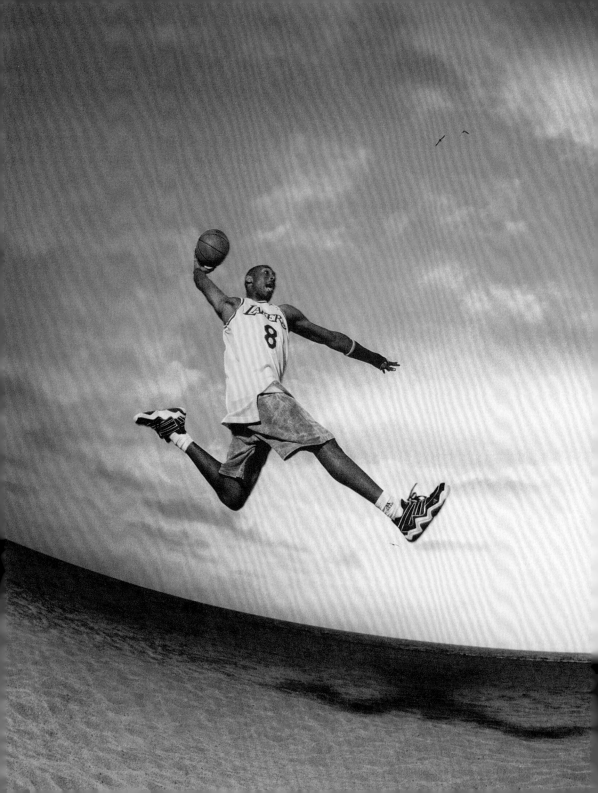

FORM FOLLOWS FUNCTION

ADIDAS VISUAL LANGUAGE 1996–2002

When Rob Strasser and I first came to adidas, the company had forgotten who it was. It had lost its leaders: first Adi Dassler, then his wife Käthe, and then their son Horst. It had no follow-up plan. There were no new natural leaders ready to step up, so it lost its foundation, if you will. A company that had been a leader all of its life, was now chasing. It wasn't just the company; the brand was lost. There was no brand person there who stood up on a soap box and preached the gospel of adidas. In fact, there was no gospel. We had to write one.

A brand is more than just a symbol. It's the fingerprint of an organization. It's the sum and substance of who we are, what we do, why, how, when and where we do it, and who we do it for. As such, a brand is both the memory and future of an organization. Like a person, it grows and matures with time and experience. Its attributes or characteristics will take shape, dictating which products and directions are or aren't legitimate for it.

Adi Dassler was a cobbler—a man who was passionate about sports and sports shoes. His whole life was about meeting the demands and needs of athletes. He made them the best products he could to help them perform better. This is his legacy. This is what the brand stands for. And this should never change.

To be successful, a brand has to have a clear vision and mission—why it exists, how it intends to transform its industry, and what its worldview is. This vision can be shared and promoted with consumers only after the brand's direction and mission are set and understood. At adidas, ours was to be the best sports brand in the world. Being the best meant exceeding all others in our industry. But it didn't necessarily mean being the biggest.

Our goal was to have our consumer and the industry believe that real athletes wear adidas to reach peak performance. If we achieved that, size would follow. There will always be athletes who desire the best. And if we were true to our mission, we would have the best product offering. Being the best meant exceeding all others in performance, quality, customer satisfaction, value, communicating (internally and externally), and in employing people. People think you have to look at industry rankings to know if you're the best, but you know you're the best when you're both respected and imitated by your competitors. Your competitor may be bigger, but if they're always looking over their shoulder at you, you know you're doing something right.

It was also key that our people understood the meaning of "sports." Sports can't be limited to traditional organized or team activities. In many ways, these activities have been tainted by professionalism and big marketing money to appear excluding, deterring participation. New sports are always emerging and evolving, and it was essential adidas be a part of them as well as traditional sports. It was key that the brand went back to the origins of sport—to the days when people participated for the sheer pleasure of competition. Our brand strategy needed to be associated with any physical and competitive activity. Adi Dassler understood that an athlete was anyone who sought to improve their performance in sport. The vast majority of athletes will never win a medal. Their finish line is the tree in the park or their own porch, and adidas had to be there for them, not just Olympians and major leaguers.

"A BRAND IS MUCH MORE THAN JUST A SYMBOL. IT'S THE FINGER-PRINT OF AN ORGANIZATION."

"THE PERFECT EXAMPLE OF A BRAND AND A PRODUCT WITH CONSISTENT DESIGN LANGUAGE IS THE PORSCHE 911. EVEN IF YOU ONLY SEE THE SILHOUETTE OF A 911, YOU STILL KNOW IT'S A 911."

When your objective is to build the best products for the athletes of the world, you can only really have one design philosophy. **You may not think it's pretty or exciting, but the philosophy has to be, "Form follows function," because form always played a secondary role in adidas's shoes. As long as they worked, that's what they looked like.** So that's what we did. We said that "Form follows function" would be the philosophy for everything that we did.

It's not glorious, and it's not exciting as I said. When you ask somebody about design today, they may tell you that "Form follows function" is an old idea. To that I say, "Fine, you don't belong designing for adidas." Track spikes are track spikes. Tell me one thing they can do other than being track spikes. You can wear them on the streets if you want, but you're gonna look silly and be pretty uncomfortable. To me adidas is a no-bullshit brand but, sadly, a lot of design language today is bullshit. I've always believed in "Design by philosophy" and not "Design by committee." As I said many times at adidas, "This is not Burger King. You don't get it your way. You get it adidas's way." That wasn't very popular with sales, but it was the way it was.

In addition to "Form follows function," we were trying to do something that I think is very challenging: to create a design language where you could see an adidas shoe without the 3-Stripes and still know it was adidas. The perfect example of a brand and a product with consistent design language is the Porsche 911. Even if you only see the silhouette of a 911, you still know it's a 911. It doesn't matter what year. It could be from the '60s or the latest model. You know what it is without even seeing the Porsche badge. I believed that if adidas could get to that point, it would be an invaluable asset. If a brand can achieve that, you don't have to rely on traditional branding as it's called, by putting a trademark on something. To me, traditional branding should also be the form that the product has. That form should speak the brand.

To the surprise of some, I even believe that color should speak brand, but to a lesser extent. With Equipment, the green/black/white/grey color scheme was a signature. Nobody had that green. It was the first time I'd ever tried to do color as part of the brand signature, and I think, for the most part, it actually worked. The problem was we went away from it too fast. However, I maintain that color should never make or break your design philosophy. Coming back to the 911 example, it doesn't matter what color a 911 is—whether its black, red, yellow, or pink—the color is not intrinsic to the design language of the car.

Opposite: The evolution of the Porsche 911

Beyond a mission, vision, and design language, as a brand grows it needs a consistent visual language. A visual language is best described by the root of the word "visual," or "vision" —sight, identity, image perception. For a brand, visual language is how you look, how you visualize yourself, and how you want the outside world to recognize you. It allows you to create a clear definition of the brand, anytime and anywhere people experience it.

For adidas, visual language was a set of aesthetic standards created to provide the brand with a clear and consistent image and identity as we grew. It was the "handwriting" that would appear in everything the brand did visually across product, communications and consumer interaction.

As the company grew globally and added new faces, businesses, and partners to its family, it began to lose some of its identity and image. It was obvious that not everyone had a universal understanding of who adidas was, its products and communication, or what it looked like. While there were parts of the adidas heritage that continued to play a strong role such as our Mission and Vision, they weren't enough to establish a complete and understandable handwriting for the brand.

I felt we needed to create visual language tools to give adidas a consistent handwriting that would be recognized in anything visual. It would give our retailers and consumers a clear definition and understanding of the brand and, ultimately, would allow anyone to say "That's adidas" even if the branding or logo was absent.

Five elements form the foundation of any visual language. The first two, Brand and DNA, are elements that have a permanence about them, providing your visual language with longevity. Physical, Trend, and Consumer are the elements that change and adapt over time, allowing your visual language to maintain its relevance.

What makes a visual language tick are a brands key attributes, its core characteristics. For adidas, we identified nine. Authentic, Sport, Honest, Quality, Innovative, Courage, Functional, Performance, and Timeless. Together, they described the overall nature of the adidas visual language. **While these traits were specific to adidas, any brand can go through the process of identifying its own traits—those that are both inherent and desired.**

Once you've worked out what your brand's overall attributes are, you can then drill them down into the dialects of your brand. Dialects are categories where your brand needs to communicate. At adidas, these were Product, Comms, Advertising, Retail, Events, and Architecture. We used the term "dialect" because each category needs to speak in a particular way to the people to whom it is communicating by selecting which of the Attributes best engage with the people to whom you are talking.

Before we defined our visual language at adidas, frankly our branding was a mess. It was inconsistent and confusing, but, by going through this process, the brand began to finally define its fingerprint and handwriting. It wasn't perfect, but it did get us closer to that holy grail of adidas being a brand that anyone can instantly recognize.

"FOR A BRAND, VISUAL LANGUAGE IS HOW YOU LOOK, HOW YOU VISUALIZE YOURSELF, AND HOW YOU WANT THE OUTSIDE WORLD TO RECOGNIZE YOU."

AUTHENTIC

RESPECTING AND USING ADI DASSLER'S TRADITION IN A RESPONSIBLE WAY

SPORT

ANYTHING THAT IS PHYSICAL & COMPETITIVE

HONEST

SIMPLE, UNDERSTANDABLE, NO BULL

QUALITY

HIGH STANDARD OF DESIGN, CONSTRUCTION & EXPERIENCE FOR THE CONSUMER

INNOVATIVE

UNIQUE APPROACH AND SOLUTIONS TO PROBLEMS

COURAGE

THE CONFIDENCE TO FOLLOW ONE'S CONVICTIONS

FUNCTIONAL

IT WORKS

PERFORMANCE

A MEASURABLE STANDARD OF PURPOSE

TIMELESS

CONTEMPORARY THROUGH TIME

Shortly after my arrival at adidas, Ina popped over to see me one afternoon and plonked something down in front of me. She was going through Peter's archive and found my first ever presentation to him, titled the "Architects of Performance" concept. He had kept it in his archive, and here I was, now the chief creative officer of adidas, following in his footsteps.

I've worked with adidas as an external partner for a great number of years, dating back to around 2003. While I was working with the training side of adidas, I had an idea for a project for the brand. And that idea was based around working with a number of different industrial designers, product designers, and architects to develop footwear across categories, but coming from a very different perspective. I put this project together, which was initially called "Architects of Performance." I was presenting in my studio, and Peter was on the call. My first impression was "Jesus, this is Peter Moore on the end of the phone!" It was certainly an eventful moment for me and many of the designers who were in the room at the time, including Jasper Morrison, Barbara Roscoe, Konstantin Grcic and Alex Taylor, who is now head of design innovation

here at the brand. And that was my first interaction, hearing the great man on the end of the line. Then that project went forward. It turned into something called Puretech, which was ultimately Alex Taylor's first forays into knit.

Wanting to follow in Peter's incredible footsteps and have my moment, my chapter in the brand, was 100% a factor in my decision to come here. The first thing I did was to go back through everything that Peter had done. Not just to learn from his work, his writing, his thinking—but to understand his philosophy. I realized it was about principles and attitude, **which are still absolutely pertinent and relevant to the brand today, to today's consumer and industry.** *His "no bullshit" approach is something that I have definitely taken on board and use in this organization today, because you have to find a way to create amidst chaos. My starting position for the new direction and the teams was a line I came up with, which is, "When you cut away the noise, the silence gets louder." Peter's legacy definitely lives on.*

ALASDHAIR WILLIS CHIEF CREATIVE OFFICER, ADIDAS

Golf.

From the original 1991 adidas Equipment launch catalog

PRETTY BIG HITTER

ADIDAS GOLF & TAYLORMADE 1987–2022

Golf meant everything to my dad; it was his first real passion. He wasn't an only child. He had two older siblings, but he was quite a bit younger than the were. He spent a lot of time on the golf course, alone or with people around the course. It was his outlet. He was always an athlete. He played other sports, but golf was his first love from a young age. He spent all of his free time golfing. He was the kind of person who goes all in once he's into something. It's something that intrigued him throughout his life, as it intrigues me. He made me realize that you're never perfect. You're always working on it, or tinkering with it. You're always trying to get better. It always comes back and smacks you when you think you have it figured out. And he appreciated that you never master it.

He became super competitive at golf. It was a nice way for him to get away from the pressures of Nike and adidas and everything else and just go focus on that. If you're gonna play golf at any kind of high level, you must have focus. You can't have anything else on your mind. So for sure, golf was a great escape into something that still kept those competitive juices going later in life, for him, me, and my two brothers too.

For most of his life, Dad was a scratch golfer. He even got below scratch a couple times, but he was around a scratch to a two handicap. As he started getting a little bit older, he started dropping to about a four or five handicap, which was when he was battling Ménière's disease. But it was pretty late on until he really got sick that he was a two to four handicap. And, for his age, he was always a pretty big hitter. He had a little bit of an old school classic golf swing that was really long, and he was able to hit the ball a long ways for a long time, which is something that a lot of people lose when they get older—the flexibility.

He not only liked playing golf but also really loved hitting balls. Golf takes a lot of time. He didn't always have a lot of time, but he'd love to hit balls and work on things and test things out. And in Germany, any time he could, he'd escape to go hit some balls. He wouldn't always go to the driving range. At our country club, there was an open field between a couple holes that he would go hit balls down with his own bag and go collect them and hit him. And that forced him to make sure he didn't spray them all over the place because it's hard to pick them up.

He was a tinker and loved product, so he was always between putters and drivers. I think he'd had hundreds of them because he was always thinking, "How do I maintain that distance? What's the next gadget or gimmick or technology that I can use to make sure I don't lose that distance?" He was always buying the craziest bazooka driver or whatever it was and he always tinkered with clubs. My brothers and I got hand-me-downs from him when we were smaller, and he would cut them down himself. He knew how to do all that and loved to do that. He was always putting a heavier tape down on the back of his putter or putting more wraps on his grips to have a fatter grip or some narrow grip. He was always playing around with the clubs, even grinding them down sometimes, which I'm sure is why he loved getting involved with TaylorMade. He really felt passionate about that.

When he was at Nike, he loved working with Seve Ballesteros. Seve was a god back then. My dad wanted to get him. He looked cool, and they made him the face of Nike. He was the new, up-and-coming player. Obviously, he's a European, and in the US, Jack Nicklaus and Tom Watson were the guys. Seve really came on strong and had that Spanish charisma, and he could hit the ball. So my dad worked with him a lot. And, if you look back at the Nike shoes, the whole color palette was this red, black and, maroon color palette around Seve. He wore a lot of black back then. He was really known for creating shots. And the stories of him hitting, three irons out of bunkers, people could barely get a sand wedge out. They did a poster with him taking a shot out of a tree, and they did the same with Sergio Garcia. Being another Spaniard, he was also known for hitting out of weird spots. Like Seve, he was able to get out of anything.

For my brothers and I, golf offered us a nice way for us to spend time with him because he didn't get a lot of time with us when we were younger. We were able to share that same love for the game and spend time, walking the golf course with the sun going down. Those were pretty awesome moments that you don't often get in a busy life. Being able to be outside, walk, and talk about the game and whatever in life was just great.

DYLAN MOORE SNR DESIGN DIRECTOR, ADIDAS

"Golf is a funny game with very different consumers. These are people who care more about their sport than they ever will about brands or companies within the sport. They have certain likes and very clear dislikes. If you are on the 'dislike' side of the ledge, you have little or no chance of success or acceptance."

PETER MOORE

"This must be me hitting a ball" (self-portrait)

The Art of Golf

Taylor Made

Above: To design the updated 1999 TaylorMade logo, Peter took inspiration from the brand's signature metal woods to create the iconic "T" symbol
Below: One of a series of paintings by artist Bernie Fuchs for the TaylorMade Art of Golf campaign

My TaylorMade story with Peter began when Rob Strasser called me and said "Hey, I really need some business. You gotta help me." So I said, "Ok, no problem." To tell the truth, I really needed help because TaylorMade was an old-fashioned golf business, and we needed to do something modern. So we signed up Sports, Inc. for advertising, graphics, and so on. The first thing that Peter did was refresh the TaylorMade logo. Altering the logo for a golf company that makes its primary product in metal was a really, really big deal. It wasn't taken lightly. So Salomon, who owned TaylorMade, had to agree to change the logo (and they loved the one that Peter did).

The second thing that Peter and I start talking about was the image. Peter came up with a campaign called "The Art of Golf," which uses those illustrations. It was the first television commercial that TaylorMade ever did and the first magazine ads. There were five or six different magazines, and every golf company would split work between the various guys because they didn't want anybody to feel bad. We finally decided that we would take all our budget and put it on one magazine, so we owned Golf Digest for three months. It was the first time a golf brand did that, as sort of a saturation thing. And then Peter filmed Lee Trevino and did "The Art of Golf" commercial. It was pretty cool as it took what Peter was doing and posterized them. So when the first ad came on, people were like, "What's that? That's really cool." And Bernie Fuchs was the guy who did that. He's an artist from San Diego. He had a whole series of paintings that were based on photography. That was his thing. It was beautiful.

The next phase was when I left TaylorMade. I took a look at the golf business and said, "Hey, we just kinda did something cool." We changed the rules for some things. It's still golf. It's still the same rules, but how you looked at it changed dramatically. All of a sudden, Callaway came on, and Callaway took up the same model for advertising and Titleist

did too. So I didn't know if I wanted to stay in the golf business. I called up Paul Fireman, chairman of Reebok. They had signed Greg Norman, whom I had met during my TaylorMade days, so I knew Greg a little bit. I called him up and I said, "I've got a couple ideas about the way you could do Greg Norman." At that time, he was just an endorsement athlete. In other words, they put him in a Reebok shirt and shoes, and that was it.

So we structured Greg Norman Enterprises, and then I asked Peter to do the logo. He and I were talking and I said, "I don't want to do just golf shirts, I'd like to do sportswear." We talked about it, and he came up with two or three different versions of the shark logo. The way he explained it, they were all primary colors, which we could use on apparel without conflicting. And still to his last day, he was always on me, because Reebok only paid $1,400 for the logo. Not only did I feel bad at the moment but, over the years felt even worse. Greg Norman and Reebok then did a joint venture where Reebok owned half the logo and Greg owned half for sportswear. When Greg Norman put it all over the place, **Peter and I had another discussion. He said, "Jim, you got to have Norman get rid of all these other logos that he's got, like McDonald's. We can't have the shark next to McDonald's."** I had to try to convince Greg and I remember sitting with him and his agent. I said, "Look, Ben. This apparel thing, it's got to be clean. You're not going to put different logos on your wine, so why are you doing this?" The agent said, "If I do that, I'm going to lose $500,000 or so. Reilly, you've got to make up $500,000." And I said, "You know what? I can't do that, but I **guarantee you having just one logo, he becomes a brand versus being an endorsement." And Norman replied, "Yep. That's it. And that was the end of that discussion.**

JIM REILLY FMR PRESIDENT, TAYLORMADE

The Greg Norman Shark logo

In 1997, adidas owner Robert Louis-Dreyfus was looking at buying Salomon and TaylorMade. He came to Peter and then to me because I had been at both brands. Along with Robert Erb, we worked on the whole acquisition together. Peter was extremely excited about TaylorMade because of the golf angle. We ended up being successful in the acquisition and, shortly after, Dreyfus asked me to become the CEO.

We engaged Peter as our marketing consultant. He came in and basically helped us rebase completely. We had to turn TaylorMade around. We were losing money. There were so many things we needed to do. We brought Peter in to help rebrand the company. It had really lost its way, so Peter did a refresh, changed the logo completely, and was involved in all the advertising and the corporate identity program. He sat in on all the marketing meetings. We were very interested in his takes on product. He loved tinkering with the product,

so he got very involved in the ideation of the new metal wood we were working on and the concept of a customized club built for each golfer's swing type. The first pass was our 300 series, which consisted of three different drivers that were based on your swing type. It paved the way for our 500 series, which Peter was involved in, and then ultimately the R7, which was the completely adjustable driver. It was a driver that you could adjust the loft into many different permutations, based on a fitting session with a local club pro. It was one of the most significant advancements in the game. Peter was on the team that created it. He helped to market it and build the surrounding brand support.

By the time we launched the R7, we were in excess of a billion dollars in revenue and making 200 million dollars. It was one of the biggest turnaround stories in golf, and Peter was a major contributor to that.

JIM STUTTS FMR CHIEF EXECUTIVE OFFICER, TAYLORMADE

Opposite: The TaylorMade R7, which Peter was part of the creation and marketing of

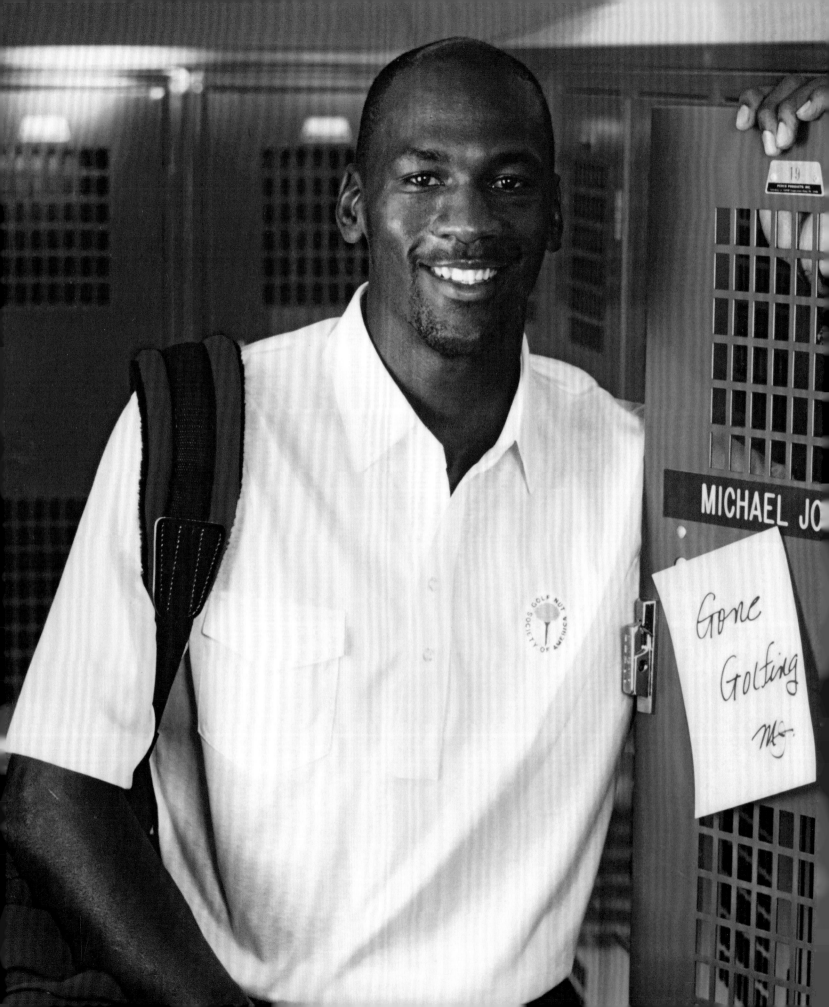

There are friends, and then there is Peter Moore. I first met Peter at Columbia Country Club in Portland, Oregon in the '70s. A little background on Peter as it relates to golf: While still living in Southern California as a young man, he won the California Public Links, a very important amateur championship, defeating the finest amateurs in the state—a couple who later became tour professionals.

Don't get the idea that Peter played just for fun; he played to win. One of the more hilarious moments in playing golf with Peter was when he would hit a bad shot and get angry. He would slam the bottom of his golf bag repeatedly until the plastic would shatter. He went through so many golf bags! After his temper tantrum, he would look at us sheepishly and say the same thing every time: "Today's golf bags are cheap! They used to make the bottoms out of vulcanized rubber!" Then he would go into the pro shop after the round and buy a new bag.

As a golf buddy, Peter was unparalleled. One day, a few months after launching the Golf Nut Society, as I was working in my office, my phone rang. It was Peter. "What are you doing tomorrow?" he asked. "I'm working. What do you think I'm doing?" I replied. "Would you like to play golf with Michael Jordan and me?" he asked. "That's the dumbest question I've ever been asked. I'll be there," I replied. That round resulted in me becoming Michael's chauffer and chaperone for numerous rounds of golf over the ensuing years when he was in town to meet with Peter and Nike. During that first round with Jordan, Peter said to Michael on the 18th tee, "Hey, Michael, Ron has a club you might be interested in." "What kind of club? A driver?" Michael asked. "No, it's a membership club called the Golf Nut Society," Peter replied. And I chimed in with, "Yeah, and I'll give you a free membership!" Michael looked at me like I was nuts and said, "You don't understand, man. You've got to pay me to be a member!" And I replied, "No, man, you don't understand, "I can't afford you!" Michael joined the Golf Nut Society on the spot, became Golf Nut of the Year in 1989, and agreed to a photo shoot and to write the foreword for my book Golf Nuts – You've Got to Be Committed, all because of Peter Moore and the respect Michael had for him.

How much did Peter love golf? When he retired from adidas and word got out throughout the industry, he received offers from a few of the major sports shoe and apparel companies asking him to go to work for them. They said, "You can stay in Portland and name your terms." He replied, "No, I think I just want to play golf."

RON GARLAND COFOUNDER, THE GOLF NUT SOCIETY

Opposite: Michael Jordan sporting a Golf Nut Society polo
Above: Membership cards for the Golf Nut Society

FROM OUT OF NOWHERE

TRACY MCGRADY 2002

ADI DASSLER WAS ALWAYS FOCUSED on building a great rapport with the athletes he equipped. It just made sense that if you understood them as people and what their needs were, you created better product. We wanted to do the same by creating a "garden" of athletes—sports men and women who were not only future stars that we could help nurture, but who also had great character and shared our values. One of those guys was Tracy McGrady.

Like Michael and Kobe, Tracy was a Sonny Vaccaro find. He spotted him as a future star in the ABCD Camp. The crazy thing was that Tracy was the last guy taken into the camp, so he got the last shirt number, 175, because he came out of nowhere. No one had heard of him. But by the time he finished, he was number one. Sonny and Tracy connected immediately, and he proved Sonny's instincts were right yet again when he was named an All-American and National Player of the Year.

As part of our "raise your own" athlete strategy, we signed Tracy alongside Tim Thomas, Antoine Walker, and Antawn Jamison—all future stars, but all very unique players and characters. McGrady had this kind of effortless fluid style. Thomas was urban and old school. Walker was a hard nosed Chicago kid. And Jamison was your classic blue-collar leader. This was something we wanted to reflect in their shoes.

The inspiration was the Pro Model, the classic shell toe hi-top that had dominated the courts in the late '60s and early '70s and was still iconic decades later. The name also worked. All four of these guys was a pro and role model. The idea was that each of them would have a different version of the shoe that reflected their characters. To make the shoes distinct from each other, each one had a different designer who was handpicked by Charles Johnson, who headed up our basketball design team.

For Tracy's shoe, he chose Natalie Candrian, a young Swiss designer fresh out of Art Center who was a future star herself. The thing with Natalie was she wasn't a basketball player, so she brought an outside perspective to it. Charlie wanted to go against the tradition that you had to be a baller to design basketball shoes, which could've been a risky decision, but it paid off. Natalie came up with a great performing shoe that captured Tracy's character. When Tracy took off and we needed to turn it into a signature shoe, the T-MAC 1, she handled that like a pro.

> **"THE INSPIRATION WAS THE PRO MODEL, THE CLASSIC SHELL TOE HI-TOP THAT HAD DOMINATED THE COURTS IN THE LATE '60S AND EARLY '70S, AND WAS STILL ICONIC DECADES LATER."**

The adidas Pro Model, the shoe that along with the low-top Superstar ended the dominance of the Converse All-Star in basketball in the late '60s and early '70s

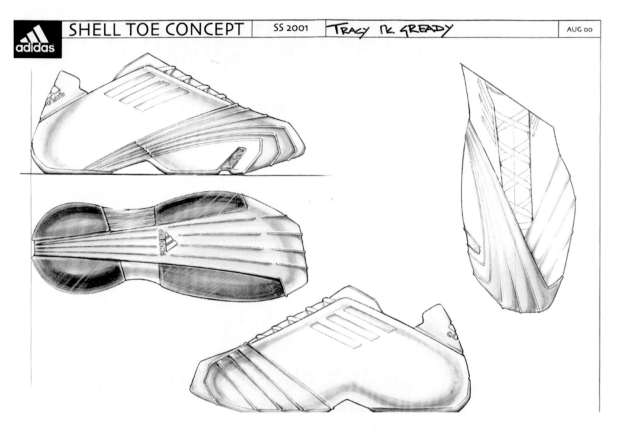

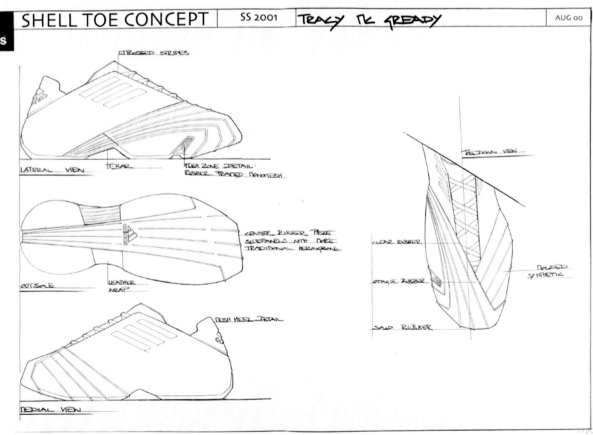

EMBOSSED STRIPES

LATERAL VIEW T-BAR FLEX ZONE DETAIL:
RUBBER TREATED MONOMESH

CENTER RUBBER PIECE
SIDEPANELS WITH MORE
TRADITIONAL HERRINGBONE

OUTSOLE LEATHER
WRAP

MESH HEEL DETAIL

MEDIAL VIEW

PEELDOWN VIEW

CLEAR RUBBER

MOLDED
SYNTHETIC

ORANGE RUBBER

SOLID RUBBER

FROM SLAM KICKS' *INTERVIEW WITH TRACY MCGRADY ON HIS ADIDAS LINE:*

I remember that time. I was like a kid in a candy store, about to have my first signature shoe. It took me back to me, when I was a kid. I had the Pennys, the Jordans, and you know when I was winning, wearing those guy's shoes that I idolized when I was a kid. And now I'm that dude that's about to have his own signature shoe, I can't even put into words this great feeling. It's not just the kid has my shoes on, but that kid appreciates what I'm doing on the basketball court.

I remember sitting in my house with the designer and we were just going through some ideas and talking about the Run-DMC shell toes and the Pro Models. I wanted to do something different because I loved shell toes back then. They hurt my feet, but I loved wearing them. When they brought me the final version of what the shoe would look like, I said, 'Yeah, these are dope. These are big dope.'"

TRACY MCGRADY

Peter Moore came up with the creative direction. This was all just before T-Mac went to Orlando, and exploded as the next big player. So Peter's idea was to handpick four players and design a collection of four shell toes. That would be a good new starting line for basketball with Kobe at the very top and in his own league. We started with that, and he set the creative direction for us.

I was paired with Tracy McGrady as his playing style "matched" my design language. A few weeks in to the process, Tracy performed insanely well, and adidas was desperate to have a signature shoe ASAP. Peter insisted to keep me on it even with the high-profile bullshit around it. I got to meet with him every week at his office, and he creatively directed me through T-MAC 1. Looking back, I think what a crazily amazing experience for a junior designer to have. It was crazy privilege to learn from Peter one on one.

NATALIE CANDRIAN FMR FOOTWEAR DESIGNER, ADIDAS

Opposite: Concept drawings of the T-MAC 1, which drew inspiration from the Pro Model.

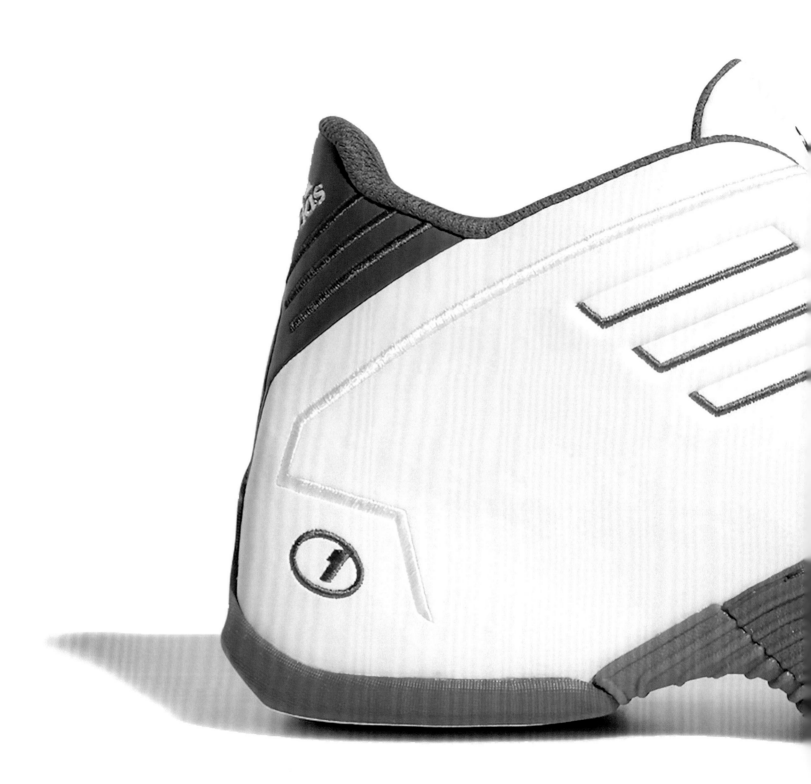

T-MAC 1

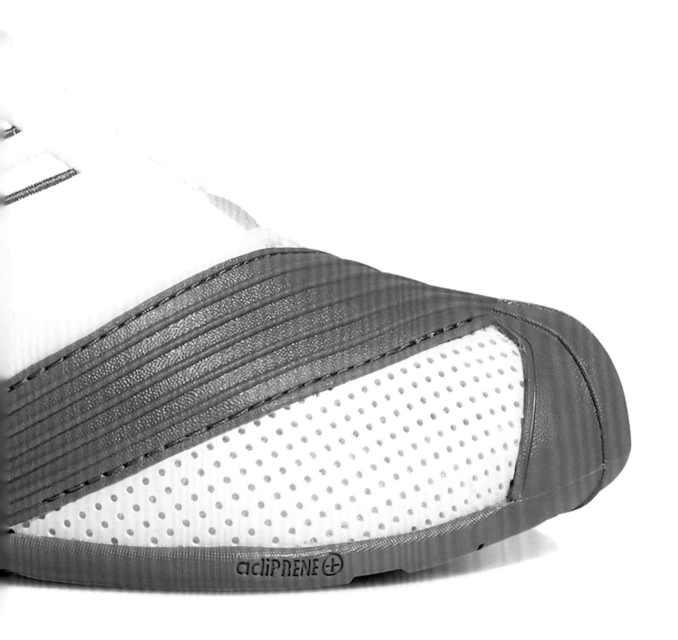

adiPRENE ⊕

Above and Opposite: The shell toe and herringbone tread pattern of the T-MAC 1 that were inspired by the groundbreaking Pro Model

NON MARKING

"ADIDAS... WAKE UP, IT'S NOW OR NEVER"

ADIDAS STANDARDS & ARCHIVE 2007–2011

I T BOTHERED ME AT ADIDAS that nothing much, or at least nothing significantly meaningful, had been done to preserve the company's past. This was especially true when it came to products—specifically footwear. One of the major reasons for this was there was no perceived value in protecting and preserving the past and connecting it to what adidas was doing in the present day, and would do in the future. But I was sure that if we made a commitment to the past, it would guarantee our future.

Adidas's past should be adidas's greatest advantage. This has never been a secret, it seems almost everyone has always known this. When you look into adidas's past and compare it to the past of the competition, the advantage becomes pretty clear. The only athletic brand that comes close to adidas in terms of a meaningful history is Puma. But the question was if adidas really understood the importance of its history and did it know what to do with it? Yes, there was Originals, which grew from a product line to an entire division, but Originals was and is about using the past to inspire the products of today, not about the preservation of history (nor should it be).

For me, two things needed to happen to connect the past with the future. Firstly was the creation of an adidas archive. The archive would be a curated preserve or collection of products, photos, advertising, speeches, and almost anything that has affected or depicted the adidas brand.

Second was the creation of adidas Standards. The idea was to document the various characteristics of what made an adidas shoe an adidas shoe. The Copa Mundial was the perfect example of a product that upheld the adidas standards. First made in Germany in 1979, almost unchanged, it still sells today. Why? Because it was a great shoe to begin with and all the product standards that had been well established before it ever went to be manufactured in Asia were then maintained. It's an example of doing something great—something of quality and that is still profitable today.

My proposal, which I titled "adidas... Wake Up, It's Now or Never" was to bring the two efforts together, creating an entire system and department devoted to preserving and serving the adidas heritage. Done correctly and with purpose, this program would not only protect what adidas is but, help create better products, in turn creating more business, and better business.

Opposite: Copa Mundial 2023 model

"THE COPA MUNDIAL WAS THE PERFECT EXAMPLE OF A PRODUCT THAT UPHELD THE ADIDAS STANDARDS. FIRST MADE IN GERMANY IN 1979, ALMOST UNCHANGED, IT STILL SELLS TODAY."

ONLY THE BEST FOR THE ATHLETE

LEAD, DON'T COPY

BE CREATIVE, INDEPENDENT AND TAKE RESPONSIBILITY FOR YOUR ACTIONS

NEVER STAND STILL, AND ALWAYS BE WILLING TO LEARN

THINK OUTSIDE THE BOX IN ORDER TO GET IDEAS

OBSERVE!

Be Open-Minded And Look Toward The Future

TEST, TEST AND TEST AGAIN

Respect Your Products

FUNCTIONALITY, FIT, WEIGHT, AESTHETICS & QUALITY MAKE AN ADIDAS PRODUCT

OUR PRODUCTS MUST ALWAYS BE RECOGNIZABLE AS ADIDAS PRODUCTS

The adidas Standards are inspired by Adi Dassler. Adi was not only a shoemaker, athlete, visionary, and business man but also was a teacher. He was constantly writing down thoughts on scraps of paper or on a tablet. He even had a notebook by his bed so that when he was sleeping, if he had an idea, he could wake up and write it down. We were given these notes by one of his daughters, and we boiled them down to thirty-one adidas standards. While there are thirty-one of them, there could actually be ten times as many. This is the essence of Adi. This is how he wanted his company to be, and to me adidas is still his company. These are some of my favorite standards:

"Only the best for the athlete." That's how this company should live and breathe.

"Observe." Don't tell kids what to wear. Don't ask kids what they want to wear. Observe them, and you'll understand what you need to do. Observation is my idea of research—not focus groups, not all the other stuff that fills those black boxes called data centers.

"Always attempt to simplify every process as far as possible." It can't be any plainer or clear. Or in other words, eliminate the bullshit.

"If you are not in favor of trying new things, at least don't be against them." In other words, don't play politics. This is as relevant today as it was when Adi first wrote it—perhaps more so.

"Respect your products." And one that I really like is, "Our products must always be recognized as adidas products." For those of you who don't like the 3-Stripes, move on.

"Learn from worn products and returns." In another words, the athlete may tell you one thing, but, if you look at his shoes, it may tell you another thing about what's really happening.

"Test your own product yourself." You don't have to be a world-class athlete, but if you're in Running, you probably should at least have run enough to experience what a runner experiences, so when a runner talks about these things, you can relate.

While based on past experience, the adidas standards were intended to address key issues facing the brand today. Issues at the forefront of good product design, like optimal fit, comfort, and performance. Through better quality, a consumer perception would be built that adidas has the best fit, comfort, and performance in the industry. This perception would be fact and the result of great design coming from adherence to the standards. It would not be at the expense of technologies, or margin or commercial gain—none of these things would be compromised. Rather I think they would be enhanced and be more honest.

So, for me, while informed by Adi Dassler and the past, the adidas standards were a modern way of life for the brand. They were what the brand should and shouldn't do today. The first thing I would say to anybody coming into the company is these are your ten (or thirty-one) commandments. Live by them.

Following: Adi Dassler inspecting soccer boots

"'ONLY THE BEST FOR THE ATHLETE', THAT'S HOW THIS COMPANY SHOULD LIVE AND BREATHE."

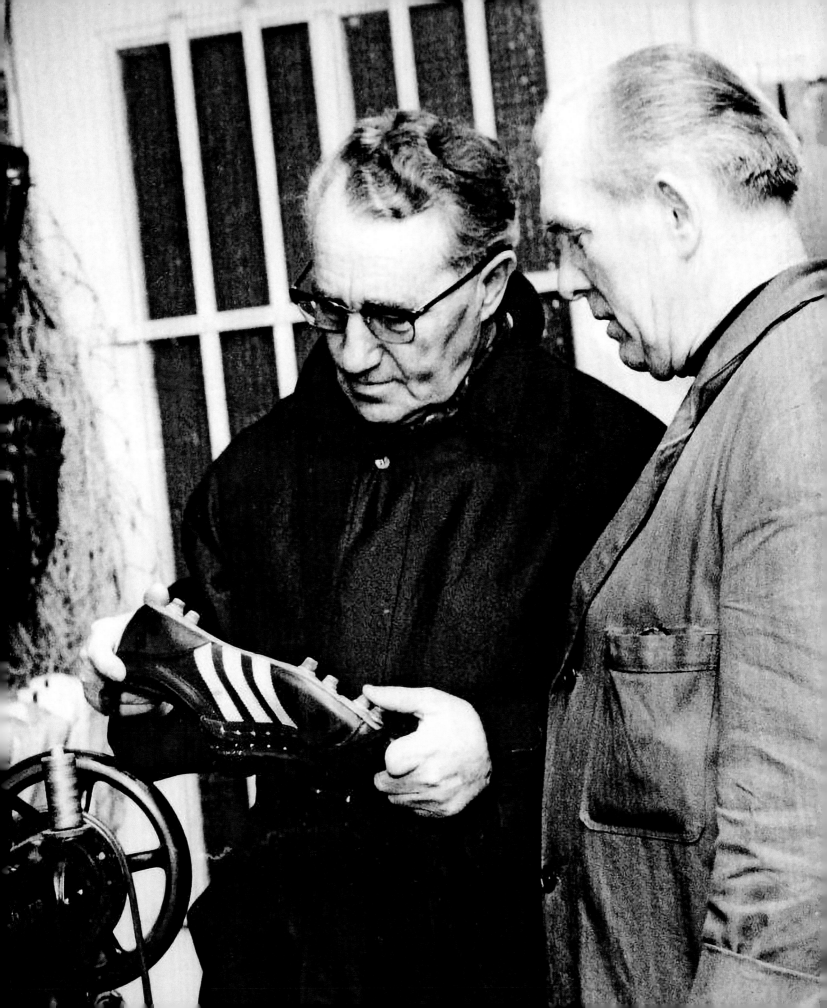

Alongside the adidas standards, the second piece to preserving adidas's heritage was the creation of an archive. It seems crazy now for a brand so steeped in history not to have a proper archive, but previously the adidas archive was just a dark, dingy room in Scheinfeld, an old adidas factory. It wasn't qualified to preserve anything, much less items that are historic and one of a kind. Thankfully, it was managed by a great guy named Karl-Heinz Lang, who had worked with Adi Dassler as a technician and was passionate about preserving what history he could with little means and resources. Some might call it an embarrassment. (It was closer to a disgrace).

Many others at adidas and I had campaigned for there to be a formal archive created for years. Although everyone thought it was a great idea, no one in a position to do anything about it actually did anything. As often happens, it was effectively an ultimatum that led to action when Lang finally retired and approached adidas CEO Herbert Hainer. He said, "This is your legacy. Keep it or lose it." It was a case of "adidas, wake up! It's now or never."

The dream of an official archive finally came into existence thanks to the persistence of Karl-Heinz Lang, Viktor Körber, Ina Heumann, and the support of Mike Riehl, who was the head of sports marketing. Initially, the archive, which was still mainly shoes at the time, remained in Scheinfeld, but with the new "Laces" HQ being under construction at the adidas World of Sport campus, Ina asked if it would be possible to move the collection to the new building. Thankfully, her timing was perfect, as there was still room available tucked away on the ground floor. When Laces was opened in 2011, the archive finally had a permanent home and a dream was realized.

Today, the archive is a key part of adidas. The collection now contains far more than just shoes, although there are certainly a lot more of them. It also contains apparel, accessories, marketing and comms materials, historic documents, and even some of my old sketch books (who knows if they'll ever be of use though). In many ways, calling it an archive doesn't do it justice. The term conjures up images of dusty old relics that sit rotting, but the adidas archive is one of the brand's most vital resources for building the future. While preserving the past was always going to be one of its main reasons for being, rather than just housing a bunch of moldy antiques, it's a source of inspiration and learning. **Designers, creatives, athletes, whoever—they can go to the archive and not only see historic artifacts from the company's history but also what did work and what didn't work. A lot of people see history as an anchor to where we've already been, but it really isn't. Used properly, it can show the way to where we need to be.**

Opposite: Karl-Heinz Lang at the adidas archive in Scheinfeld

"CALLING IT AN ARCHIVE DOESN'T DO IT JUSTICE. THE TERM CONJURES UP IMAGES OF DUSTY OLD RELICS THAT SIT ROTTING, BUT THE ADIDAS ARCHIVE IS ONE OF THE BRAND'S MOST VITAL RESOURCES FOR BUILDING THE FUTURE."

When I started working with the adidas archive in 2014 to help build the collection, I was known as the 3-Stripes "kellerassel", or 'woodlouse', because I spent a lot of time exploring through moldy storage places and cellars in the old adidas buildings to see if there was anything of our history left. Thankfully, there was!

Today, the adidas archive contains more than 40,000 products and more than 2.5 kilometers of files, trademarks, patterns, videos, images, and catalogs. But it's more than just a collection of objects. It's a source of inspiration and connection for everyone, because every single item contains our DNA. Naturally, people assume it's just our Originals team that use the archive because they might be looking to do a one-to-one retro or a new interpretation of an original model, but it's used by many people. For example, a lot of our colleagues come for creative inspiration. It could be for ideas for the design of the specific part of a shoe, different iterations of 3-Stripes, or different versions of tongue-labeled slogans that are on shoes. When the marketing team are doing new campaigns, they like to get inspiration from the old images, catalogs and communications materials that we can give them. We also support the collaborations adidas does, for example, Gucci, Wales Bonner, Sean Wotherspoon, and Jerry Lorenzo. All of them have taken inspiration from the archive. And we have athletes coming in to see the world record breaking shoes of their predecessors, which is a part of the brand induction program we do.

There are so many connections that people have with the adidas brand on a personal or professional level. When people come to the archive you really see how it has been part of their lives. Someone came to the archive recently and started to cry because he had always wanted to hold the gloves of Manuel Neuer. Those are the moments we live for because it shows that we have this deep connection and credibility with people over decades. Even I still have my pink tracksuit with the Trefoil on it from when I was one year old! There are two sides: the inspirational side as part of creating new products and the emotional side that you see during those special moments.

To connect our history with our colleagues, we have two exhibitions on our campus that get updated regularly. Our history is what makes us special. We are a brand with a tradition that spans many decades, and that's something we can be proud of and want to share. If you don't share it, it's not worth anything. People also want to share their stories with us. We like to get their feedback, connections, and stories. You can put an old shoe out on display, and people might say, "That's a nice old shoe," but if you can tell a story around it, that takes it to another level of connection.

The legacy of Peter Moore is in almost everything we do. It was Peter who reminded us of who we are as a brand, and that's why we have him in our everyday life. He's a big part of the reason that we have an archive. Without Peter, we would not be here in Herzogenaurach, where our founder Adi Dassler started the company. I'm not even sure if we were somewhere else in the world the archive would have been kept. As a brand talking about its founder's roots, not being in Herzo wouldn't make any sense.

When I go through Peter's old sketchbooks, there are so many of his ideas that are still part of our brand—most visibly for example, when we tell the stories of our logos. If we talk about the Performance logo or the Equipment logo, that's Peter Moore through and through. What we also learned from Peter is that sometimes simplicity is more effective than anything else. Simplicity in design, simplicity in communication.

His work continues to force us to ask questions of ourselves. What does Originals stand for? What does adidas as a performance brand stand for? Peter taught us that sometimes you really need to risk something and compete to find success. Look at Adi Dassler and Rudolf Dassler, their competition forced them to strive to be better, and that's why they were both so good at that time. Peter showed us that when adidas was on top and then lost our place to Nike in the late '80s, it was because we were too lazy and didn't risk anything. We've never forgotten that lesson, and that's why we feel his spirit every day."

SANDRA TRAPP SENIOR MANAGER HISTORY MANAGEMENT, THE ADIDAS ARCHIVE

6/6 7/2018 MY IDEA

MOORE WORKS ON PAPER

ART 1977–2022

"ART NEEDS TO COMMENT, IT NEEDS TO HAVE OPINIONS, IT NEEDS TO PROVOKE, IF NOTHING ELSE, CONVERSATION."

ART, IN MY OPINION, doesn't have to be beautiful, or visually pleasing. However, it does have to stimulate some emotion, and thought.

This statement is how I feel about this thing we call art. I look at art often, and often I see a very wonderful, technical piece that after two of three viewings, loses something. This is an issue, for me. Pieces which are technically perfect often don't say anything, so after a number of viewings you begin to find flaws in the technique, that to me isn't what art is about. This it seems is rendering, or illustration.

Art needs to comment, it needs to have opinions, it needs to provoke, if nothing else conversation. As someone who is trying to enter this rather clicheish world of art, and artists, doing this kind of opinionated work doesn't make the task any easier.

Sister Corita is the person who got me interested in screen printing. I went up to the school where she was teaching one evening in LA to hear a talk on printing and she was the one giving the talk. I hung around and talked with her afterwards. That is what was so great about the LA that I lived in way back in the day 1967.

This work is only a few results of a life-long fascination with combining pure graphic images or symbols together sometimes with photographic images. This can make for a rather powerful, visual way to say something. And it seems, I have a lot to say.

My main goal in doing art is simply to express an observation, an opinion, and in doing so, stimulate a conversation with the viewer, or between the viewers.

It is only through conversation that any real progress can be made in this world.

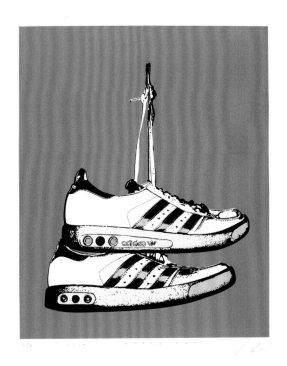

Grand Slam (2004)

ADIDAS

Unfortunately, I've never had a conversation with Peter about this specific peace Trefoil. When Peter arrived in Germany in 1989, the Trefoil represented why adidas was in trouble at that time. But, Peter being Peter, he took on the challenge. He realized that there are so many emotions connected with this logo that he couldn't ignore. He put a lot of effort in to revitalizing this beautiful shape...and finally made peace with the Trefoil.

INA HEUMANN

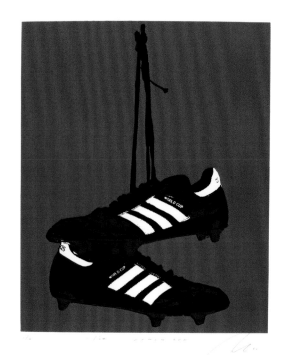

World Cup (2004)

Kegler (2004)

9/10 6/2018 PEACEFOIL

Peacefoil (2018)

2/5 2/12 ORANGE DEFENDER

Orange Defender (2012)

3/5 7/2016 AfriCAN

African (2016)

AFRICA

I don't expect everyone to agree with what I want to express with my pictures. And I have no intention of making any. The messages in my pictures are my reaction to reports in the US media and various articles about Africa. For me, Africa is a synonym for wasted opportunities. Africa is a continent with enormous potential that, tragically, is never recognized by the majority. Perhaps this can change as more people talk about Africa, and perhaps these art pieces can be one of the sparks that ignites these conversations.

PETER MOORE

Freedom Is Expensive (2012)

2012 53 11 712 434

Africa for Sale (2012)

PLASTIC POLLUTION

In 2015, I got involved in opening a culture and art café in Accra, Ghana. Not only did Peter design the logo for Abajo after I sent him some photos of the plastic pollution at the coast, he started to create art pieces. And this is how it started...

Ina......... What is the name of the most popular fish in Ghana......... ocean fish not fresh water?

Dear Peter, the most popular fish is Red Snapper. Why are you asking? Ina

Oh, you will see........... Peter.

Subject: Now You Know. Ina.......... The first of the sea prints............. What'a ya think?

And Peter was excited to see that those prints against plastic pollution made it to Accra to be put on the walls there.

INA HEUMANN

Toxic Drink (2016)

Plastic Snapper (2016)

9/2016 TRUTH!

Truth (2016)

The American Way (2004)

M.L.N.W (2007)

Outta Control (2015)

POLITICS

A lot of my dad's art work was political and social commentary. He had his opinions, which are fairly evident in his work, but his point wasn't to tell you what is right or wrong… His point, in my view anyway, was to cause a reaction and inspire action. Exactly what the reaction and action are must come from within the person viewing the work. If nothing else, he hoped to open up a conversation through his art. We had a lot of those conversations together, and what I took away from them was this idea that, as humans, we are all complicit in what happens here… So are you going to do something about it or not? For my dad it was all about peace, and one of the things he did about it was to promote it through his art. He believed that if he did enough of it, someday, someway, it might help create peace in the world.

HAGEN MOORE

Express Yourself (2020)

SW 99 (2003)

H (2004)

The Way We Are (2004)

What'a Ya Want? (2008)

At What Price Success (2006)

WORK LIFE

If you were ever in a meeting with my dad you probably noticed him scribbling in his sketchbook. Most often he was taking notes or sketching up design concepts, though not always, sometimes those scribblings were a little different, a little odd you might say... He liked to draw people with screws going through their heads. I think it was his way of coping with bureaucracy and an overabundance of meetings.

HAGEN MOORE

Paper Work (2003)

7/55 Christmas 77 12/20/77

Peace (1977)

PEACE

I honestly believe that only through conversation of issues, opinions, and feelings can we begin to understand. And only with understanding of each other can we learn to live with one another in a peaceful way.

If we keep talking about this peace thing, who knows? Maybe some day it'll make a difference.

PETER MOORE

Think (1983)

Peace (1985)

Peace (1978)

Monica (2008)

One Defines the Other (2019)

Peace (2020)

Peace (1995)

Peace, It's Complicated (2016)

Peace (2006)

Peace (2016)

Peace (1987)

Peace (1987)

Peace (1991)

Peace (2001)

Peace (2010)

Peace (2017)

Peace (2019)

Peace (2021)

THE LAST ONE

Come Together Right Now...

Okay, Christmas has past, and for being late I'm sorry. But, time should not, and will not, get in the way of my plea for Peace. This year, some would say it was a good year for Peace, I would disagree. Ending a war disgracefully, walking away leaving the very people you were there to protect does not create a peace it creates genocide. Having the capitol of the United States of America attacked, damaged, and basically overthrown is not creating peace; it is civil war, treason, and criminal. Having the monster who created the above treason, none other than the President of the United States, be allowed to walk free and continue to spew his hateful rhetoric speaks for itself and how ununited these States, and people really are.

That's enough of that.... point made I hope. My thinking recently has been more toward accepting the facts and finding common ground where we might come together and create a third. That's what this years card is trying to convey...... Look at the image, is it black or is it white.......alone there really is no image... but together there is. Another interesting thing that happens the black is still black the white is still white. The Dove is not gray, not a compromise, rather a unique third, element. A moment to be enjoyed. It might take you a few minutes to get your head around this, but don't take too long the clock is ticking, in more ways than one.

PEACE

Devo (2007)

Dil (2002)

An Irish Rogue (2004)

FAMILY & FRIENDS

My Dad loved doing portraits, for us, for our family, but also for friends and even people he had just met. He was very interested in people and learning about their interests, their work, their ideas, and so on... I think doing portraits was a way of commemorating what he'd seen in the person or experienced through them... That and sometimes I think it was just to screw with us a little. He had a great sense of humor that you can see come through in some of his portraits."

(Following) "For my parents and our family, the beach has always been a place to escape the day to day to simplify everything, and to enjoy the moment with family. My dad captured that nicely in some of the beach images that he created for the family beach-house. In those images, I see a single moment in time portrayed through a simple graphic style with a pleasing color palette. I love that it's got that more-is-less approach and comes off so relaxing and comforting, just like being at the beach-house.

HAGEN MOORE

Rogue Rob (2004)

Alaska Fishing (2017)

Safe Harbor (2018)

Boatsman (2017)

Crabber's Twilight (2018)

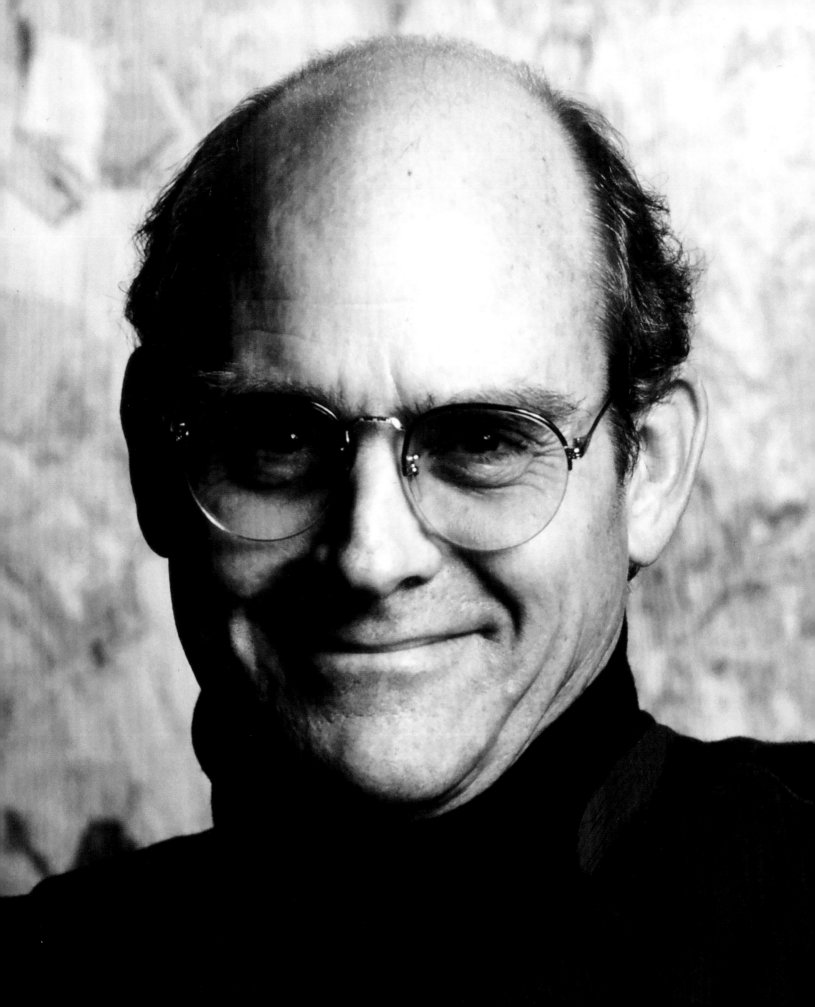

DEEP
ROOTS
& MANY
BRANCHES

LEGACY 1944–2022

PETER MOORE WAS A VISIONARY. A creative genius. An industry legend. He was a man that helped shape the footwear industry and shoe culture from the earliest days. He created some of the most iconic logos, products, and marketing campaigns of all time. He was a gifted creator and a generous mentor. He was also my father, giving me a front row seat to all of it, and I would not trade that for anything. He influenced every part of my life, personally and professionally. And he is greatly missed. I've often been asked what I think my father's legacy is. To me, his legacy is not all the amazing things he created, rather it is the impact he had on people, the designers whom he mentored, those with whom he worked and even those who never knew the man but loved his creations. He was always available for people, and he loved collaborating with and mentoring other creatives, willingly sharing his time, talents, and teachings. I believe his legacy lies in those people whom he impacted, and it lives on through them to this day.

At heart, Peter was a creative problem solver. He followed a few design philosophies, like "The solution to the problem is in the problem itself," "Form follows function," and "Keep it simple, no bullshit." He loved to look at a problem and find the simplest solution, usually one no one else could see until he created it. The original Air Jordan winged basketball was done on a napkin during a flight when he saw the plastic pilot's wings that the flight attendant gave to a little kid. Jordan was a flier. They were going to call it Air Jordan, and the winged basketball just made perfect sense. The Jumpman was done as Michael's version of the Ralph Lauren Polo player logo. It was literally Michael doing what he does: flying. Again, a simple idea well executed. The adidas logo was taken from the stripes as they sit on the side of a shoe. Start with the problem, (i.e., how to design a logo for a shoe brand), and the answer will be found. Look to the shoe for inspiration. He said he was never the best designer, illustrator, or painter, but he was amazing at finding the perfect idea at the perfect time. And he could express that idea in a way everyone could understand. He passed this on to everyone with whom he worked over the years. And he made an impact.

When Peter passed away, the outpouring of kind thoughts and words from around the globe were very comforting to my family and me. However, I also noticed every one of them included something about the impact Peter made on their lives. Certainly, he lives on through the things he created, but also through the people he impacted. Some of the top designers in the industry today came from the Peter Moore tree. Many of the designers whom he taught and influenced are now teaching and influencing others. Each, in turn, will take a little of what they learned into their careers and pass it on to the next generation. The Peter Moore creative tree has deep roots and many new branches. It continues to grow, even after he has gone. Now that is a legacy.

DEVIN MOORE

There are very few magicians in the world, and Peter Moore may be one of them.
ULI BECKER FMR SVP BRAND MARKETING, ADIDAS

Peter was the brand keeper!
SABINE BEYSEL FRM DESIGN DIRECTOR, ADIDAS

There's an old trick where if you put four dots on a sheet of paper and I give you a pencil and tell you to connect all the dots with a straight line in as few lines as possible, your first reaction may be to draw a box, but the actual answer is you should go all the way out, come back up, and come across. It's a triangle. And that's where the phrase "break out of your box" comes from. Peter and Rob always let me be a triangle instead of a box.
KEN CALLAHAN FMR VP SUPPLY CHAIN, ADIDAS

A really wonderful quality of Peter's and something I really picked up looking at his posters is that, as a creative person, **he was able to hold two opposing ideas in his mind. He could play visual games of, "Is it a hawk, or is it a dove? Is it black or is it white?"** It's both. It's many things. I think that was definitely a part of his genius. Even as a human being, as a person, he held so many things within him. From using swear words to being a very gentle, humble person, to giving people room to do what they want to listening, to having fabulous sense of humor, he was so many things in one person, not just a singular thing. One day you might meet Peter and think, "Yikes, stay away!" Then another day think, "Oh, my God, he is such a prankster!" There were just so many things about him that seemed like opposites, yet it all worked, wrapped up in one human being.
KADIE CASEY FMR VP BRAND DESIGN, ADIDAS

I have only one word to describe Peter Moore: "marshmallow." **Crusty on the outside, soft on the inside.**
OWEN CLEMENS ADIDAS

If you didn't know Peter, the first time you met him it could be quite imposing because he didn't open up immediately, but once he got to know you, then he opened up. **He always had time. He always listened to what you had to say.** The way he communicated with people, he was very direct and he didn't cut corners. He didn't have to say much for you to understand. Not many people have this ability to communicate in such a clear and concise manner. When we were in the Jantzen building, if it was someone's birthday or we were celebrating something, on a Friday afternoon after work, he used to love to coming with us across the street to a little bar called Club 21. He really appreciated that, and

he always had the loudest laugh in the room. Peter was always open for good humor and to have a good time with his people. You don't see that in many places, where the person in charge always spends time with the team, but he was always open to us. His office didn't have a door to close. I think everybody who worked with Peter had two phases in their lives: pre-Peter and post-Peter. You're a different person once you know Peter.
JUAN DIAZ FMR SNR DESIGNER, ADIDAS

I never got to work closely with Peter during his building role at adidas. It was before my time. But something I learned from him is that regardless of what part of the brand I've been leading creatively, **adidas is more important than your project**. I worked a long time on fashion-led projects like Y-3, but it was driven home to me by Michael Michalsky and Hermann Deininger from the schooling that they went through with Peter and Rob. Sport has to be at the core of everything adidas does. And then you have to have the courage to see how far you want to take it. And that's why I think it's really important not to be afraid to look at the work that Peter did and take it to new places. We shouldn't be afraid of that because he would have done it himself. We should also have the courage to really stretch it, because there's no point sticking in the past and being in a museum. He'd have hated that I'm sure.
NIC GALWAY SVP CREATIVE DIRECTION, ADIDAS

There was a poster that was an Equipment ad and Peter was absolutely behind it. It was "adidas welcomes Nike to Europe" and it was these guys in Equipment gear, all dirty and muddy mooning. That's Peter in a nutshell. That was why I wanted to work with him, and the goal was to be the best. It was never any discussion. Best sports brand in the world, what does that mean? If you said Nike is bigger than us, you would get chewed out. Peter brought it up. BEST: you got to make the best shoes, you got to go work with your athletes, you got to make the best creative. People have to be able to say, "Who's the best?" That's what Peter wanted and the standard he held us to.

When I took over the studio here in Portland and we had some open headcounts to fill, I asked him, "What are you looking for? I can get one or two 30-year-old guys from Nike, or I can get four or five kids out of school." He'd say, "Kids out of school. It's going to be harder. And yeah, that's what you want." He loved that young and hungry mindset, and he believed wholeheartedly in the power of design to move business forward. He would send us into the fire, but then he would back us. You knew, if you went into an argument

with a bunch of marketing guys or developers, you could go there knowing that Peter was back there. He just believed in the power of design, he wanted it to succeed as unfettered as possible and so he nurtured and supported it. He stood out in front with you with the flag. **Peter's legacy is all of us—the people that he worked with and gave opportunities, as well as supported, defended, coached and hung out with. We've certainly passed those lessons on to others. There are people working all over the industry right now, who benefited from Peter, if not directly then indirectly through people like us. We learned from him, more than you can learn from anybody.**
PAUL GAUDIO FMR GLOBAL CREATIVE DIRECTOR, ADIDAS

I think in terms of influence at adidas, Peter is the first soul who comes after Adi Dassler. I can't think of a person spoken so much about when it comes to what he or she has done for the brand after Adi Dassler. **Peter's legacy stands for creativity and the brand. I might be wrong on this, but there's no other name that comes to my mind in the last forty years that people have such respect for when it comes to what the brand is about.** Of all the people who have been good in product, design, and of course, on the commercial side, I think Peter is unique. He is only second to Adi Dassler in importance to adidas.
BJØRN GULDEN CHIEF EXECUTIVE OFFICER, ADIDAS

There are so many memories I have with Peter, but there are those little moments that just stuck to me. Once, I received Equipment apparel samples from our manufacturer. I got them out and put a scarlet red Equipment sweatshirt on my desk. Peter was two desks away and he said, "Ina, that logo is wrong. The dimensions aren't right." I looked at him and I looked at the sweat shirt. I thought, "Wow. He is right." And he was even looking at the logo upside down. This to me was the purest example of "watch the details."

Remember the time before computers? Peter's favorite machine was his fax machine. I received many faxes from him with his very concise handwriting. Then when computers were introduced and even email, Peter said, "I don't need this, I have my fax machine." But one day I received my first e-mail from Peter. He did fight a lot with technologies. He could be a real angry man, throwing phones around when they didn't work. But then seeing him figuring out Illustrator was fascinating because he was able to create different things with it.

This story might be minor for some people. **Peter, as our creative director and board member, he would**

get a memo saying, "Mr. Moore, we have a driver for you during ISPO in Munich. He will bring you wherever you need to be." Peter's answer was, "I don't need a driver. I take the U-Bahn." I took a lot of U-Bahns with Peter and went on a lot of trips with him. Getting to see the world through his eyes is something I do not want to trade for anything else. By the way, Peter never rode a skateboard!

Many years later, Peter asked if I ever did a mock-up of a book. After I said no, he said, "Come on, I'll show you." We went to the printer room where he printed out a PDF of our first brand book. He cut the pages, glued them together, put the cover around, and gave it to me with both hands and said, "Here you go, Ina, now you can do the next ones." And ever since, I did a mockup for every book I was involved with, including this one, which meant I could finally give back to Peter.

INA HEUMANN BRAND CARETAKER, ADIDAS

The crazy thing is Peter called me a lot more than I called him. Even when I was still in the mail room, he'd call on me and say, "What do you think about this? How do you think these colors go together? What do you think about this shoe?" And it could be a five-minute conversation or a twenty-minute one. So I felt really privileged to know him because I had to ask myself, "Why am I even here? I don't have a degree in design." But all he saw was my passion. I was just a mail room person and to have the creative director asking your opinion was like, "Wow!" As I grew in the company, the thing I loved most about Peter was his honesty. He was always so honest. **He didn't hold his tongue and right or wrong, he was always honest.** That's one of the things I've always tried to model; be honest and true to yourself. He'd probably get fired in today's world because he was always so upfront, but I think that's what everybody appreciated about him. You knew where you stood with Peter. Like you actually knew. The other thing with Peter was his passion for the industry, design, and sport. It was second to none. I really don't think people understand how important he was. He never took credit, but he's really, really important to this industry. A lot of stuff in this business just wouldn't have happened without Peter Moore."

TONY HOLMES SNR PRODUCT MANAGER, ADIDAS

To me, Peter Moore's impact at Nike included the following in order of importance:

1. He introduced me to Dan Wieden and all that followed. He had known Dan from working on the Georgia Pacific account together.

2. He designed the Jordan "Jumpman" logo which has become world famous.
3. He designed the McEnroe tennis clothing line, which was our first athlete signature clothing line.
4. He designed the original Jordan logo: the winged basketball logo, the product that became famous for being banned by the NBA.

Peter was the opposite of the corporate executive type. He was a very creative guy with a bit of quirky personality, which meant he fit in perfectly at Nike.
PHIL KNIGHT CHAIRMAN EMERITUS, NIKE

"Erich Stamminger, who was my predecessor, kept Peter very close. He did it because Peter wasn't just a brilliant visionary and creative director but also because he knew how to get ideas across. He talked. Peter talked. He's one of those guys who talked in ideas. There's the famous expression, "Small people talk about people. Great people talk about ideas." Peter was a truly great person. He talked about ideas, and ideas overcame people. He got to the bigger thing of, **"What's best for the brand," and he always had his North star, which brought people who also cared about the brand to him.** Everybody came to him because they knew his heart was always in the best interests of the brand and the people. I think there was a level of psychiatry to it because Peter was such a listener and processor. He didn't always have the right answers, but sometimes he let us just talk things out for ourselves. But in typical Peter humility, he always brought things together, then stepped the hell out of the picture. He would say, "No, this is about what Adi Dassler would do." I think about Peter at least every day. He's one of those guys who leaves a hole in your life. And it's not like I spoke to him every day. It's not like we ever really worked arm in arm together. He was a creative director, and I was a marketing schmuck, but he had an impact. You could go to him for counsel, friendship, and guidance. And he was there. His door was always open. He was an amazing human being.

ERIC LIEDTKE FMR CHIEF MARKETING OFFICER, ADIDAS

I don't remember my first actual encounter with Peter. I just remember being incredibly intimidated by him, because he came across as a hard nut to crack, especially as I came over from Reebok, so I was trying hard to prove I belonged. He was famous for always being first at the office, so I decided to try to beat him in. **I started going in at 4:30, and he was already there. I tried 4:00 for a while, and he was there. I gave up when I got to 3:30.** Eventually, though, I managed to crack the nut. Typically, I worked Saturdays, and I would bring my youngest daughter, who was probably seven at the time,

into the office. Because it was a big open warehouse space, she'd bring her bike so she could ride around the office. Because I knew Peter didn't like to be disturbed, I used to warn her, "Don't go talking to the man in the corner office. Leave him alone!" So one Saturday, she's riding around, and then all of a sudden, she stopped riding past my office. And I was like, "Shit! Where is she?" So I started searching the building to find her, and I found her talking to Peter at the copy machine. As I started walking up, I realized that Peter was incredibly animated and explaining to her what he was doing. He just looked like a grandfather, talking to one of his own grandkids. Later, he came over to my office and said, "Hey, do you have any pictures of your daughter playing soccer?" So I brought some in, and he did an adidas poster, "A Brand to Grow With." From that day on, the ice was finally broken and we started to have a good relationship. I always give my daughter the credit for really breaking the ice between Peter and me. So that's really my first memory of him, thinking he was this scary tough guy, but then getting to see that actually there was this soft side to him.

ED LUSSIER FMR DIRECTOR OF US MARKETING, ADIDAS

I met Peter and Rob Strasser on one of their first visits to Germany. At that time, I was based in a research lab we had in Switzerland, but I was called to Germany because two guys were coming to Herzogenaurach and they thought I should meet them. The first time I met Peter, he didn't talk that much. Rob Strasser did all the talking. I had heard of Peter from an industry point of view, but I didn't really know what to think about him because he didn't talk. It was only later that I got to know him well during the times at adidas and then afterwards when he had his own business and I had mine. When we met, we talked about projects and stuff. His real ability was to listen and ask the correct questions, not pretending that he knew everything or understood everything, but he had the right questions. **His ability to combine what he heard with creativity and then come back and say, "What do you think?" was unique for me—just that ability to listen, to combine, to create and come back and ask if that's correct. He was the ultimate creator.** If I had something, he would be the guy to go to and say, "Hey Peter, look at what I have. What do you think? Can you make something out of it? Does it make sense to make something out of it?" That was his thing, and I have never met somebody like this in the industry before who really had this ability."

DR. SIMON LUTHI FMR VP RESEARCH & INNOVATION, ADIDAS

ADI SIGHT...
ALL I SEE
FOR MILES &
MILES IS ADIDAS.

Self-portraits by Peter Moore

Peter was the dude who first taught me to understand that you could still be in design, or you could be athletic, but also still be an artist. *I was amazed by that, because when I was brought up, my grandmother told me that artists go broke and blind. I went to design school to keep away from that, but I've always had this urge to just paint and create. When I saw Peter doing the same thing, I tried to model myself after him. In design, sometimes you get into a rut and you can't think of something. Art became a way for me to put that away for a second and rejuvenate. My whole life I've been doing that, and I regret I never got a chance to sit with Peter and talk about my work. To this day, I still try to paint. To me, Peter was the best example of a well-lived artistic life. To the very end, his artwork had a story and a message. My trying to be an artist? I haven't figured that out yet. But I still do it, because I think that's where clarity comes from. I thank Peter for that. I'm a Black man from North Carolina, and I've designed everything from women's pumps to cowboy boots to basketball shoes. It's all because of the experience I had with him. There has been no bigger influence on me in my design life than Peter Moore.*
GUY MARSHALL FMR SNR DESIGNER BASKETBALL, ADIDAS

My relationship with Peter began in 1977, when I was working with my father at our family commercial printing business and was making cold calls around town. I called on the studio in downtown Portland where Peter, Jim Bagley, and Ron Dumas, his student at the time, had set up their graphic design shop. I introduced myself and asked if he could spare a few minutes of his time, to which the swift reply came, "I don't have a minute." Among many of his traits, Peter was efficient, wasted no time, and was very direct. But eventually, I found that Peter did have minutes. In fact he devoted many of his minutes to the people and things that were most important to him. I eventually wore him down showing up unannounced with print samples. Peter would just shake his head and say absolutely nothing. Finally he said, "Are you just going to keep coming down here 'til I give you a job?" To which my swift reply was, "Yes." That was where our business relationship began and over the next forty-five years we would spend many minutes together working on Nike; Sports, Inc.; and adidas projects. Peter dedicated many of his minutes to me and my struggling business. When it was clear that his star was rising in and many wanted a piece of him, Peter remained incredibly loyal.

It was in those long days and late nights over press checks that our friendship grew and I got to know my friend Peter. On paper, we were so different but, in

those late minutes, we bonded and it's where I learned about where the other half of his minutes lived: with his three boys and his sweet wife, Christine. We'd brag about our kids. He talked excitedly about the sports the boys were involved in and, later in life, he talked with pride about the career paths that they had chosen and about his appreciation for his daughters-in-law and his amazement over his grandkids. In those minutes over the years, I came to know Peter not as a creative wizard but as a big old softy dad and grandpa, just like me. In those late minutes, we'd commiserate about our wives' shared love of junk, as we called it, and how Heather and Christine could not at any cost pass a garage sale, antique sale, or anything that was for sale anywhere, that they could potentially stick us with.

Over the early years, our families became close. It only took a few dinners to see who the real boss was—the rock, the cornerstone of the Moore family. It was Christine, and Peter knew it. It's not difficult to understand why Peter circled his wagons so close. He was sure to spend every one of his minutes purposefully. *His legacy was not only in the art and the work he created, but in the way he spent those minutes. He was an honest business partner, a loyal friend, and a loving family man.*
TJ MCDONALD PRESIDENT, IRWIN HODSON PRESS

I first met Peter Moore after I was recruited by Rob Strasser when Nike were closing its Exeter R&D facility. I was running my grandmother's garment factory and my husband at the time, Sandy Bodecker, was a wear tester there, making $11,000 a year. They wanted us to move to Oregon but I wasn't moving across the country for $11,000. Rob showed me some of the wild tennis stuff Peter was working on and somehow convinced me that we should move to Oregon. On my first day at Nike, I was sitting in my office and, in the conference room on the other side of my wall, this crazy meeting was going on. The apparel team was presenting to Rob. He got so mad at how this stuff looked that he started throwing stuff and swearing, "This is the worst shit I've ever seen!" Afterwards, this guy walked out and stopped at my door. He said, "So, you're the person who's supposed to know how to make stuff." And I was like, "That's me, I guess." So then he said, "Let's go to lunch." We went for what would become the usual burger and beer. That was my first meeting with Peter.

My first project for him was like my test. They were trying to potentially sign Patrick Ewing, but I think what they were really trying to do was get somebody else to pay a lot more money because they couldn't have both

Jordan and Ewing. Peter's idea for Patrick Ewing was a sort of Terminator costume. We sketched all this out on a napkin. He was like all padded and he said, "Well, let me see what you can do with that." So I took it, made the samples myself and brought them back to Nike Design in four days. He looked at it and he said, "Wow, you really do know how to make stuff." From there, we just hit it off, and every idea he had I would try and figure out, because some of his ideas were way ahead of their time. He was just incredible. **I learned so much from him about how to think about design. His ability to communicate with everything that he put on a piece of paper, it was like I could feel it, I could see it, I could imagine it, so it was really easy for me to bring those things to life.** *It was a great relationship that lasted a really long time. It was fun. So much fun.*
MARY MCGOLDRICK FMR APPAREL MANAGER, NIKE & ADIDAS

Peter was my introduction to the athletic apparel industry. When he took me on at adidas in the early '90s, I didn't know exactly what he wanted me to do. I think it was more that he was allowing me to explore what I could do, and so I had a chance to work in all these different areas of apparel and find my space. I felt really honored that he saw that value in me at that time. It was like nothing I've ever experienced. Those were formative years for a lot of us. It's a moment stamped in history. All of those designers who started out in that space have gone on to be director or VP, CEO, or founders of their own business. Peter was the foundation of a lot of our lives. Peter was so protective with the designers. To me, it always felt like his hand was always over the design community, protecting them. **He saw a place for me in the industry that I hadn't figured out yet. He knew before we knew, who we were.**
ANGELA MEDLIN FMR APPAREL DESIGNER, ADIDAS

I got started with Blue Ribbon Sports in 1976. I still boast about my employee numbe,r which was twenty-seven. I started as a receptionist and, back then, we didn't even have time for a job interview. It was just, "Oh, my gosh. We're growing so fast. Patsy, can you go into sales?" So in '78, I ended up being the advertising manager's assistant. She'd done a price list. While she was on vacation, we needed to change it and that's when Peter and I started working together. We had to figure out how to fix the price list. After the ad manager was fired, Peter and I worked really well together, but they hadn't filled the role even though I'd been doing the job for maybe a year or something. At the time an organizational chart came out. It showed Peter as the

advertising manager! I thought "Well this isn't fair! And Peter isn't even an employee!" They apologized and I became advertising manager. I got to travel around with Peter doing the photo shoots for the posters. He did all the marketing collateral, the brochures, price lists, and annual reports. I learned so much from him.

We had an advertising agency, John Brown & Partners, but they weren't turning things around fast enough so we decided to find someone local. Peter was good friends with Dan Wieden, who he'd worked with at Georgia-Pacific, and Dan was at William Kane agency in Portland with Dave Kennedy. We began working with them, but Dan and Dave didn't like Bill Kane. He was too restraining, and he always wore a three piece suit. He was not Nike. So Dan and Dave came to us and asked if we would go with them if they branched out on their own. I ran it by the director of marketing and he ran it by Phil Knight. The answer was yes. **So they started Wieden+Kennedy, but they literally had nothing. Not even a typewriter. So I loaned them mine from my college days and someone else gave them a card table and they rented space in an office building. There wasn't even a phone, so they had to use a pay phone down the hall.** The first thing we did with them was the back cover ad on Runners World, which Dan typed up the copy for on my typewriter. That was the start of Wieden+Kennedy. They went on to become a global agency and had a fantastic relationship with Nike and did some of their most famous ads, and Peter and I were part of the start of all that.

PATSY MEST FMR ADVERTISING DIRECTOR, NIKE

In the '90s I was working for Levi Strauss and got headhunted because Robert Louis-Dreyfus had bought adidas and was trying to gather a team of people who could help him make adidas great again. Peter Moore was the creative director and I was told to meet him at ISPO. At that stage, I had no clue who he was. I thought, "Why all the fuss?" The first thing I said to Peter was, "Do you mind me stripping?" He looked up and said, "What?!" He obviously knew I was gay because I'm very camp, and I said, "It's so hot!" And he replied, "It's fine, as long as you keep your T-shirt on." I think that really broke the ice! First, I talked about "Form Follows Function," and his eyes lit up. At the end, I asked him, "So, do I have the job or not?" And he just said, "Yeah, Michael, you got the job." It was the start of a very unlikely "love affair," unlikely because we were so different, but we had a lot of things that connected us. I spent over a decade at adidas, and our relationship became a true friendship, one I don't think many had with him as close as I did.

There was a time I was flying to Portland with Erich Stammiger to see Peter. He asked me, "What are we going to do about Originals?" And I said to him, "You know what? I have an idea." I got a piece of paper and I drew three columns. We split the companies in three divisions. One was for performance (everybody understands this is what you wear for sport), then Originals, which is headed by the Trefoil logo and is our Non-Plus-Ultra-Street Wear and Sportswear Brand rooted in our heritage (of course, it's called Originals because we are the original), and then we had a third column because we were already talking to Yohji. We were thinking that we could have a more luxury version there. Erich said, "Oh, let's go straight to Peter's studio." So we went to Peter, and I gave him the paper. He said, "I think this is a really great idea." And the next thing is we moved everybody and put them in divisions. That's how we started it. **He was quite a big picture guy with a vision. He was telling people that's how we have to do it. I really lived in that vision.**

About a year before I left adidas, I said to him, "Peter, we are such great friends. It's a pity none of your sons is gay." He said, "What do you mean?" I replied, "Well, if one of them, like Dylan for example, were gay, we could go out and you'd be my father-in-law!" He said, "I have to think about that, but you know, he's not gay." I said, "I know, but then we would be related!" Of course, I was making a joke, but we were always playing jokes on each other.

MICHAEL MICHALSKY FMR GLOBAL CREATIVE DIRECTOR, ADIDAS

As a kid, I didn't really think my dad was special because he was just my dad, but I definitely knew what they were doing at Nike was very unique. It was awesome for me because I loved shoes and sport and he did it all. As a kid, I would be in little photo shoots on our street corner, like for a hang tag. I always had, of course the latest and greatest sneakers, and all our friends and neighbors wanted to see them. And Michael Jordan coming to our house was cool. **Once, I came home from summer with my aunt and uncle and there were a bunch of my neighbor kids outside. They were like, "Dude! Michael Jordan's in your house!"** I walked in and there was Michael sitting right in my kitchen.

One time my dad took me up to Seattle for the All Star game. That's the one where Michael did what I think they called the Magazine Dunk, where he's laying sideways. We were sitting in the front row, which was pretty crazy. Then afterwards, we went up to his hotel room. We took the elevator with Hakeem Olajuwon and

he said, "Hey!" and shook my whole arm with his hand. His buddy Adolph was on the phone talking to some girl, saying "Girl, you better get your heels up here." My dad was like, "Alright, time to go!' Going to photo shoots and things with him, and talking and being around athletes and things like that, helped me in my job today. I don't really like people who clam up around athletes or get all weird. Thanks to my dad, I realized they're really just normal people."

DYLAN MOORE SNR DESIGN DIRECTOR, ADIDAS

I worked with my father for a number of years. Almost instantly, once he opened his studio, he started getting back into silk screening pretty heavily. He was always into it, but there was a time when he was still heavily involved with adidas that he just couldn't do it or didn't have the time to do it. But once he opened that studio, he started getting back into it right away. It became evident very quickly that this was his passion. It started with one silk screen, then it quickly went to five silk screens, then it went to ten and now I think there's probably thirty silk screens laid up in there that he would rotate through. Originally, he had a saw horse with a piece of wood on top and some clamps that he would use to hold the silk screen in place. Eventually he bought this super fancy vacuum table that would suck the prints down and hold them in place. He was very much into it. I could just tell that was his creative outlet. He really enjoyed it and used it as his primary medium. He did do some paintings. He did a few but not quite as many as silk screens, and his subjects span the gamut.

There was the political, environmental, and social justice stuff. He did studies on people. He was really into people. He did work on Africa, and he also did a lot of special projects for people to commemorate special occasions— and not only for people he knew, but also for their siblings, nieces, or nephews. He did just tons of that stuff, and that stuff was really inspiring too. I align with his political ideologies a lot. **Watching the stuff that he did for people, like a special silk screen poster for somebody's niece, impressed me. He didn't have to do that. He didn't really even know that person, but yet he did this nice thing for them because he cared about them. That was always inspiring.**

HAGEN MOORE CHIEF COOL DUDE

Peter was always searching for the unknown. He wanted to be unique and rare. He was always trying to find this gem inside of somebody by talking to them, but he also looked to the people around them, for example, their mom, their brothers, or sisters, and that's where he always found a nugget.

It was more about trying to find what's unique and special about that person that breaks through and becomes unforgettable. That's what he was always trying to do. If you look at every single one of the athlete projects he did, you could pinpoint what was unique and unforgettable and would last the test of time. He was just so insightful on everything. We signed these tennis twins, the Jensen brothers, who won a tournament. Our head of tennis said, "These are the two young rebels of tennis. They are the next John McEnroes." Peter's eyebrow went up because he did McEnroe with Nike. He made these guys look as cool and desirable as you'd ever seen. He did a poster with them in which where they were just hanging out on the back of Harley motorcycles. It was basically a McEnroe 2.0. These guys really were rebels. They didn't want to follow the rules, and he brought that out. The thing is Peter was the same. He never wanted to do the obvious, which I thought was so cool.

RYAN MORLAN FMR GLOBAL DIRECTOR OF BRAND COMMUNICATION, ADIDAS

The day I first met Peter was the day he hired me. It was the end of '94, and I was a product designer just a few years out of Art Center. Coming to adidas and working for Peter, being part of that team, having a blast every day, and having both clear direction and autonomy was transformative. It changed my career. Peter's impact on me meant that later in my career, because he did it for me, I genuinely wanted to pay it forward. **How Peter took care of the team and created a bubble around us was super important. It was where he kept bad shit out and kept good shit in, protecting you from all the stuff that's just going to just distract you.** You could just go and create cool stuff. When I was VP of Footwear Innovation and Design, the mission from my boss was to build the world's best design innovation team. Think about that. The world's best. I thought, "Holy shit! That's a huge goal, but okay, we're going to do this." It was a long hard road, but about three years in, I genuinely believed we had built the world's best innovation team. It was basically because I did what Peter did. I created the bubble. I gave the team clear direction and autonomy with accountability by inspiring them to our vision. They outperformed every expectation. I didn't once have to raise the bar; they did it to themselves. I think that's a real lesson from Peter. He never said, "Here's the bar, do this, I expect a ten page tech pack by next Thursday." He just said, "I want you to know, we're the best athletic brand in the world. That's it. And that became our goal.

JON MUNNS, FMR VP CONCEPTS GLOBAL INNOVATION, ADIDAS

I came to Portland in '98 to work at adidas. By then, Peter was like Keyser Söze to the new young crowd. He was a myth. His son Dylan sat across from me and I only knew him as Dylan's dad, but everybody was telling me he's this industry titan. I only met him through Dylan, and hanging out at the house. I never got a professional exposure to him until maybe ten years into it, when we developed a mentor/mentee relationship. **He was the old man on the mountain I could go to. He was so open to talk. Tapping into his energy, experience and wisdom, I tried not to take it for granted, because it was access to an industry leader that was so unique.** When Dylan assembled the dream team of bowling, I got to be Peter's teammate every Thursday for seven years. It was another luxury I didn't take for granted, because he was so current with sport. He knew what was happening that day, and he would give diamond morsels of opinion. I would take that, let it marinate, consume it, and bring it into my professional life.

The other thing I got to see close up was that Peter wanted to give back to people—the less fortunate who were incarcerated, and those who wanted to deliver sports to them. Peter had a connection at the McLaren Youth Correctional Center near Portland, where they play sport as a means of teaching life lessons. Peter helped connect our business unit at adidas with them to gather sports equipment. I brought my team in, and we met with them and had a day of conversation. We put shine on to Peter in front of all these kids who were super artistic and said, "Hey, you can make a career out of your athletic and artistic ability if you channel your energies the right way." Even later in his life, when he didn't have to be doing that, he wanted to help. Even in the bleakest of situations, he wanted to help artists and designers flourish. You have guys in there who are doing real time, but he didn't care. He just wanted to show them that using their talent, there was a way out of their situations.

TODD ROLAK FMR SNR DESIGN DIRECTOR, ADIDAS

Compliments were like dog whistles from Peter. He wouldn't load praise on you. And that was kind of the same with Rob Strasser. I would tell people that my marching orders were **"Don't fuck it up." Most people could have been threatened by that, but with Peter it really meant the exact opposite. It's like he was saying, "You're the guy. We know you're going to do a great job. We completely trust you. Go do it."** So that was really a badge of honor to be threatened with "Don't fuck it up," because it really meant, "We have complete faith in you." But you had to know those guys to know what that meant. That's why I said compliments came like

dog whistles. You had to know the interpretation of who Peter and Rob were and what that meant. I do remember, there was some event. I don't know if it was an anniversary— some event where Peter brought Christina. I was actually sitting next to her at the table. I remember thinking,"Oh, that's Peter's wife, she must be a saint. How could she put up with this guy!" And she said, "You're Steve?" I said, "Yes." She said, "Peter thinks you are really good." That was the only time I ever really knew what he thought of me. Another of those rare compliments came when I designed a poster for muscle tights, an innovative little apparel concept that I had a comp of in which everything was done by hand. We were cutting and pasting, and he walked by my office and saw that comp sitting up on the wall. He said, "Sandstrom, that poster is so tasteful, it makes me wanna puke." I thought, "Ok, I guess it's good then."

STEVE SANDSTROM FMR SNR ART DIRECTOR, NIKE

I remember going in once on a Thanksgiving Day, and he was in there working. He was working as hard as everybody else. He didn't expect more from you than what he was doing. Peter did have that innate ability to really see the good in people and see the possibilities and just taking a chance on them. And I did glean that from him, and I was able to manifest that in my approach at HappyLucky. I also echo what many people are saying about Peter being a strong art director and creative director, but also letting you do your own thing, sometimes knowing well that's gonna be really fucked up, but go ahead. He gave people a way to learn and make mistakes. That's a hard thing to navigate as a creative director because you ultimately want the project to be perfect. That gentle guiding, it's a real art form.

The biggest gift I got from him, is the ability to see the talent and possibilities and really operating with integrity and loyalty. He was very loyal to his support people: the typographers, the printers, pre-press houses, and the photographers. He really stood by them. It paid off because people go above and beyond when you are loyal to them. Later, that really was what made HappyLucky work—my consistent loyalty to people who were proving themselves and doing good work for us. Peter was also a "tender heart ass." He could be really hard on you, but he did it in a way that he had your best interest in mind and the project's best interest in mind or the brand's best interest in mind. It was really hard, because he legitimately cared about you, and he was doing it to make you better and the project better.

TONI SMITH FMR SNR ART DIRECTOR, ADIDAS

One of my favorite Peter stories was from '84, the year Nike was in big trouble. Rob Strasser decided they couldn't spend big on a sales conference, so instead they rented the Linfield University campus at McMinnville. All the sales guys flew in and had to stay in dorms. The only thing they spent money on was a Learjet to fly Michael Jordan in. Michael was early, and it was meant to be surprise. Because they didn't want any of the sales people to know, they had Michael land on a strip there in McMinnville. The idea was for him to appear in the evening, so he had all this downtime. He and Peter went to the tiny McMinnville golf course and there wasn't anybody at the shed, so Michael wrote a note saying, "Hey, we're playing golf. We'll pay when we get back." He signed it "Michael Jordan." The guy at the golf course thought it was a prank, so he called all his friends and said, "Hey, assholes. Why are you doing this to me?!" He was on the phone and all of a sudden in came Michael with Peter. He was beyond himself. He couldn't believe that Michael was using his golf course. That night all the sales reps were in the gymnasium, and we had smoke machines and a giant light. **The doors opened up, a light beam came through, and Michael ran in through the smoke and dunked in front of everyone. Nobody knew that was going to happen. It was an incredible moment and it marked a turning point in Nike's fortunes.**

ROGER THOMPSON FMR DIRECTOR/ CINEMATOGRAPHER, NIKE

The first time I met Peter was when Rob Strasser put together a group to sign Michael Jordan. Rob specifically took me to Peter and said, "Here's the guy that's going to make this work." I didn't know anything about him other than the posters, but from the day after we signed Michael, we were never separated. From that moment, I don't think I ever left him or he me. If allowed, I could talk for a day or two about Peter because he's so easy to talk about. There weren't any negatives to his life in my eyes. Even when we had differences of opinion, Peter saw beyond the negative and only saw the positive. He allowed people to have an opinion. He allowed them to disagree. **Peter's great strength was that when he met someone, whether it be business or anything else, he didn't necessarily have the same opinion as they did, he saw beyond that. He saw the human part.** With Peter, Rob Strasser, and me, I was the little guy compared to the two titans. They taught me through their initiative and the vibrancy of their personalities. They were two very different people. Peter was silent and intuitive, whereas Rob was boisterous, loud, and demonstrative. Together they were formidable. In meetings between the three of us, Rob and I talked

and Peter would barely say anything, but he would be listening intently and sketching things we were talking about. Then he'd go off and be the guy to make them happen. It was the same when it came to signing the athletes. Rob would talk, and then it was Peter who made it work. He had a passion for golf. You wouldn't have known it because I don't know when he ever had time to play golf! But his life was his art, his life was his mind. It wasn't knowing how many shoes he sold. That's Pete's legacy, his art. Most people leave their ashes, but Peter leaves us his art. And in my life, Peter's like a spirit. Something that you know is there.

SONNY VACCARO BASKETBALL SPORTS MARKETING PIONEER, NIKE, ADIDAS & REEBOK

Something I learned from Peter completely changed my approach to design leadership and creative direction. There was a time when I was working at GH Bass, I felt really insecure because they had charged me with overseeing apparel. I thought to myself, "You know, Peter wasn't really trained in footwear design. He studied architecture and then graphics. So, how the hell did he eventually oversee footwear and apparel?" **I asked him about his philosophy on creative direction. He said, "Shane, being a creative director is not about being an expert in every discipline. It's all about being the conscious of the brand. When you're the conscious of the brand, you know it when it feels right and you know when it feels wrong."** I was like, "Holy shit!" When he spelled it out in that manner, talk about an epiphany. It gave me so much courage when it came to leading as I do now, because I lead not just footwear designers. I lead color designers, material designers, 3D designers, makers, and a sample room. I feel confident that I can speak with them and help them shape what they're creating—not because I know what they know, because I don't, but because I'm the consciousness of the brand and an ambassador of Peter's philosophy. It's made everything so much more navigable through this journey of mine.

SHANE WARD SNR DESIGN DIR., FEAR OF GOD & ADIDAS

A story that tells you all about Peter is the last time he saw Momma J. When MJ came to us, he and Peter became close. They both loved to play golf, so that became a bond between them. Peter got to know Michael's parents too. It was all new to them, but they trusted him with their son. Mrs. Jordan was out here in Portland, so I said, "Let's go somewhere, I got somewhere I want to show you." So we drove across town, and I took her to Peter's office. **When she realized who we came to see she was like, "Oh my God Howie! That's Peter!" Her face lit up and**

they hugged and had tears in their eyes. It was like all the years that had passed were nothing. Afterward she said to me, "I thought that was I coming out here one more time for a different reason, but that reason was obviously to see Peter Moore again." To see them together and so happy to see each other after all that time is one of the most beautiful things I've seen on the planet.

HOWARD "H" WHITE VP, JORDAN BRAND

A friend called me one day. His daughter was a senior at high school, and she had taken a sports marketing class or something and had to make a presentation. My friend asked if there was anybody who works at Nike that she could talk to. I said, "You know, I don't really know anybody, but I know a guy who used to work at Nike. Let me call him." I called Peter and asked if he would talk to this young woman and he said, "Sure, I'd be happy to talk to her." I set it up and they connected and had a one hour phone conversation. This young woman wrote the report and had to do a presentation in class too. Her father called me later and said that not only did she get an A+ on her report, as she was giving the presentation when she mentioned that her major reference was Peter Moore she instantly went sky high in the estimation of all the boys in the class because they were all saying, "You know Peter Moore?!" They were totally blown away by the fact she got to interview him. That was Peter. **He had the image of being an old curmudgeon sometimes, but he had a real soft spot, especially when it came to helping young people.** It meant so much to me that he was willing to take an hour out of his life just to help that young lady.

BOB WOODELL FMR CHIEF OPERATING OFFICER, NIKE

Peter and Rob. They were the greatest act going. When Rob died in '93, it felt like the end of the world. It was so sudden. He was such a force. There was an entire company on two continents who were completely stunned. Peter lost his best friend, his partner, and his biggest fan. He immediately made sure that every adidas America employee got a phone call with the news; he didn't want people to learn about it secondhand. In the weeks and months that followed, **Peter put aside all of his own grief, and put the weight of the whole company on his shoulders. He took on all the roles that Rob had always filled, and he pulled us along as we—bit by bit—learned to run the company without Rob.** I don't know if Peter ever got to mourn Rob. He was too busy saving the rest of us.

CINDY YOSHIMURA FMR ADVERTISING MANAGER, NIKE & ADIDAS

Opposite: Peter and Mrs. Deloris Jordan

296

Peter's last words... the twelve commandments.

For a long time, I was thinking, "What if Peter narrowed down the adidas standards? What would they be?" Finally, in spring 2022, I reached out to him asking this question. The twelve commandments he came back with are, to me, almost a summary of the life he lived.

On 09.03.22, 22:13, "Peter Moore" peter@whatayathink.com wrote:

Ina........
The original standards are orders, commands, the way it should be.
Thinking commands and today's generation......
I have nothing to add only that these commandments are only as good
as they are excited and committed to...
See attached
Peter

Enough of all that fuss... now it is on everyone to continue what you taught us. Thank you Peter...from all of us.

INA HEUMANN

PETER MOORE'S
TWELVE COMMANDMENTS

1. ONLY THE BEST FOR THE ATHLETE AND THE PLANET

2. LEAD, DON'T FOLLOW

3. CREATE THE FUTURE

4. DON'T WASTE TIME

5. TAKE OWNERSHIP

6. OBSERVE FIRST, SOLVE PROBLEMS

7. THINK OUTSIDE THE BOX

8. TEST YOUR CREATIONS YOURSELF

9. WE ARE ONE

10. TRANSPARENCY IS A MUST

11. SIMPLIFY

12. INNOVATE

"YOU KNOW, ALMOST EVERYTHING
I'VE BEEN INVOLVED WITH—THE NIKE
POSTERS, JORDAN, AIR, EQUIPMENT,
TURNING ADIDAS AROUND—IT DIDN'T
COME THROUGH RESEARCH CENTERS,
DATA ANALYSIS, OR ANY OTHER
BULLSHIT. IT WAS ALL DONE BY THE
GUT FEELING OF WHAT'S THE RIGHT
THING FOR THE KID IN THE STREET.
THOSE SNEAKER COLLECTIONS
PEOPLE BUILD UP, FILLED WITH
HISTORY COLLECTING DUST, WELL,
I WASN'T TRYING TO MAKE HISTORY.
I WAS TRYING TO MAKE THE FUTURE."

ACKNOWLEDGMENTS, CREDITS & SOURCES

ACKNOWLEDGMENTS

Our gratitude to the following people who helped in the creation of this book.

The Moore Family
Christina Moore
Devin Moore
Janna Moore
Emalee Moore
Katie Moore
Lilli Moore
Dylan Moore
Tracy Moore
Hagen Moore
Morgan Moore
Mathilda Moore

Thanks to
Kris Arnold
Ryan Austad
Les Badden
Jim Bagley
Uli Becker
Sabine Beysel
Erik Blam
Ken Callahan
Natalie Candrian
James Carnes
Owen Clemens
Lee Clow
Juan Diaz
Julie Dixon
Michael Doherty
Ron Dumas
Jack Fleming
Nic Galway
Ron Garland
Paul Gaudio
Gregg Guernsey
Bjørn Gulden
Mike Hamilton
Tinker Hatfield
Hein Haugland
Tony Holmes
Walter Iooss
Laura Jenks
Dr. Jonathan Jensen
Luke Jensen
Murphy Jensen
Charles Johnson
Phil Knight

Adrian Leek
Eric Liedtke
Chris Lotsbom
Eirik Lund Nielsen
Ed Lussier
Dr. Simon Luthi
Darryl McDaniels
TJ McDonald
Mary McGoldrick
Guy Marshall
Pablo Maurer
Angela Medlin
Patsy Mest
Michael Michalsky
Ryan Morlan
Jon Munns
Jim Reilly
Todd Rolak
Steve Sandstrom
Nick Schonberger
Toni Smith
Penny Steinmann
Jim Stutts
Sarah Talbot
Roger Thompson
Sandra Trapp
Susan True
Pam Vaccaro
Sonny Vaccaro
Bernd Wahler
Shane Ward
Howard White
Alasdhair Willis
Bob Woodell
Ronnie Wright
Cindy Yoshimura

And to all those who would have loved to contribute.

Special thanks to
Kadie Casey
Jacques Chassaing
Scott Reames
Toni Smith
Penny Steinmann

Extra special thanks to
Ina Heumann, without whose tireless devotion to preserving Peter Moore's legacy, this book would not exist.

First published in the United States of America in 2024 by
Rizzoli International Publications, Inc.
300 Park Avenue South
New York, NY 10010
www.rizzoliusa.com

Written by Jason Coles
Art Direction by Jacques Chassaing, Kadie Casey & Toni Smith
Design by Jason Coles
Cover design by Hagen Moore
Art section curated by Toni Smith
Project management by Penny Steinmann

Publisher: Charles Miers
Associate Publisher: Anthony Petrillose
Editor: Gisela Aguilar
Production Manager: Rebecca Ambrose
Design Coordinator: Tim Biddick

"adidas", the Trefoil logo, the 3-Stripes mark and the 3-Bar logo are registered trademarks of adidas, used with permission.

"Nike," the Nike logo, the Nike Swoosh, the Air Jordan "Wings" logo and the Jordan "Jumpman" logo are registered trademarks of Nike, used with permission.

Distributed in the U.S. Trade by Random House, New York.

Printed in Asia

2024 2025 2026 2027 2028 / 10 9 8 7 6 5 4 3 2 1

ISBN: 978-0-8478-3543-0
Library of Congress Control Number: 2024933889

Visit us online:
Facebook.com/RizzoliNewYork
X: @Rizzoli_Books
Instagram.com/RizzoliBooks
Pinterest.com/RizzoliBooks
YouTube.com/user/RizzoliNY
Issuu.com/Rizzoli

Jason Coles: Instagram @madebyjase

To learn more about Peter Moore, visit petermoorecreated.com.

DON'T FUCK IT UP...

Friend Humble Mentor Wind-Beneath-Our-Wings
Family-first Humility No-Bullshit
Smart Current Timeless Competitive
Conviction Willing Grandfather Admired best-of-adidas Infatuating Grandfather Driven
Introvert Believer Brutally Pissed-off Pioneering Finger-on-the-Pulse Curious
Blunt Intrigued Hilarious
Impact Brilliant Magician Humorous Frank Intrigued
Inspiring Disciplined Glamorizer Super Passionate Direct
Courage Comedian Gem-finder Wind-Beneath-Our-Wings Admired Genius Brave Outside-the-box
Heroic Hard-nut Believer Inspiring Wise
Comedian Warm Stubborn
Pure Authentic
Dedicated Integrity Intense Fighter Shar
No-Nonsense Humility Hilarious Visio
Dude Funny
Brutally Honest Laugher Frank Driven
Futurist Father-figure Cynical Conversation Welcoming
Sponge Marshmallow
Master Rebe
Hope
Daring Loyal Yes-attitude Candy-coated-steel Conviction
Willing Courage Men
Determined Raven Soft Candy-coated-
Introvert Listener
Builder Caretaker Hone
Humble Welcoming
Integrity Sensitive Positive Outside-the-box
Uncompromising Thoughtful Brand-builder Yoda One-Man-University Hard
Devoted Rebel Staunch Cyni
Profound Marshmallow Family-first
Open Dependable Revolutionary Bold
Wise Larger-Than-Life Raven Gracious
Friend Creator Warm Current Sculptor Dude
Cranky Heroic Focused Caring
Creative No Bullshit
Determined Glamorizer Humorous Cerebral Wisdom Compassionate Bl
Hard-nut Humanitarian Impact
Simplicity-in-a-Bottle Man-of-Few-Words One-Man-University Humanitarian